For my family

"Our echoes roll from soul to soul
and live forever and forever"

The Princess.

Cartes-de-visite album Tennyson frontispiece, c.1866-67.

Contents

Foreword

Flattered to have been asked to contribute this foreword, I found myself plunging down a series of engaging rabbit holes; the exploration of each adding immeasurably to an understanding of Mary Fraser Tytler and the forces that both influenced and drove her. These are all unpicked and reassembled to illustrate the many strands of thought, drawing on everything from the Celtic imagery surrounding her in her childhood, Classical iconography, Romanesque and Egyptian motifs, absorbed on her travels, through to Art Nouveau designs, that all fed into broad sweeping themes of Love, Life, Death, Justice and Innocence, which poured out into her work, the apogee of which was the remarkable Mortuary Chapel at Compton. As she herself said, 'A symbol may well be compared to a magic key. In one hand it is nothing more than a piece of quaintly wrought iron, but in another it unlocks a door into a place of enchantment.'

Mary was a remarkable artist and craftswoman, but almost more than that she was an enthusiast, who knew the power of art to change lives. She became both an educator and a collaborator. Her Compton Potters' Arts Guild, shaped by the idea that art and craft was for all, was an early example of a social enterprise scheme, pioneered by Liberty & Co, her Scottish ancestry coming to the fore.

The detailed and loving research by Veronica Franklin Gould brings all this into focus and allows Mary to step fully out of the shadows, in the year which marks the 175th anniversary of her birth.

Emma Verey
Watts Gallery Trustee, 2015-21.

Foreword

In the 1868 photograph of the Fraser Tytler sisters entitled *The Rosebud Garden of Girls* by Julia Margaret Cameron, Mary sits bottom right, with eyes demurely cast down. It is a classic example of appearances being deceptive, for who could guess that this shy young lady would become one of the leading figures of the Arts and Crafts movement, and even an advocate of Votes for Women. All that, however, was some way in the future.

Mary's brief entry into the Cameron circus led to her meeting George Frederic Watts, by whom she was greatly impressed. Travels on the Continent broadened her mind and her artistic knowledge. She was already painting, mostly portraits – one or two show a dazzling insight into the character of her sitter.

Her painting, the social round, even being presented at Court was not enough. She had a desire to do good. Not with tracts and buns for the deserving poor, as one would expect from someone of her social background, but to teach arts and crafts to people less fortunate than herself and help them realise the inner potential she felt everyone had.

Valiant Seton chronicles her lesser-known early history, and for those of us who have long admired her, it is gratifying that thirty years ago Mary emerged from the long shadow of her husband (*Unsung Heroine of the Art Nouveau*, 1898), to be recognised as the truly remarkable woman that she was.

Richard Jefferies
Curator, Watts Gallery 1985-2006.

Preface

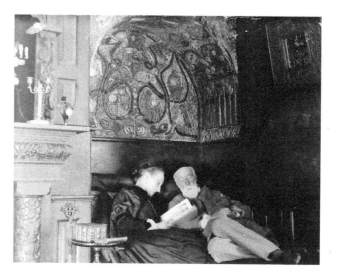

Mary reading to Signor in the niche at Limnerslease.

'I picked up the Newspaper casually & read of the end of a life very dear'. In November 1902, 53-year-old Mary Watts was having a break from her pioneering arts and crafts work, to entertain a brace of duchesses at Limnerslease, the home she shared with the world-famous octogenarian artist George Frederic Watts (1817-1904).

'Casually'? As I read Mary's diary entries, I was astonished by her restraint. The suppressed power of her emotional, still unconfessed shock drove me to uncover the mystery. *The Times* that day announced the death of a former Guardsman, whose name had often appeared in her diary of 1868. This was an eventful year for Mary and the only diary she preserved before her marriage to Watts two decades later.

Sir James Gordon Graham-Montgomery met with a violent death on Saturday morning while travelling from Edinburgh to St. Pancras. He was found lying in the six-foot way on the Midland main line at 7 o'clock, just outside Seaton tunnel. His hand was badly injured, and one of his feet was cut off. Life was not extinct, but he died shortly afterwards . . . it is supposed that on awakening suddenly he must have unconsciously opened the door of the compartment he occupied by himself, and have fallen on the line, the six o'clock train from Kettering passing shortly afterwards, and severing his foot.[1]

That November evening, as her husband lay on his sofa in the fantastical reading niche she had designed for him at Limnerslease, their home in Compton, Surrey, Mary handed him the news cutting and wept. His obituary had reignited tortured feelings for an unidentified lover, confided only in verse and prayer in her commonplace book. Like Mary, Graham-Montgomery grew up among the Scottish aristocracy. A rakish bachelor two years her junior, Sir James had recently inherited Stobo Castle in the Scottish borders, a baronetcy and respectability as Deputy-Lieutenant for Kinross and Peeblesshire. He had achieved some distinction as Lieutenant-Colonel in the Coldstream Guards but confessed to have led a louche life. The few valuables he bequeathed to his brother and heir comprised 'an erotic work or two and my jewels' – in case he failed to return from foreign travels. As a young lieutenant he had had a profound and, I believe, devastating effect upon young Mary.

She laid her head in her husband's tender hand upon his shoulder and wept. Their partnership as social reforming artists among the most inspired men and women of the day drew her to the heights of joy, yet thoughts of her philandering lieutenant sent Mary reeling into a metamorphic pivot that epitomised Wattsian art. 'How blessed, how crowned my life of love & work is,' she wrote '& yet I sorrow, sorrow'. During their loving, creative partnership, Mary had developed extraordinary iconography to express his universal vision of Love and Death, Love and Life, Love Triumphant. Now she was crying her heart out for the life of another man, claiming in her diary that her distress was 'more because of the sadness & failure I seem to see must have beset that life.' I wonder?

'Did you know him?' asked Signor, as her husband was affectionately known, due to his resemblance to and reverence for Titian and the great

Venetian artists. The subject of his earlier marriage to the teenage actress Ellen Terry (1847-1928) – tempestuous together in life, eternally loving in paint – was taboo between the Wattses. Mary had held a torrid secret to herself for decades. 'Yes, very well once,' she admitted. Leaving the power of actual knowledge unspoken, she shared only the emotion of loss, 'your little sorrow', Signor described it, more tender than understanding. Intensely passionate, Mary felt that her own aspiration that morning to rise above personal issues, 'to realise one is part of a big whole', was the only way her turmoil could possibly be described as little. 'My own philosophy mocked at me.' Tempted yet afraid, she yearned to send a wreath to his funeral, with a note 'If free spirits grow more through new life – surely we are nearer them now than when the loud of earthly form stand between.'[2]

Mary was herself a leading light in the social reforming Home Arts and Industries Association, a pioneer of the Celtic Revival and craftswoman of international repute. It is due to Mary that Limnerslease, the Watts Gallery she commissioned to house her husband's art and a hostel for her apprentice potters, and the Watts Mortuary Chapel which she trained them to create, is today known as the Watts Village.

* * *

Valiant Seton: Mary Fraser Tytler of Aldourie explores Mary's transformation from amateur artist brought up in a remote highland castle, her long march into the heart of Watts, punctuated by years of torment and experiments in clay with the dynamic French sculptor Aimé-Jules Dalou. Until at last, she emerged from her aristocratic chrysalis as a craftswoman with a mission to teach and uplift the lives of the poor, becoming life partner extraordinaire of England's Michelangelo.

ONE

Valiant Seton

Where's Nigel Bruce, and De La Haye
And valiant Seton, where are they?
Where Somerville, the kind and free,
And Fraser flower of chivalry?[i]

The soul of Scotland coursed through Mary Seton Fraser Tytler's blood and that of her swashbuckling forebears. Shakespeare featured the founder of her Seton ancestry – originally Seytoun – as officer to *Macbeth*; and the eleventh-century Scottish king Macbeth's successor Malcolm III granted lands in East Lothian to Seier de Seytoun de Lens of Flanders.

Sir Christopher de Seton 'Gude Sir Chrystell' was an especially gallant knight. He fought alongside national heroes, Sir William Wallace and Robert the Bruce in the First War of Scottish Independence. At the age of 23, he had married Bruce's sister Lady Christina; and when the newly crowned king fell from his horse in the Battle of Methven in 1306, Sir Chrystell saved his life. Captured by the English and executed at Dumfries, he left a noble legacy – the Seton arms surrounded with the Royal tressure of Scotland.[3]

Less heroic after the defeat of the Scots in the Battle of Flodden Field was the chaplain, Patrick Seton. He killed a man in a duel and fled to France. There Patrick changed his surname to Tytler and rather wonderfully emblazoned his shame in a metamorphic family armorial device '*Occultus non extinctus*,' inscribed above rays of the sun issuing from behind a cloud.

His sons returned to Scotland in 1561 as escorts to the eighteen-year-old Mary Queen of Scots. 'Her whole train not exceeding sixty persons' was

[i] Sir Walter Scott, *The Lord of the Isles*, 1820.

scathingly described by Queen Elizabeth I's chief adviser Sir William Cecil as 'of mean sort'.[4] The Tytlers and their cousins – Mary Seton, who later became a nun, and George, the seventh Lord Seton soon to become Master of the Household – remained in the retinue of the Queen of Scots and fought with her pikesmen in the Battle of Corrichie (1562) near Meikle Tap in Aberdeenshire.[5] The auburn-haired Queen has remained in the minds of generations of the Tytler family.

After her execution, her son King James I of England and VI of Scotland, became obsessed with witchcraft. Shakespeare's *Macbeth*, written for him, was first performed before the king in 1606, the year Patrick's grandson Alexander Tytler was born. Alexander begat a dynasty of distinguished lawyers, historians and *literati*, unafraid of controversy and passionate in their search for truth,[6] not least Mary Fraser Tytler's great great grandfather, William.

William Tytler, a historian and Writer to the Signet, was an important influence on the developing cultural imagination of Scotland. Born in Edinburgh, he was a leading member of the Select Society debating club founded by the artist Allan Ramsay. Scotsmen fearing loss of national identity determined to re-establish Stuart rule. 'Bonnie' Prince Charles Edward Stuart returned to his ancestors' palace, Holyroodhouse. His French and Highland forces triumphed in the first major conflict in the Jacobite Rebellion of 1745, the Battle of Prestonpans. But the slaughter of 5,000 Highlanders in the Battle of Culloden in Inverness-shire on 16 April 1746, followed by 1,000 more deaths, marked the end of the campaign to restore Stuart rule.[7] Tales of horror and heroism, memorable landmarks and objects from the fateful battle would remain to fascinate generations of Fraser Tytlers.

William caused an almighty stir when his forensic *Inquiry, Historical and Critical, into the Evidence Against Mary Queen of Scots* was published in 1759. His *Inquiry* reclaimed the Stuart cause, vindicating the Queen of adultery and the murder of her husband Lord Darnley. He challenged evidence of the Earls of Moray and Morton and exposed fallacies in the historical writings of the Reverend Dr William Robertson and the philosopher David Hume. Leading thinkers of the Scottish Enlightenment, they too were members of the Select Society.[8] William's 'acute and able' analysis

established that the hand that wrote letters to the Earl of Bothwell inferring collusion in the murder of her husband, was not the Queen's, that the damning Casket Letters were forgeries.[9] The English lexicographer Dr Samuel Johnson (1709-84) was among prominent contemporary reviewers of William Tytler's *Inquiry*:

> It has now been fashionable for near half a century, to defame and vilify the house of Stuart, and to exalt and magnify the reign of Elizabeth. The Stuarts have found few apologists, for the dead cannot pay for praise; and who will, without reward oppose the tide of popularity? Yet there remains still among us, not wholly extinguished, a zeal for truth, a desire of establishing right in opposition to fashion.

So seismic was the *Inquiry* that the finest intellects of England and Scotland, generally convivial society men, engaged in heated debate. Tytler could be quite vehement in defence of his case. Hume, whose philosophy could be notoriously provocative – 'I am apt to suspect the negroes, and in general all the other species of men… to be naturally inferior to the whites,'[10] denounced his challenger. 'A sound beating or even a Rope [is] too good for him.' Tytler fought back with lethal courtesy in a revised edition of the *Inquiry*, supporting each point with vigorous accumulated evidence. The moment he entered the room, Hume walked out. 'What a terrible little man you are, that can discomfit such a Goliath!' Tytler shot back, 'Aye, the Philistine boasted, but I smote him in the forehead'.[11]

His friendship with Robertson survived the controversy; and when the historian invited him to dine, Tytler was amused to see that he had hung Gavin Hamilton's painting of *The Abdication of Mary, Queen of Scots[ii]* flanked by portraits of his host and of himself. Sir Henry Raeburn had painted Tytler in splendid wig and hat, at his Midlothian estate Woodhouselee in the Pentland Hills.[12] His evidence, widely read and argued for centuries – as Mary Queen of Scots's biographers Lady Antonia Fraser and Alison Weir demonstrate – still stands today.[13]

[ii] 1756, National Galleries of Scotland.

Tytler's defence of their wronged queen roused his 28-year-old protégé Robert Burns to write an 'An Address to William Tytler Esq.' Burns, while working as a farmer and exciseman, had begun to produce some of his finest poetry and satires:

> Reverèd defender of beauteous Stuart,
>> Of Stuart, a name once respected;
> A name which to love was the mark of a true heart,
>> But now 'tis despised and neglected.
>
> Tho' something like moisture conglobes in my eye,
>> Let no one misdeem me disloyal:
> A poor friendless wand'rer may well claim a sigh,
>> Still more, if that wand'rer were royal . . .
>
> I send you a trifle, a head of a bard,
>> A trifle scarce worthy your care;
> But accept it, good Sir, as a mark of regard,
>> Sincere as a saint's dying prayer.
>
> Now life's chilly evening dim shades on your eye,
>> And ushers the long dreary night:
> But you, like the star that athwart gilds the sky,
>> Your course to the latest is bright[14]

Cultural entertainment ran in the family. That year 1787, William was among the guests painted listening to Burns' poetry recital at the Edinburgh home of the beautiful Duchess of Gordon;[iii] he played the harpsichord and flute with gusto and would collaborate with Burns to revive folk music, compiling poetry to set to music for the influential six-volume *Scots Musical Museum*. Both men appear in James Edgar's 1864 tableau of an Edinburgh party hosted by the eccentric Judge of Session Lord Monboddo, a philosopher, actor and evolutionary theorist.[15] William had a splendid prescription for a happy life: 'short, cheerful meals, Music, and a good conscience.'[16]

[iii] 1887, Irvine Burns Club.

His eldest son Alexander Tytler carried on the family arts patronage. Father and son were prominent figures in the Scottish Enlightenment and founder members of the Royal Society of Edinburgh. Alexander expanded their surname extended to Fraser Tytler in 1776 on marriage to Anne Fraser, heiress to the Frasers' Inverness-shire estates of Erchitt, Balnain and Aldourie.[17] As Professor of Universal History, Greek and Roman Studies at Edinburgh University, he inspired the young Walter Scott, who went on to join preeminent figures exchanging 'wit of the purest flavour' at Alexander and Anne's literary salon, enjoying 'pyramids of cakes' in the mirrored drawing room at 108 Prince's Street in Edinburgh.

Alexander sat in his library for an elegant conversation piece by the master of the Trustees' Academy, David Allan. In 1790, the year he was appointed Judge Advocate of Scotland, he published a marvellously esoteric essay on 'Extraordinary Structures on the Tops of Hills in the Highlands [and] Progress of the Arts among the Ancient Inhabitants'.[18] This mystical passion to investigate early civilisations to help stimulate modern social and cultural advance, would inspire his great granddaughter a century later.

Mary Fraser Tytler would treasure Aldourie manuscripts of the 1793 edition of Burns's *Poems*, which her great grandfather Alexander had proof-corrected, compelled by the wit, *naïveté* and imaginative power of 'Tam o' Shanter'. There were, though, four blood-curdling lines that he could not stomach:

> Three lawyers' tongues turn'd inside out,
> Wi lies seam'd like a beggar's clout;
> Three priests' hearts, rotten, black as muck,
> Lay stinking, vile, in every neuk.[19]

Burns is now known to have been suffering from 'a damn'd melange of fretfulness and melancholy'.[20] A letter preserved in the Aldourie library revealed how anxious he was not to antagonise the judge, whose endorsement meant much to Burns at this stage in his career: 'To have that poem so much applauded by one of the first judges, was the most delicious vibration that ever thrilled along the heart-strings of a poor poet.' Burns deleted the lines: 'As to the faults you detected in the piece, they are truly there; one of them, the hit at the lawyer and the priest, I shall cut out,' he wrote to Alexander.

'Your approbation, Sir has given me such additional spirits to persevere in this species of poetic composition.'[21]

On elevation to Judge of Session at Scotland's supreme civil court in 1802, Alexander assumed as his title, Lord Woodhouselee, after his late father's estate in the Pentland Hills. Portraiture became increasingly significant to the family as he rose in stature. He sat to the artist Archibald Skirving in 1798 for a striking portrait in pastel, the luminous, velvety medium of choice for European portraiture.[22] Raeburn painted twin portraits in oil of Lord and Lady Woodhouselee in 1804. Anne's, now at the Brooklyn Museum in New York, is the finer; she is seen sitting in a fur-trimmed coat, lace collar and cap, her face warm, confident and inviting, as if about to speak.[23]

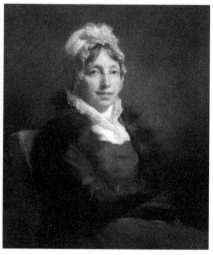

Archibald Skirving, *Alexander Fraser Tytler*, 1798.

Sir Henry Raeburn, *Lady Woodhouselee*, c.1804.

Such was Alexander's literary influence that when he wrote to congratulate Lord Byron on his first poems in 1807, the nineteen-year-old was immensely proud to receive a critique from 'the head of the Scottish literati, and a most *voluminous* writer'. Lord Woodhouselee had that year published *Memoirs of the Life and Writings of the Honourable Henry Home of Kames*, the founding father of the Scottish Enlightenment.[24]

Tales of the Woodhouselee ghost, Lady Bothwell emerging from a turret room in a white muslin dress decorated with 'a wee flower', inspired Walter Scott to immortalise her in 'Cadyow Castle'.

… Few suns have set since Woodhouselee
 Saw Bothwellhaugh's bright goblets foam,
When to his hearths in social glee
 The war-worn soldier turn'd him home.

'There, wan from her maternal throes,
 His Margaret, beautiful and mild,
Sate in her bower, a pallid rose,
 And peaceful nursed her new-born child.

O change accursed! Past are those days;
 False Murray's ruthless spoilers came,
And, for the hearth's domestic blaze,
 Ascends destruction's volumed flame.

What sheeted phantom wanders wild,
 Where mountain Eske through woodland flows.
Her arms enfold a shadowy child –
 Oh! Is it she, the pallid rose?

The wilder'd traveller sees her glide,
 And hears her feeble voice with awe;
"Revenge," she cries, "on Murray's pride!
 And woe for injured Bothwellhaugh!"[25]

Scott would remain a lifelong friend. The Fraser Tytler children loved visiting his cottage at Lasswade. Together they would climb up into the Pentland Hills, the summer air fragrant with wild thyme. As soon as Woodhouselee came into view through the trees, with the Carnathae hill behind, the novelist would sit down with his young friends and thrill them with ghost stories or whatever he was writing at the time. Alexander's daughter Anne recalled:

> Drawing round the clear wood fire, we listened with such excited feelings of terror and of awe, that very soon for any of us to have moved to ring a bell would have been impossible. How could we dare to doubt the truth of every word, having ourselves our own legitimate ghost to be believed in and whom Walter Scott himself, in one of his ballads has celebrated.[26]

He was reciting *Marmion* when suddenly he broke off, at the point where Constance de Beverley rejected by Lord Marmion was to be bricked alive into the convent wall:

> An hundred winding steps convey
> That conclave to the upper day;
> But ere they breathed the fresher air,
> They heard the shriekings of despair
> And many a stifled groan:
> With speed their upward way they take,
> Such speed as age and fear can make;
> And crossed themselves for terror's sake,
> As hurrying, tottering on.'[27]

Trembling with eager fear, the Fraser Tytlers demanded to know whether Constance would die there. 'I give you my sacred word, ladies', admitted Scott. 'I have not at this moment the slightest idea of what I am to do with Constance.' After publication in 1808, record-breaking sales of *Marmion: A Tale of Flodden Field* would exceed 28,000 copies within four years.[28] Happily, if less financially rewarding, *Lord of the Isles* commemorated 'Valiant Seton' and 'Fraser, flower of chivalry'.[29]

Scott now applied the professor's empirical vision to his new genre, the historical novel. So successful was his first, *Waverley*, published anonymously in 1814 and set against the backdrop of the 1745 Jacobite Rebellion, that he planned to document the history of Scotland in this manner. Instead, he continued his series of Waverley novels; and in 1820 when he was appointed president of the Royal Society of Edinburgh and created a baronet, Scott invited Alexander's youngest son Patrick Fraser Tytler KC to write the definitive history.[30]

Patrick was completing the last volume of his *History of Scotland* (1828-43), when Queen Victoria commanded him to report on the Darnley Jewel, one of the most important early jewels in the Royal Collection. This highly symbolic heart-shaped gold and enamel locket, set with Burmese rubies, Indian emerald and polychrome enamel wing-shaped heart – a motif dear to Mary Fraser Tytler – had been commissioned by the Countess of Lennox to commemorate her husband who fell in battle in 1571.

Proclaiming 'Death shall dissolve', the Jewel is now on display in Mary Queen of Scots' Outer Chamber at the Palace of Holyroodhouse. Patrick was recalled to Windsor to catalogue the royal miniatures and portraits and granted the fearful honour of taking home a precious box of 130 enamels: 'I hope no one will come in from the roof of our house!'[31]

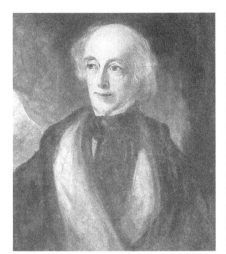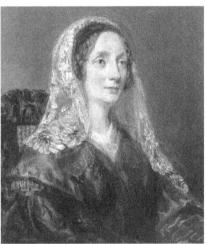

Margaret Sarah Carpenter, *Sheriff William Fraser Tytler*, and *Margaret Fraser Tytler*, 1841.

His eldest brother was Mary's grandfather, Inverness-shire's longest serving Sheriff-Depute. William Fraser Tytler appears as a long, curly-haired *Boy with a Bow* at Woodhouselee, in a painting by David Martin, the first pupil and principal assistant to Ramsay.[32] In a golden year, 1801, William was appointed Sheriff and married Margaret Cussans Grant, the heiress to a large estate Burdsyards, renamed Sanquhar, at Forres in Morayshire. She was so ravishingly beautiful that people used to stand in their doorways just to watch her pass. Skirving captured her warm nature in his pastel portrait of the fresh-faced highlander.[33] William and Margaret, who sat to the fine female portrait painter Margaret Sarah Carpenter, in 1841, named their ninth child – Mary's father – after the 'Bonnie' Prince.

Charles Edward was born on 30 September 1816 at Aldourie on the south bank of Loch Ness, four miles west of the highland capital, the Royal Burgh of Inverness. His birth could not be recorded in the parish register because his family was Episcopalian, the Anglican church then outlawed in

Scotland. Charles was a rare, introverted figure in his otherwise gregarious family. More of a mathematician and classicist, he was brought up at Sanquhar and educated at Anderson's Academical Institution in Forres. While the Sheriff held court at Inverness Castle, his sons, like most of their highland friends, enjoyed a healthy sporting upbringing before joining the military or civil service of the East India Company. Charles's social conscience drove him to find ways to mitigate the harm the Company's relentless colonialization of the Indian subcontinent was causing.

The original Company of London merchants had been granted a charter from Queen Elizabeth I in 1600 to trade for spices in the East Indies, on behalf of the Crown, with the ability to wage war, to fend off rival traders and extend trading interests across the Mughal Empire. Over the decades the Company had been aggressively collecting taxes to purchase Indian goods and export them to England, amassing huge fortunes, seizing control of the Mughal state of Bengal and enriching its unscrupulous governor, Robert Clive. By 1805 Margaret's late cousin Charles Grant had been chairman of the Company, ruling India from its London offices.

Charles Grant was born at the Fraser Tytlers' farmhouse at Aldourie on 16 April 1746, the very day his father was killed in the Battle of Culloden, six miles south-east. Grant was a social reformer opposed to the Company's warlike policies, a powerful activist for the abolition of slavery and director of the Sierra Leone Company whose purpose was to provide a refuge for freed slaves. But he supported the Company's transformation of India into a primary producing country, especially its aim to educate its people and train them to develop their resources in the name of progress – thereby Company profits and his own. As an Evangelical Christian, he had proposed to convert the Hindus, whom he characterised as 'universally and wholly corrupt . . . depraved as they are blind, and wretched as they are depraved.'[34] Eighteen-year-old Charles Edward, who would have been horrified at this, enrolled in the East India College at Haileybury, founded by Grant, to train for a writership in Bombay, where his son Sir Robert Grant was governor.[35]

Death took its toll on William and Margaret's boys. Postal delay from India meant that five months passed before the family learned that their eldest son Alexander had died of malaria. Sixteen-year-old Charles was the first to know as he happened to be spending Christmas with the

Grants at Moniack Castle when the news came in.[36] No sooner had his third brother William embarked on his military career than their second brother George was killed. Their father erected a grand empty tomb in their memory as a centrepiece to their family cemetery at Aldourie, an ever-present reminder. Shattered by the loss of his brothers, Charles turned 'deeply and *engrossingly*' to religion.[37] At the age of 20, he too sailed for India.

He arrived in Bombay on 3 May 1837 to a welcome dinner on Malabar Hill with Sir Robert.[38] His postings to assist the principal collectors of Dharwar and of Poona suited not only his mathematical and linguistic skills, but his sensitivity to the natives' needs. He proposed higher price structures to enable them to produce commercial crops, with less struggle.[39] In his analysis of experimental revenue settlements for the Collector and Magistrate of Ahmednagar at Nassick, Charles recommended generous allocation of land to the *ryots* – peasant farmers – to accommodate their feelings, habits and tastes. 'To yield much to the *ryots* is to receive much from them ... take only so much as the present necessities of the State demand ... to heave our cultivators out of poverty into well-being.[40]

Charles looks quite a dandy in the watercolour exhibited by Benjamin Richard Green at the Royal Academy Summer Exhibition in 1850. His brow and nose are strong, the hair neatly coiffured around his almond-shaped face, a curl over the right temple; he sports a blue cravat, his frockcoat is open wide. Charles appeared to enjoy the company of friends. His depression vanished when as he confided in his journal, he made a discovery that would absorb him for the rest of his life. 'I obtained the keys to the

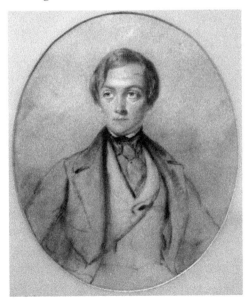

Benjamin Richard Green,
Charles Edward Fraser Tytler.

Gospel, a new sun rose upon me.' Finding in Revelation aspects of prophecy, upon which he was to become an authority,[41] he set about juggling spiritual cravings with sorting out his mother's financial concerns about Sanquhar.[42] A man with a mission, free of anxiety, he wrote on Christmas Day, 'I have now tasted of higher things, and such trifles as these scarcely cost me a moment's solicitude. Shall He that feeds the ravens, not feed me!'[43]

Swiftly elevated to Second Assistant Collector of Ahmednuggar, Charles fell in love.[44] Thirty-two-year-old Etheldred St Barbe sailed into Bombay in November aboard the East India Company steamer *Cleopatra*, very probably in search of a husband.[45] As women outnumbered marriageable men in England, and Englishmen in India had little opportunity to travel home, the Company had been escorting adventurous girls to travel aboard their matrimonial 'Fishing Fleet' for over a century, risking disease and drowning on the months-long voyage. Once they had met their match, the marriage would quickly take place, to safeguard their prize from other predators.[46]

'God is Love,' a triumphant Charles wrote on 26 January 1843. 'Emphatically and without reservation!' He acted so fast that the news did not reach his parents until well after his marriage to Ethel at Malligaum in Nassik on 4 April 1843. Through the Bombay newspapers the Sheriff – now laird of Aldourie[47] – found her father's address. John St. Barbe worked in London for the St Barbe's family merchant bank, which was based in Lymington in Hampshire. William Fraser Tytler wrote warmly to John and Elizabeth St. Barbe. Conscious that his son was comparatively young – Ethel was seven years older than Charles – he warned that their married life would not at first be one of affluence, but the Sheriff reassured his son's in-laws that his habits were 'far from being so expensive as those which most young civilians indulge in.'[48] Ethel's heart and mind mattered to Charles infinitely more than fine breeding.[49]

The match will have delighted both families. Her ancestors had also devoted their lives to imperial service. William St. Barbe had been a Gentleman of the Privy Chamber and witness to the will of Henry VIII; and his descendants had entertained James I at Broadlands, their Romsey manor house, where they were involved in the planning of Charles II's escape route. Furthermore, like Sheriff Fraser Tytler, Ethel's grandfather was Deputy Lieutenant of his county, Hampshire.[50]

There was excitement in Inverness-shire in August, when the Sheriff as Deputy, with his cousin Lord Lovat, Lord Lieutenant of the County, organized the Highland Gathering to greet Queen Victoria and

Prince Albert from their yacht at Fort William. The Sheriff threw down a web of Fraser tartan[51] and led Her Majesty by the arm over the landing stage. Lovat was intrigued to know 'What the *chat* was the Queen and you had up the pier?'[52] Never before had a British sovereign travelled so far north, as the Queen recorded in her journal. Dazzled by the tartan-clad crowds, she was enchanted by 'the chivalrous, fine, active people', the wild romance, mountains, streams and solitude of the Highlands – the heart and soul of the Fraser Tytlers. Her Majesty came to feel an absorbing passion for her Stuart ancestry and in 1848 she acquired the lease of Balmoral Castle in the Grampian mountains, fifty miles south-east of Aldourie.[53]

* * *

Far away in India, on Sunday 25 November 1849 Ethel Fraser Tytler gave birth to her third daughter, Mary Seton – following Ethel who was born on 25 May 1844 and Christina Catherine on Valentine's Day 1847. A useful Bombay publication *Indian Domestic Economy and Receipt Book* offered guidance on the running of an Anglo-Indian household. Readers, first warned against the trustworthiness of servants, were swiftly reassured of their faithfulness and caring character towards their employers. More interesting was their cultural range: Portuguese, Parsee, Musselman, Hindoo and Euroasian. Servants were employed on a monthly basis: A butler, the head servant, could earn 10-30 rupees – ten rupees being equal to £186.80 today – a table servant 6-10 rupees, a cook 7-20, a washerman or Dobie 7-25 or more, a tailor 7-15, 10-15 for a coachman, 5-9 for a gorahwallah (groom), mussulchee (in charge of candles and guarding the house) 6, totee or sweeper 2-5, chuprassee (messenger/letter carrier) or punkah wallah (fan operator) 5-7 rupees.

For baby Mary, there was the ayah or wet nurse, who would be paid 8-15 rupees. Indo-Portuguese ayahs spoke English, some could also dress hair, wash lace and silk stockings, even sew, but by and large wet nurses tended to come from the lower classes and had an unsavoury tendency to liquor, opium and tobacco. So what if they happened to lie or steal food, servants were to be treated with kindness. Ethel and Charles were well primed to run a family home in India, The Bombay register records Mary's baptism on 16 December in the ancient city of Ahmednagar and that her first home, at Sirur, lay on the river Ghod.

TWO

Highland Mary

Many highland communities were reeling from the clearances that followed the brutalities of the Battle of Culloden. Clan chiefs had evicted half their cattlemen and small farmers, imposed a crofting system and replaced cattle with more economical sheep runs. Amalgamations had taken place on the Aldourie estate, but few smallholdings were disbanded after 1834, cattle had been preserved and new crofts set up. Mary would later refer to 'the difficulties of the crofters' existence in Grandpapa's day.' Concern for their tenants' welfare permeated Fraser Tytler correspondence and was warmly reciprocated in April 1850.[54]

Shots rang out from the hilltops across Loch Ness; a huge banner stood on the highest peak of the Red Crags, flags fluttered in the trees and highlanders turned out *en masse* to welcome Captain William Fraser Tytler back to Aldourie, from heroic service in India. Tenants had erected a Gothic triumphal arch wreathed with heather and inscriptions for every victory. The *Inverness Courier* devoted rapturous columns to Captain Bill's return. As his carriage turned off the Inverness Road built by the

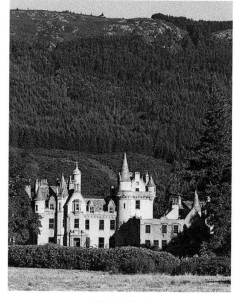

Aldourie Castle.

17

British commander-in-chief General George Wade during the conflict against the Jacobites,[55] a piper led the procession of cheering highlanders through the arch, past lawns laid out with parterres to the house on the south bank of the loch. There were highland reels on the lawns, and a feast for 150 men, women and children. Tumultuous speeches concluded with a toast to the captain's younger brother soon to arrive on furlough from India.

Charles brought his wife and daughters home to Aldourie in July 1850.[56] Happily striding over the moors with his father and brother, he breathed in the highland air; and ran to bathe in 'the bonny burn' at Clune, the hillside home where the family treasured two blue bonnets with the white cockade from Culloden. His parents were enchanted by Ethel and by her 'beautifully trained' daughters. Three-year-old Christina captivated them all. 'Mary will soon have her turn,' Margaret wrote to the St. Barbes. 'The lisping age is always attractive'.[57] Tragedy struck again. Ethel's longed-for son was stillborn. Mary was just fourteen months old when her mother died on 25 January 1851.[58]

Her father distracted himself with a ground-breaking analysis of the structure of prophecy and the Apocalypse. Confident of his vision, Charles began, 'The Apocalypse, or, in plain English, "The Unveiling" is emphatically the book of the age. The rapid whirl of passing events baffle alike our writers and our statesmen'. Political upheavals had seen revolutions in Europe, thousands of Chartists marched in South London demanding votes for the working classes, there was potato famine in Ireland; and Victorians had been in a state of religious turmoil since the publication in 1844 of *Vestiges of the Natural History of Creation*, which questioned the existence of the Creator. Charles sought to diffuse the dilemma, to reassess God's 'Sure Light', presenting Biblical unity in the Book of Revelation as the fulfilment of the Book of Genesis. The Unveiling explored mighty warfare between Truth and Error'. His next study, *A New View of the Apocalypse*, earned him a reputation as a vigorous and authoritative, if controversial, thinker, 'a man whose mind will not consent to run in the narrow groove of common stereotyped opinions.'[59]

Charles did not remain single for long. On 13 July 1852 he married Harriet, whose mother Dorothy Pretyman, the widow of the rector of Sherington in Buckinghamshire, happened to live across the Solent from the St Barbes, on the Isle of Wight. Her son Henry officiated at the wedding which took place at Trinity Church, St Marylebone in London.

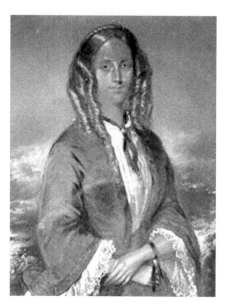

Harriet Jane Pretyman, 1850.

Harriet's portrait shows a young woman with a slightly prim smile, delicate hands and hair fashioned into luxuriant ringlets from her temples and over her shoulders. Her primness momentarily released, the loving couple's daughter Eleanor Dora was born at Aldourie, barely nine months later, on 9 April 1853.

Mary was left behind in August when Charles and Harriet took her sisters, their governess and maid to stay with his sister Elizabeth 'Lisby' in Norwich. 'As regards Little Mary you can dispose of her as you think best', Charles wrote to his mother, hoping that the three-year-old would be a comfort to her grandmother. He had wished to bring her too. That they had not done so is an early mark of her stepmother's thoughtless, unpleasant attitude to Mary.[60]

The family were reunited at Aldourie for the funeral of her grandfather, who had died on 4 September. Earlier Tytlers had been buried at Greyfriars Kirkyard in Edinburgh. Mary's grandfather, having set in train ambitious plans to transform the seventeenth-century manor house into a baronial-style castle, was buried in the family cemetery at Aldourie and his record-breaking stint as Sheriff was commemorated with a marble bust by the Royal Scottish Academician Patric Park. Charles and Harriet set sail for India. They took Eleanor, leaving Mary and her sisters in the care of their grandmother and uncle at Aldourie, an 11,000-acre estate at Dores on the banks of Loch Ness.[61]

The wild beauty of the Highlands gripped Mary's soul. She awoke to spectacular views over the loch to the Red Crags. The mountains were dotted with Scots pines, heather and wild thyme that turned purplish blue against the sun, 'blue as gentians.' There was a witch with an evil eye, a woman from Culloden called Nean-a-Charier – the carrier's wife – who aroused a thrill of fear in the parish and featured in Mary's family papers.[62]

The sisters' life at Aldourie Castle was filled with adventure. Highland history sprang to life in the cairns and tumuli on the moors where stones and landmarks commemorating heroes who had fought at Culloden were so significant to her that Mary would later acquire relics for Aldourie. Among them was a flask in which drink had been secreted to her kinsman James Fraser of Foyers, who was taking refuge in a cave after the battle.[63] The Fingal's Seat boulder marks the spot where the legendary Ossianic warrior-king was believed to have observed the battles between his Pictish men and Norsemen led by Ashie, after whom a nearby loch is named.

There had long been sightings of phantom battles on May mornings, when soldiers and cavalry appeared to be forming up to face an attack force and ancient warriors clapped sphagnum moss to their wounds, tearing their shirts into strips to bind them. A man cycling[iv] to Inverness behind three horsemen, rounded a bend and found that he not only ran into them, but through them. He fell off his bicycle, then to his astonishment saw the armies. These and other magical, ghostly incidents were later recorded by Mary's nephew Neil Fraser Tytler in *Tales of Old Days on the Aldourie Estate*.[64]

It was at Dores Bay that St. Columba was reported to have terrified the monster of the loch. In 565, on a mission from his Celtic monastery on the island of Iona to convert the heathen Picts, he sailed up Loch Ness with his monks. St Columba – so the legend goes – saw a group of men struggling to bring ashore a body savaged by the monster and directed a monk to swim across the water to fetch his boat to help them. Disturbed by the movement, the monster rose to the surface, with a mighty roar headed for the swimmer and was within a spear's length from its prey when the saint raised his hand and commanded the beast in the name of God not to touch him. The monster fled. Whereupon pagan witnesses praised the God of the Christians.[65] The legend is as alive today at Aldourie as it was in Mary's day, the rippling source of her Celtic spirit.

The Barony of Dores, which lay within the estate and formed a portion of the Earldom of Moray granted by Robert Bruce to Sir Thomas Randolph, was inherited in 1346 by the Earl of Dunbar. Angus Mackintosh of

[iv] The first pedal bicycle was invented in Scotland in 1839 by Kirkpatrick Macmillan.

Kyllachie married into the Dunbar family, and his son obtained a charter in 1626 to build the manor house of Aldourie. Sir James Mackintosh, author of *History of the Revolution in England*, Mary later recorded, was born there in 1765, by which time the house was owned by her ancestor William Fraser of Erchitt and Balnain.[66] The central section dates back to his time.

Aware of architecture from a young age, Mary was not yet five years old when the *John O'Groat Journal* reported in April 1854 that the baronial style transformation of Aldourie Castle, to designs by the Elgin architects Mackenzie and Matthews and overseen by her uncle Bill, were almost complete. A cement fireproof floor was installed to separate the ground and first floors and lay the ghost of the lady in grey, who used to wander downstairs from a west bedroom – unlike the spectral figure who would materialize through the bathroom wall at another highland castle, and startle guests at their most private and vulnerable.[67] Oriel windows, turrets, castellated gables, square towers crowned by tourelles in the style chosen for the new Balmoral Castle, then under construction, gave Aldourie a more imposing external appearance.[68] In harmony with the land, its red sandstone walls and grey conical roofs and peaks echo the mountains, which are reflected in the deep, glassy waters of the loch.

There was fun to be had inside the turrets as Mary and her sisters scampered up and down the narrow spiral stairs to their hearts' content with their governess, away from the adults at the other end of the castle. Historic family portraits painted by the cream of Scottish artists lined the walls – among them Mary's great grandmother Grace Grant of Auchterblair, painted by Raeburn, then known as the 'Highland Queen' of Jamaica – (here we should acknowledge Grant connections with slavery).[69] There were swords and stags' heads shot on the moors by the menfolk. Whether the watercolour by Sir Edwin Landseer in the dining-room was there in her day, his iconic *Monarch of the Glen* had been exhibited at the Royal Academy in 1851.[70] The family owned a bedhead that had belonged to Mary Queen of Scots; and of course the Aldourie library housed manuscripts by Burns, Scott and her uncle Patrick.[71]

Two swivel gun cannons that once guarded the loch shores from the first of six galleys that had been built on the estate and moored at Aldourie Pier, stood at the entrance to the castle. When Mary was a child, a steamer

ferried tourists along the loch from their pier to Fort Augustus. But for much of the time, the water was calm and fishermen enjoyed the sight of a heron or stag drinking at the water's edge.[72]

Growing up carefree and happy in the remote, almost sublime setting at Aldourie with magnificent ancient trees of larch, birch and fir, Mary and her sisters played in 'the burn, & the bonny, bonny dell where our happy times were spent, knowing nothing beyond our little world of half a dozen & nature's great world – beautiful as she is there'. She longed to explore further. 'There was something so alluring in the unknown other side of the hill'. How her imagination burned, but without her father or an elder brother to stride over the greater distance, Mary sensed a tantalising physical restraint, her feminist passion yearning for equality. 'We felt rather than knew [nature's] great feast & in her kindly lap, worshipped the trees & flowers & moss & burn of that place.' The Fraser Tytler sisters led a healthy, spirited life, running across the moors, riding their ponies, skating over frozen lochs in winter, and dancing highland flings.[73]

Uncle Bill ran a largely female household at Aldourie, looking after his septuagenarian mother, his sister Lisby and Ethel, Christina and Mary. The latter two known affectionately as 'Choonie' or 'Choons' and 'Mollie' will be referred to here by their formal Christian names. Only one of the six resident servants listed in the 1851 census was male, though the farmer, farm servants, gardener, coachman, gamekeeper and the majority of the estate workers were men.

Charles's comments on his daughters' French governess, before he and Harriet left for India, indicate the education she too would receive in his absence, in the schoolroom at Aldourie. Mademoiselle gave 'sound and sensible management in small as well as great things.' She sang beautifully with her pupils and was game to put her hand to anything, teaching them to march as well as dance. They were fond of her, which was just as well, as she was instructed to keep her eye on them at all times. 'She knows that her *whole* duty is with them [that] she should not divide her time between them & society nor they theirs between the nursery & schoolroom.'[74] Diction would have come naturally, for, since the settlement of English troops in Oliver Cromwell's citadel at Inverness, inhabitants were said to

speak the purest English in Scotland – or as Colonel Angus Cameron put it when asked whether his great aunt Mary spoke with a Scottish accent: 'We in Inverness-shire speak English better than the English!'

Railways were beginning to open communications and travel in the Highlands. While far away in India, Mary's first brother Charlie was born, all Inverness was on holiday on 21 September 1854 for the cutting of the first sod for the construction of the new Inverness and Nairn Railway. Uncle Bill was a director, major donor and, later, chairman of the railway. What jollity for his young nieces to join the flag-waving throng, cheering the procession of navvies shouldering shovels and pipers, followed by the provost, magistrates of Inverness and Uncle Bill. The sun shone brightly over the field. To the right, the town steeples and castle rose against the mountains around Aldourie, and behind the field, beyond the Moray Firth, were the hills of Ross. The Culloden woods lay to the east, with Fort George in the distance; and 'within a gunshot' was the forested Crown Hill with the ruins of Macbeth's Castle, or so it was believed at the time.

Over 6,000 spectators watched as the Countess of Seafield, Mary's cousin by marriage, stepped forward to receive the spade and toss the soil into an ornamented mahogany wheelbarrow, which the chairman and Aldourie habitué, Cluny Macpherson, wheeled to the edge of the crowd and ceremoniously tipped out the contents. Highland entertainment continued with the Northern Meeting in Academy Park. As major landowners, the Fraser Tytlers were members of the annual meeting founded in the aftermath of Culloden to encourage social intercourse. There were pipe music competitions, kilted competitors tossing the caber, putting the stone, and a grand Highland ball.

The opening of the railway a year later on Monday 5 November, shortly before her seventh birthday, would have been great fun for Mary who adored adventure. Crowds gathered along the concourse and 180-foot platform, where the thirty passenger coaches and goods wagons were bedecked with pennants. At midday the enginemen blew their whistles, and men in spotless white stoked the fires of the two locomotives. 'Raigmore' and 'Aldourie', garlanded with flags, flowers and evergreens, puffed and snorted as they were manoeuvred into position at the head of the train. Guns were fired, flags were raised and amid deafening cheers the train set

off and reached the hair-raising speed of 45 miles an hour. Eight hundred passengers took the fifteen-mile 'Grand Pleasure Excursion Trip via Culloden to Nairn that day, at the half-price return fare of a shilling, or two shillings first class, in a covered carriage; and for the 500 travelling back on the train, there was much singing fuelled by refreshments.[75]

Apart from the odd celebration or excursion to Highland games or unrecorded family outings, life for the Fraser Tytler sisters centred around Aldourie, with visits from cousins. Little is known about Mary's childhood. Her bond with her sisters was close. She was fond of tenants and crofters on the estate, but left no record of joining the sporting activities – fishing, deer stalking, pheasant and grouse shooting – which offered opportunities for house parties and friendships with great highland families.

Harriet gave birth to twins, Edward Grant 'Ted' and Eva, on 19 July 1856. At Ahmednuggar, they were safely to the south-west, well away from trouble in May the following year, when the Indian Mutiny broke out at Meerut and spread to Delhi, Agra, Cawnpore and Lucknow. Such was the impact of the British programme to transform India, the imposition of taxes, land annexation and a particular insensitivity in Bengal, that the sepoys revolted. Offended and enraged by the introduction of Enfield rifle cartridges which they believed were lubricated by cow and pig fat – animals sacred to Hindus and Muslims – they massacred not only British officers, but wives and children were cut to pieces. The officers, who believed that they had been helping the natives, were appalled. The *Inverness Courier* reported warnings of mutinous spirit in the Bengal Army, but it was not until July that Highlanders heard the horrific facts. It must have been an anxious time at Aldourie.[76]

In his journals, Charles conscientiously chronicled the natives' concerns and their plight in the name of progress. While he resented the influx of further troops, his younger brother 'Ban', Mary's godfather, Lieutenant-Colonel James Bannatyne Fraser Tytler, served as Assistant Quartermaster General to Sir Henry Havelock. A highly skilled cavalry officer, Ban fought in every action to the first relief of the northern capital, Lucknow, in September.[77] Their nephew Lieutenant Aldourie Grant had been murdered by mutineers on 29 May – the awful reality brought home to his eight-year-old Mary when his body was returned to the Aldourie cemetery for burial.[78]

His father Lieutenant-General Sir Patrick Grant, as acting Commander-in-Chief of the British forces, was rewarded with the KCB and Britain's new, supreme military honour, the Victoria Cross.

Uncle Ban, constantly at the fore in battle, faced the Nana Sahib's[79] huge force at Fatehpur on 12 July. He rode up to his artillery officer Captain Francis Maude, to point out a rebel commander: 'Knock over that chap on the elephant!' Maude aimed under its tail, and as the elephant rolled over – a hideous concept today – and toppled their leader, the rebels fled in panic. Ban witnessed the devastating aftermath of the massacre of the women and children at Cawnpore. After his horse was killed beneath him – not for the first time – at Lucknow on 25 September, he directed the regiment towards success on foot. He mounted another horse, was wounded in the groin and for months lay between life and death.[80] For his daring and heroism under fire Ban was highly decorated, promoted to brevet colonel and awarded the Companionship of the Bath. The Victoria Cross, for which he received impressive testimonials, could not though be presented owing to the death of his superior officers.[81]

Highlanders were well-known for their resourcefulness and courage in battle. A piper shot through the legs and lying helpless in the face of death from an advancing native cavalryman, raised himself up, aimed his bagpipes at the mutineer, squeezed and blew out an ear-splitting drone. Never had the sowar seen or heard such a weapon. Terrified out of his wits, he turned tail and galloped for his life.[82] There were bloodshed, atrocities and hatred on both sides. The rebels were defeated, but so too was the East India Company, disbanded in the British endeavour to conciliate the inhabitants in the promotion of progress.

Queen Victoria's 'Proclamation' on 1 November 1858 announcing the transfer of authority from the Company to the Crown, does not, however, appear to have affected Charles's work. His letter home after the death in February 1859 of two-year-old Eva – the half-sister Mary never knew – from inflammation of the windpipe, illustrates how spirituality has engulfed him, so that he sees his child on a higher plane. With only a passing reference to their sadness, Charles expressed no regret for a life cut short, but saw Eva's death as a relief from the sins of the world. Her twin, 'dear little Edward is like a broken harp, his single voice no longer gives out the

dual music that for two years & a half gladdened our ears & hearts. He asks for his sister, & when told she has gone to Heaven, he says "I must go too".[83]

At home, ten-year-old Mary posed for a formal photograph, standing by a studio pillar in a calf-length dress clasped at the waist, and laced ankle boots. Her auburn hair, combed with a soft centre parting, falls down to her neck and is curled and pinned into a loose coil above the ear. She has a generous lower lip, but as her head inclines a little to her right, her expression and clenched fingertips hint at her dislike of formality. Mary would have been happier reading a book, as later photographs show her, or striding over the bog myrtle and enjoying the fresh highland air.

Her father returned home briefly on furlough in 1860, left Charlie, Ted and their governess with Harriet's mother on the Isle of Wight and brought seven-year-old Eleanor to join the household at Aldourie.[84] Here Uncle Bill was taking on increasingly distinguished positions. He had become a director of the Caledonian Bank, Justice of the Peace, was appointed Major Commandant of the Inverness Volunteer Artillery and now followed their father as Convener and Deputy-Lieutenant of Inverness-shire.[85] The 1861 census records expanded staff at Aldourie, the butler James Munro and his family, two lady's maids, an under housemaid, an Irish cook Mary Falconar, and a thirty-year-old governess named Johanna Walmsely.

Inspired by the wealth of nature all about her, Mary developed an early talent for drawing and painting in watercolour. Christina would be the family writer. Their love of poetry had been nurtured from the cradle, by Burns and the larger-than-life highland heroes of Scott's *Waverley* novels. The sisters read Wordsworth, Milton, Shakespeare, and Tennyson whose turbulent monodrama *Maud*, which was to be his favourite poem, had aroused outrage in 1855, unlike his triumphant Arthurian *Idylls of the King* of 1859. That year he reissued his controversial poem *The Princess*, ostensibly to promote education for women, and in which Princess Ida renounces men, founds a university for women, but after the prince's subterfuge, relents and marries him.

Ossian's epic tales of Gaelic heroism passed down from the legendary Scottish Homer, were devoured in the schoolroom at Aldourie. After her marriage, Mary Watts would quote Matthew Arnold, proud that her husband

had studied Ossian, 'this colossal, impetuous, Adventurous wanderer, the Titan of the early world'.[86] So too had Scott, who drew on Ossianic imagery of Celtic Scotland, 'translated' and published in the 1760s by the highlander James Macpherson, as definitive 'ancient' poems. These were later derided as a hoax, yet they encapsulated the highland spirit. Macpherson a classical scholar, born half a mile from Ruthven Barracks – some 25 miles south of Aldourie – had witnessed the Jacobite uprisings as a child. In the spirit of the Enlightenment, he had collected ballads and tales orally from highland communities, translated them from Gaelic, and rewritten them in a distinctive style of poetry and prose that inspired poets and statesmen throughout Britain and the Continent.[87] Well versed in Ossian at their highland bower, ever conscious of their heritage, the artistic Fraser Tytler sisters flourished as joyous, sometimes grieving players in the primal heartbeat of nature, while their father lived with his new family out in India. All was about to change.[88]

THREE

Sanquhar

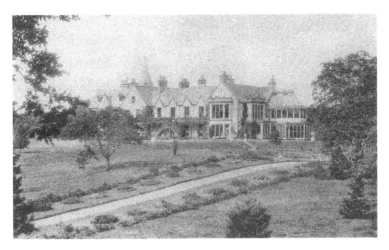

Sanquhar House, Forres.

Twelve-year-old Mary's world was turned upside down after the death of her grandmother Margaret on 28 February 1862. Her father and stepmother Harriet returned from India with their infant son, to take over Margaret's Grant family estate. They gathered all seven children, Ethel, Christina, Mary, Eleanor, Charlie, Ted and William, aged between seventeen years and six months – Mary was thirteen – to live at Sanquhar at Forres in Morayshire, forty miles east of Aldourie. The 1,243-acre estate was in debt, but long before Mary's birth Charles had promised his mother to restore the house her father George Grant had acquired from the Urquhart family of Burdsyards. Charles loved 'Sanquhar's natural brightness & lightness of air – there is all the sunniness of associations – & all the feelings

of homeness – which no other place can have'. Much as Mary adored her father, uprooted from her carefree life with her sisters at Aldourie, she now faced the challenges of a very difficult stepmother in a very different home, over three hours' carriage ride away. Mary felt as though her soul had been ripped apart.[89]

Tantalizingly, from the rising ground of Sanquhar with its commanding views over parkland, she would still have been able to see her beloved crags on the horizon to the south-west. So near, yet so far. Once again Mary's home expanded about her as her father drew up elaborate architectural plans to transform the eighteenth-century house into a grand Elizabethan-style mansion, with light flooding in through tall, mullioned windows, a balustraded porch, projecting gables at each end, a two-storey conservatory and an ornamental iron veranda reminiscent of India, along the south front, with a double flight of steps curving from the dining-room down to the flower garden. There were undulating terraces, an octagonal tower, gravel walks and parkland and, concealed by trees, a kitchen garden, peach house and vinery. The Findhorn River, rich with salmon, meandered through a wooded glen on the southern perimeter[90] and to the north-east, beyond the steep bank that led down to a large lake was a fine view of Forres and the distant Moray Firth.[91]

Forres was created a royal burgh by the Gaelic King of Scots Kenneth MacAlpin after his conquest over Pictland in 843. Overrun by Norsemen and invaded by Danes, the ancient province of Morayland held a prominent, if turbulent, position in Scottish history, rousing Shakespeare to set his tragedy *Macbeth* at Forres recreating, more violently than reality, events in the life of the eleventh-century Scottish king and his wife, Gruoch. Lady Macbeth was herself of royal descent, the first named queen of Scotland. The playwright's reference to Sweno who massacred the Scots was inspired by Sueno's Stone, the tallest Pictish sandstone obelisk still standing at the east end of Forres. Carved with battle scenes of warriors brandishing weapons, headless riders, piles of heads and magnificent Runic ornamentation, it symbolises the battle of life and the triumph of good over evil and was believed in Mary's day to commemorate the eleventh century victory by the Scots under King Malcolm II over the Danish leader Sueno.[92]

The Witches Stone at the foot of Cluny Hill still marks the spot where a suspected witch, burned for being one of the three found guilty of

bewitching *Donnchadh mac Crìonain*, King Duncan I of Scotland, in 1040, met a violent, excruciating end. 'From Cluny Hill witches were rolled in stout barrels through which spikes were driven where the barrels stopped. They were burned with their mangled contents', reads the plaque. Said to be one of three stones that marked the graves of the three witches of Shakespeare's *Macbeth*, the stone commemorates the 'witches' of Forres, and all the unknown women brutally tortured and murdered under the Witchcraft Act 1563. The last known execution of a witch in Scotland took place in 1722 at Sutherland and the Act was thrown out in 1736. A recent petition for women convicted under the Act to be pardoned - *The Witchcraft Convictions (Pardons) (Scotland) Bill* lodged at Holyrood in 2022, was rejected.

How the Fraser Tytler sisters must have relished studying Shakespeare's *Macbeth*, where in Act I Banquo asks Macbeth as they come upon the witches in the third scene:

> 'How far is't call'd to Forres?' – What are these,
> So wither'd, so wild in their attire,
> That look not like the inhabitants o' the earth,
> And yet are on't?

The sexist nineteenth-century approach to schooling constrained them to study at home with a governess while their brothers would benefit from a more worldly education at Eton. The critic and social reformer John Ruskin acknowledged in his 1864 lecture 'Of Queens' Gardens' that a girl's intellect ripens faster than a boy's, yet insisted that she should not be sent away to school, but trained to be wise, decisive and able to run the home.[93] Within two years, John Stuart Mill MP would present the first mass women's suffrage petition to the House of Commons on 7 June 1866.[94] Mary, deprived of the opportunity for growth, was an avid reader, ever conscious of her inadequate learning.

Harriet was a bitter, nervy woman. She made little effort to warm to the children of her husband's first marriage. Mary recalled that her stepmother prevented them introducing friends, 'because a friend of ours was generally denounced by Mamma.'[95] She did manage to establish warm friendships, especially too with her half-siblings, but her apparent diffidence or lack of

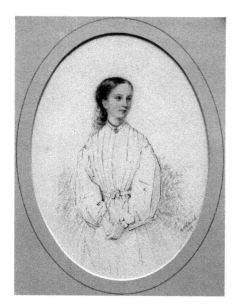

Alicia Henning Laird
Mary Fraser Tytler. 1864.

confidence in society stemmed from these secluded teenage years. Her father's shooting parties bringing lairds of Inverness-shire and Morayshire to the estate helped to give the girls access to a social life in the Highlands; and as a broadminded, liberal man, highly spiritual like Mary, he nurtured his daughters' artistic development. That year each member of the family was painted by the Edinburgh artist Alicia Laird, who exhibited at the Royal Scottish Academy and the Royal Academy in London. Mary would herself paint with a livelier, warmer brush.

Christina was the first of the Fraser Tytler sisters to sit for the art photographer Julia Margaret Cameron at Freshwater on the Isle of Wight, to dip her toe into the coterie of Watts, Cameron's artistic mentor and their friend, the Poet Laureate Alfred Tennyson. This was little over a year after she had begun experiments with a large camera, commandeering visitors to the Island, servants, local and national figures, to sit to her lens, and had exhibited her pioneering soft-focus albumen printed photographs to instant, if controversial acclaim. She had moved to Freshwater to live close to the poet laureate. Harriet's mother Dorothy Pretyman lived just over the down, at Westover House, Calbourne. Julia had just been photographing Tennyson and her house guests Watts and the novelist William Makepeace Thackeray's daughter Minnie. 'This is the funniest place in the world,' wrote her sister Anny, also a novelist. 'Everybody here is either a genius or a poet or a painter or peculiar in some way, poor Miss Stephen says, "is there *nobody* commonplace?"'[96]

So the moment Julia Cameron discovered a beautiful young poet staying nearby, seventeen-year-old Christina would have been summoned to pose at her studio at Dimbola. She sat in profile, bare-necked, in an

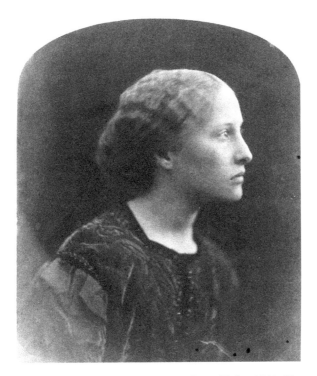

Julia Margaret Cameron, *Christina Fraser Tytlerr*, 1864-65.

embroidered velvet bodice with off the shoulder sleeves of silk, her hair crinkled and her eyes resolute. In July, Christina's photograph, signed 'From Life Julia Margaret Cameron', was exhibited with those of Watts himself, his estranged bride, Ellen Terry, also seventeen, the poets Robert Browning and Tennyson, the photographer's maids posing as Madonna and others for sale at Colnaghi's Gallery in London.[97]

Ellen had performed Shakespearean roles from childhood. Born on 27 February 1847, she had given up the theatre and growing fame to marry and model for 47-year-old Watts, which he celebrated in her bridal picture *Choosing*[v] and exhibited at the Royal Academy in 1864 after their return from honeymoon. His young bride is seen choosing between the fragrant violets of Love and Innocence at her heart and the showy, scentless red camellia at her nose, symbolizing worldly vanity.

[v] 1864, National Portrait Gallery, London.

But camellias appear all about her. Their marriage, exquisite on canvas, was doomed. For the exuberant seventeen-year-old who had long entertained theatre audiences and would rise to become Britain's best-loved actress, the social constraint required as the artist's wife proved insurmountable. Outside the studio the Watts marriage collapsed, and their separation within months had scandalized society. Their 30-year age gap was not unusual, and although other irritants might have been overcome, the artist's need for peace could never have survived the actress's understandable restlessness. Apart, they had since suffered intensely in private. Each had left an indelible effect on the other. Living with the mercurial actress had set in train a series of monumental nude pictures that expressed unfulfilled longing and his metamorphic symbolist style.[98]

Clan chiefs, Highland lairds, family and friends gathered together for a grand photograph around the entrance to Sanquhar in September 1865. The coachman arriving with a distinguished officer in his landau struggles to draw the horses to a halt. Charles stands at the baronial entrance. Fifteen-year-old Mary in a checked dress, her hand to her face, looks pensive. Her centre-parted hair, usually arranged into a bunch of ringlets behind or over her shoulder, accentuates a square forehead and high cheekbones. She has a strong nose, generous lips and a firm jaw. The clan chief Cluny Macpherson, stands in his kilt with Ewen Cameron of Lochiel beside Harriet and Harry Fane Grant, son of Field Marshal Sir Patrick Grant, Mary's Uncle Pat; and casually sitting at the feet of Lady Lovat is George Hamilton-Gordon, the adventurous sixth Earl of Aberdeen and grandson of the coalition prime minister, who was soon to embark on a life on the high seas, until a violent storm swept him off the rigging of his schooner and into the Atlantic, last seen at moonlight on the crest of a huge wave.[99]

Mary inherited her father's profound religious, yet liberal spirit, and it was their cousin Robert Eden, the Bishop of Moray and Ross and Primus of Scotland, who officiated at her confirmation at the Episcopal Church of St John in Forres on 17 December 1865. She would cherish her confirmation gift lifelong, Tennyson's *In Memoriam A. H. H.*[100] This seminal elegy in response to the death of his Cambridge friend Arthur Henry Hallam addresses the wider doubts of the Victorian era, evolution, the effects of scientific discovery versus nature and triumphantly supports the transcendence of the

soul and universal God. 'It is rather the cry of the whole human race rather than mine . . . Private grief swells out into thought of, and hope for, the whole world,' the poet explained, '[It] begins with death and ends in promise of a new life – a sort of Divine Comedy, cheerful as the close.'

In Memoriam had impressed Queen Victoria's consort Prince Albert and led to Tennyson's appointment as Poet Laureate. Since the Prince's death, the Queen had kept a copy by her for comfort.[101] Mary inscribed the flyleaf of her copy, 'This book loved & possessed by me for seventy years'. She compiled an index to *In Memoriam*, and with Highland passion would annotate symbolic verses at significant times in her life and on New Year's Eves along the verses endorsing her socialist viewpoint, her fascination for the opposing, yet entwined poles of life and death:

> Ring out, wild bells, to the wild sky
>> The flying cloud, the frosty light:
>> The year is dying in the night;
> Ring out the old, wild bells, and let him die.
>
> Ring out the old, ring in the new
>> Ring, happy bells, across the snow;
>> The year is going, let him go;
> Ring out the false, ring in the true.
>
> Ring out the grief that saps the mind,
>> For those that here we see no more;
>> Ring out the feud of rich and poor,
> Ring in redress to all mankind.'[102]

No less prized was Christina Rossetti's masterpiece *Goblin Market*, a seventeenth-birthday present from her cousins Alice and Margaret Ogilvie. In this fiery, erotic tale of two sisters as close as the Fraser Tytlers, one succumbs to the luscious temptation of forbidden fruit – 'she sucked and sucked and sucked the more' – and is saved from death by her sister's victory over the 'grunting and snarling' goblin fruit-sellers. *Goblin Market* exemplifies Victorian fascination with the dual spiritual struggle. Fast-paced, enigmatic, its wealth of imagery oozes female desire, while invoking the Biblical issue in the Garden

of Eden. The poem addresses temptation and resistance, impulsive sensuality and self-sacrificing heroism, issues of good and evil, natural and supernatural, threat and security, life and death. 'Hug me, kiss me, suck my juices / Squeezed from goblin fruits for you'. As life-saving poison is kissed into her mouth, the guilty sister, writhing in agony, rends her robes and beats her breast:

> Her locks streamed like the torch
> Born by a racer at full speed,
> Or like the mane of horses in their flight,
> Or like an eagle when she stems the light
> Straight toward the sun,
> Or like a caged thing freed,
> Or like a flying flag when armies run.

At last she falls, and the poem asks 'Is it death or is it life? Life out of death', concluding that 'there is no friend like a sister'.[103] Mary would find echoes of *Goblin Market* in the symbolism of her father's scriptural manuscript *The Apocalyptic Roll: the Title Deed of the Church, The Seals: the Mystery of Good and Evil contending for the Mastery*, in 'the cherubin of Eden: God's remedy for mystery of sin, which had just entered and poisoned creation . . . showed how fallen man was to become a new creature . . . a joint heir with Christ'. Charles's enthusiasm for the grandeur and glowing imagery of the book of Revelation would nurture his daughter's spirituality and fascination for the mystery of good and evil.[104]

Christina was presented at Court at the age of nineteen, curtseying to the Princess of Wales at St James's Palace on 24 May 1866.[105] For Mary artistic training was paramount, and she would delay her royal moment. Christina would touch on their social dilemma and educational unfairness in a short story.

> Harold was well off, for he went to school when he was nine. I think that is the reason he has turned out so much better than we have. Then, when I came to be fifteen, and felt that I had learnt nothing, I implored mamma to let me go to school. No. She would not hear of that – going to school was "so vulgar." I knew that I had some talents . . . I begged to be allowed to go for one month, when mamma went to London, to have drawing-lessons. I was told it would quite "spoil the effect" when

I came out the next spring. And when next spring came I said, "I am only sixteen, mamma, and know nothing: do give me the money my court-dress would cost, to spend in drawing-lessons.' It was no use, of course; fancy drawing-lessons coming in the way of a presentation and a London season!

Every day that I went out into society, I felt more and more my backwardness and ignorance. I scrambled through a little of everything and did nothing well. I tried to read a great deal.[106]

Mary was building up her sewing techniques into an art form. In September, the *Forres, Elgin and Nairn Gazette*, reporting on a grand church Bazaar in the park at Sanquhar, drew attention to the banner screens Mary had created of satin velvet embroidered with dressed feathers in the shape of a bird's head, which were attracting considerable interest. A large marquee on the lawn lent by the Duke of Richmond was festooned with coloured cloths and evergreens.

Contemporaries among her father's shooting companies provided warm friendships and entertaining moments which Harriet otherwise discouraged. The wedding of Emilia Gordon-Cumming, the daughter of William and Jane Gordon-Cumming of Altyre in January 1867 drew guests from near and far. To protect their feet from the snow, the ceremony was held at Cantray on the River Nairn. Bishop Eden officiated in the drawing-room, accompanied on the piano by Mary Eden. and afterwards they danced to a Glasgow band until the early hours. Christina would evoke the atmosphere in a short story 'Sweet Violet', where footmen stood at the entrance of the house to greet each carriage, out of which stepped young ladies in ball dresses, roses in their hair, white kid gloves and carrying a fan. Mary loved dancing; and among the guests was her good friend and cousin Harry Fane Grant, the future General Sir Henry Grant, Governor and Commander-in-Chief of Malta. 'Oh papa, there is the third dance beginning!'[107]

Mary was preparing etchings to illustrate Christina's *Sweet Violet and other Stories*, her first attempts at book illustration. Mary was likely now to be receiving professional art instruction. Inverness Art School had opened its doors to young ladies and gentlemen to receive tuition from nine in the morning to mid-day for fees ranged from seven shillings and sixpence to fifteen shillings a quarter. Evening classes were also available for working men and women at six shillings. Instruction was given in drawing, painting in oil and watercolour; there were classes in geometrical, perspective,

mechanical and architectural drawing, and 'special instruction' in the composition and colour of ornamental decoration, all of which feature in Mary's decorative *cartes-de-visite* album.[108]

The French vogue for collecting *cartes de visite*, small portrait photographs, albumen silver prints pasted on to card, had become an international craze. Millions of *cartes* – of members of the Royal Family, leaders of society, actors, friends and acquaintances – were collected, exchanged and displayed in ornate albums in drawing-rooms around Britain.[109]

Mary's title page (see back cover) dances with exuberance, her Celtic interlaced animal motifs and Gothic lettering learned from a manuscript created by Charles's late sister Margaret Ogilvie. Aunt 'Mousie' had studied the art of decorative lettering with the 'Sobieski Stuart' brothers, John Carter Allen and Charles Allen, whose folio volume of clan tartans, the *Vestiarium Scoticum* of 1842, was later described by the historian Hugh Trevor-Roper as 'shot through with pure fantasy and bare-faced forgery.'[110] The dashing Sobieski Stuart brothers purported to be grandsons of Bonnie Prince Charlie. Dressed in the full Highland costume of the house of Stuart, they lived on Lord Lovat's estate, where they were seen as the 'handsomest men' in Beauly.[111] Mousie bequeathed her manuscript to Ethel, the likely donor of her sister's *carte-de-visite* album, 'Mary from EFT'.

In the quivering richly coloured title-page illumination, the tail of the 'Y' frolics back and forth before landing in the direction of the donor. Above 'Mary' lines and humps suggest the Loch Ness monster. The blue illuminated 'M' falls from a hairy stem, indicative of a leaf. The letter itself takes the form of a stork, standing with its legs entwined in a red serpent's tail, its beak pecking a central emerald-green serpent, which coils upwards, with a large eye and forked tongue, from which a young bird reaches up to feed. The dual symbolism of the serpents is suggestive. Does one symbolize fertility, wisdom and healing, and the other warn of evil? 'EFT' is even more flamboyant, with a coiled purple stalk intertwined with a green and gold lizard, red, blue and green serpents.

Mary began to fill her album with full-page designs – inventive, symbolic, amusing, at jaunty angles, each inspired by one or more *cartes de visite* of family and friends, their houses and leaders of church and state and accompanied by captions in Celtic, or Gothic or her own lettering.

Mary reading.

*Her brothers Charles,
William and Edward.*

*The Primus of Scotland, Archbishops
of Canturbury, York and Dublin,
The Rev. E.H. Owen.*

Harry Fane Grant.

Cartes de visite album

Photographs form only a fraction of each page within. Mary's opening image shows Queen Victoria inset as a gemstone within her monogram, surmounted by a giant crown. Her next dedication, to the poet laureate in a gold and lapis-blue locket surmounted by a laurel wreath, slightly misquoting Tennyson's epic celebrating a university for women *The Princess*. 'Our echoes roll from soul to soul / And live for ever and for ever', (frontispiece)[112] resounds as a strident political statement.

Her sisters appear as family jewels within pearl-encrusted frames, above their emblems, the Fraser stag and Tytler cloud and sunburst, her golden Celtic-style monogram centred beneath a luscious crimson ribbon. A fine ecclesiastical drawing in the guise of a Gothic stone window presents the leading churchmen of Britain and Ireland in its lights and quatrefoil. Eighteen-year-old Harry is seen 'in disguise', armed with a huge knife and sporting a heavy beard. Beneath his elegant monogram and bursting from behind his photograph Mary has drawn frolicking horses, a long shepherd's crook and curly horned sheep grazing on the moor. The bishop's son, 'Tuck' Eden appears upside down balancing on a cake. Other friends are transformed into the eye of a peacock's tail.

On a folio captioned 'When is a ship foolishly in love?', cherub mariners take the helm of a swan-prowed ship shaped like a nautilus, on whose sail is emblazoned a portrait of Mousie's daughter Alice Ogilvy and its bargee initialled 'A.M.O.' – doubling her identity with a declaration of love – while the young suitor Arthur Hanson bobs up on a buoy anchored in the ocean. Photographs of Norwich Cathedral suggest that Mary has travelled down through England to visit her father's sister, Aunt Lisby at Upper Close.[113] Each page testifies to the young art student's knowledge of perspective, symbolism and her fertile, joyous imagination.

John Stuart Mill's amendment to the second Reform Act to extend the suffrage to women, although defeated, received unprecedented support in May 1867.[114] That month, Mary, absorbed in art, remained up in Scotland – not at Sanquhar, but at Aldourie – when Ethel and Christina travelled south to stay with their grandmother at Westover, and sit once more for Julia Margaret Cameron. The photographer fell into raptures over the girls' beauty. Her voice husky and urgent, she insisted that her 'divine artist' Mr. Watts must see them and sent them to Little Holland House in

Kensington, London, where the artist, now a Royal Academician, lived with magnificent studios in the Anglo-Indian art-filled household of Julia's sister Sara Prinsep and her erudite husband Thoby Prinsep, a director of the Council of India.[115]

Julia and Sara were the eldest and most effusive of the six surviving daughters of East Indian Judge James Pattle and his wife Adeline, the daughter of Queen Marie-Antoinette's page, Ambrose Pierre Antoine, Chevalier de l'Etang. The Pattle sisters defied convention. In exuberant contrast to the fashionable corset and wide-caged crinoline worn by the Fraser Tytlers, they draped themselves in free-flowing robes and would float into the room in a swish of falling folds. 'Artistic to their fingertips, with an appreciation – almost to be called a *culte* for beauty,' as Mary later wrote, they commanded, mesmerized and alarmed the intelligentsia in India, Paris and now Kensington and Freshwater. Ellen Terry, despite months of humiliation under Sara's thumb, would still recall Little Holland House as 'a paradise where only beautiful things were allowed to come. All the women were graceful and all the men were gifted.'[116]

Symbolic frescoes and portraits by Watts lined the walls of this legendary gathering place for geniuses of the age – artists, poets, statesmen, scientists, astronomers, musicians, beauties. Watts, famously painting their portraits for a future national portrait gallery,[117] was more passionately interested in controversial universal subjects to uplift people from the miseries of the machine age. Too rebellious to apply for membership himself, the Royal Academy had changed their rule to elect Watts an Associate and exceptionally, a full Academician within the year.

As Christina sat down beside her hostess, Sara almost swooning in ecstasy over her golden hair, insisted that the Academician admire her 'aureole', which so discomfited Christina, that he refused. 'I am not going to pay compliments. Young ladies do not like it.' The Fraser Tytlers' visit coincided with the London Season, but it was their introduction to the art world that fascinated Mary. Eager for news, she strode over the moors with her younger sister Eleanor and their governesses, to meet the postman at twilight. She never forgot the sensations as they brushed through bog-myrtle, past birch trees in tiny leaf, the air filled with a sweet fragrance, for news of her sister's entry into Watts's world.[118]

A grand exhibition of art and industry opened at the Inverness Music Hall in September, under the patronage of the Queen and of Mary's cousins, friends and neighbours, clan chiefs, Lord Lovat, the Earl of Seafield, Cluny of Cluny, the Mackintosh of Mackintosh, Arthur Forbes of Culloden, Sir George Macpherson Grant of Ballindalloch, the bishop and others. The idea was to foster and encourage a taste for the fine and decorative arts in Inverness. Prince Charles Edward's shield, sporran and silver drinking cup were on show and Constance Frederika 'Eka' Gordon-Cumming, Emilia's sister, exhibited watercolours of the Highlands. Gladstone, soon to become prime minister, lent Alexander Munro's marble sculpture of *Francesca and Paolo of Rimini*.[119] A major force behind the elevation of applied arts and their now closer links with fine arts had been the German architect and theorist Professor Gottfried Semper, who had inspired Prince Albert's Great Exhibition of 1851 and the development of South Kensington Museum. Mary, not yet experienced enough to exhibit, absorbed design techniques and the symbolic nature of motifs that Semper had propounded.[120]

Sanquhar's wrought iron staircase provided the backdrop for the family photograph that month. Charles stands proud upon the double stairs, his arms folded. Sitting on the lawn beside Christina, each encircled by their dresses, Mary poses with her book. A large caged bird is attracting attention. Behind sit their fierce-looking stepmother and the bishop, whose sons reappear in Mary's albums, which are testament to her early interest and skill in drawing architectural detail. The extended family of cousins, Ernest and Lionel 'Leo' Torin, sons of Charles's widowed sister, Aunt 'Mela' Emilia Torin,[121] Alice and Margaret Ogilvie, Robert and William 'Tuck' Eden and James and George Grant-Peterkin of Grange Hall.

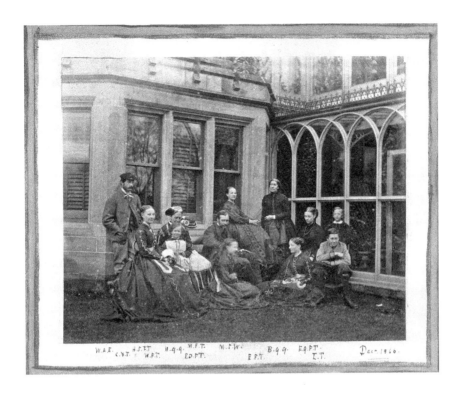

Family groups at Sanquhar. Above, 1866, left to right:
*William Eden, Christina, Harriet with Will on her knee,
Eleanor, Mary seated in window, Ethel, Leo Torin, Ted.*

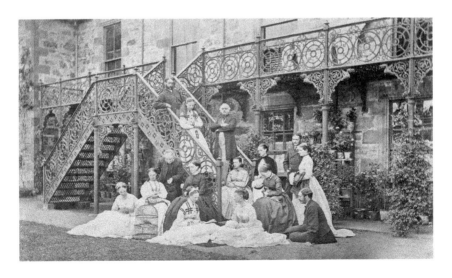

What a refreshing contrast to see a spark of hilarity in a photograph of Mary engaged in amateur dramatics with friends at Sanquhar. Captioned 'Give and Take', it shows her seated at a table with Eka and Emilia's niece Eliza-Maria 'Eisa' Gordon-Cumming, Lady Macpherson Grant and Robert Eden, leaning back and – unusually for a photograph – smiling.[122]

Sanquhar ::

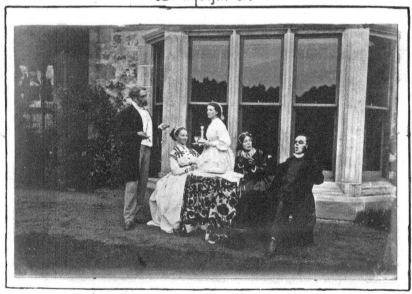

Sept. 5th 67.

William Eden, Mary, Lady Macpherson-Grant, The Primus of Scotland.
in 'Give and Take'.

FOUR

Rosebud Garden of Girls

Thankfully, Mary preserved her diary for 1868, the only one before her marriage – it was to be a seminal year. The flyleaf, inscribed 'Mary Fraser Tytler' and later 'Westover / 68', is dominated by a drawing of her left hand. Bare-wristed and workmanlike rather than aristocratic, her fingers are stretched forward, slightly splayed and bent at the knuckle, as if in the act of creation, a signet ring on her pinkie and short thumbnail. 'Most wretched day' she wrote on 18 February as her sisters and eleven-year-old Ted set off in advance for the Isle of Wight, until at last on Thursday 5 March, Mary marked the passage in *In Memoriam*:

> I turn to go: my feet are set
> To leave the pleasant fields and farms:
> They mix in one another's arms
> To one pure image of regret.[123]

Her adventure would outweigh the pang of leaving Sanquhar, which was to be let. She and her parents took the Belfast steamer from Glasgow, to stay with her stepmother's family, stopping in Dublin to visit the cathedral and Phoenix Park, and travelling on by train for a social month in the county of Cork, at Towermore House, Castlelyons, the home of Harriet's sister-in-law Eleanor and her husband Captain Horace Hayes. There, Harriet happily sang and played the piano, Aunt Nelly played the harp and Mary had 'great fun' riding to meets, dancing in Fermoy and listened to orchestras and bands. She arranged flowers, had tea, met *everybody* and found her eleventh dance 'awfully jolly'. Mary logged their route, via Bristol, Bath, Salisbury, Wilton, down to Lymington in Hampshire, where they travelled by steamer

across the Solent to Yarmouth on the Isle of Wight, arriving at Westover on April Fool's Day.[124]

They drove through the high iron gates and lodge designed by the royal architect John Nash, and across undulating parkland to the fine Regency house he had built for Sir Leonard Holmes, from whose family Dorothy Pretyman was leasing the estate. Nash was embarking on his fantastic transformation of the Prince Regent's Marine Pavilion at Brighton, when he remodelled Westover. Pediments, columned porches, elegant shallow bow windows, a curved dome staircase and canopied verandas were added to the Georgian brick house, which was covered with a gleaming stucco façade.[125]

Thrilled to be reunited with Christina, nineteen-year-old Mary's social life burgeoned. Their first callers were Mary Eden, the Misses Moberly, daughters of the rector of Brightstone and future bishop of Salisbury, Captain Grant and a certain Mr Montgomery. She was soon designing for the local bazaar, enjoying concerts, Haydn's *Creation*, dancing 'very jolly'. Mary spent her time drawing – initially, Ethel's portrait – reading, lying on the grass, sitting under the cedar occupied by white owls, riding and dancing.[126] One Sunday they drove out to Whippingham church and saw the Queen and her daughters, the Princesses Louise and Beatrice, in the congregation. Princess Louise, a year older than Mary, had carved the font. Her mother, thinking sculpture an unnatural occupation for a girl, had at first discouraged this, but now recognised her daughter's talent and was sitting for her bust at Osborne.[127] Mary's Pretyman cousins George[128] and Edward joined the house party; and as her parents left to visit her brother Charlie at Eton, 'Darkburnt officers' arrived from the nearby fort.

Emily Tennyson noted in her journal that on 8 May they joined the 'very pretty & pleasant' Fraser Tytler sisters and their large party at Westover. Mary's all too brief diary notes that she was introduced to Tennyson, and that Messrs. Graham Mont. and White stayed to dance – 'how very jolly'. The caller who appears to have captured her heart was eighteen-year-old James Graham-Montgomery, son of the member of Parliament for Peeblesshire and Lord Lieutenant of Kinross-shire.[129]

Ten days later the Fraser Tytlers moved to Freshwater itself, where again Mary walked with Mr Graham (Montgomery) and picnicked on the beach.

She saw more of the Tennysons and enjoyed a growing friendship with his sons, fifteen-year-old Hallam and Lionel, fourteen. Among entertainments was puffin-shooting – gunfire that raised clouds of seabirds, but which fortunately did not result in loss of life, although Graham-Montgomery irritated the laureate, asking 'Mr. Tennyson, when you shoot your rooks . . .' only to receive a thunderous look. 'Shoot my rooks!!!' The laureate was a keen gardener, deeply interested in the wildlife and geology around Freshwater.

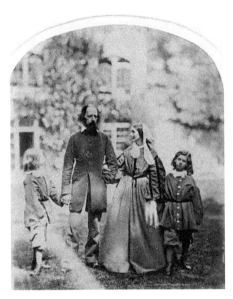

O. G. Rejlander,
The Tennyson Family at Farringford, 1863.

For nature-loving Mary, summer in Freshwater offered an idyllic entrée into Watts's milieu, albeit in the artist's absence painting Thomas Carlyle, the irascible philosopher and a founding father of the National Portrait Gallery.[130] Birdsong – yellowhammers, thrushes, tits, blackbirds, cuckoos and rooks – vied with the roar of the waves at the Tennyson's home, Farringford. Emily was entertaining Mary and her family to tea on the lawn, when up strode her husband flourishing wild white roses from Totland Bay. Afterwards Hallam and Lionel walked the Fraser Tytler sisters over the downs to Compton Bay to see the wild flocks.

Farringford lay at the foot of the High Down, golden gorse contrasting with the sea, not unlike the 'whin' in the Aldourie hills around Loch Ness. A long winding avenue of tall trees led up to the castellated house which overflowed with ivy and magnolia. Breath-taking views through the oriel window in the drawing-room looked out on Afton Down rising to the right; and to the left, over gently sloping fields to Freshwater Bay, the chalk cliff coastline curved to the distant St Catherine's lighthouse at the southern tip of the island. Farringford's 'green walls without and speaking walls within' had enchanted Anny Thackeray: 'There hung Dante with his solemn nose and wreath; Italy gleamed over the doorways; friends' faces lined the passages,

books filled the shelves, and a glow of crimson was everywhere.' Watts portraits of the Tennyson family hung on the wall, together with Mrs Cameron's photographs of celebrated friends, family and servants in symbolic pose. Giuseppe Garibaldi had famously planted a Wellingtonia in the garden four years earlier when he was drumming up support for the unification of Italy.

One evening, Mary and her sisters were invited to a dance at Farringford, with the Camerons and officers from the Golden Hill fort. To see the photographer's wild romantic gestures triggering growls of dissatisfaction from the Poet Laureate, at the nerve centre of Victorian culture, must have been extraordinary, utterly unlike the dialogue of highland sporting lairds. King Alfred, as he was known at Freshwater, was over six foot tall, with shaggy black hair and beard, a gently drooping moustache, a warm, if irascible mouth, bright, laughing hazel eyes. He danced with all the ladies, a majestic figure in white gloves, waltzing slowly around the floor. With younger girls he danced an elephantine polka. 'Jolly fun', thought Mary.[131] Often brusque and bear-like in company, Tennyson was not one for small-talk, but he loved to point out any aspect of nature, a wildflower, the flight path of the birds. In the following days, he took Mary to gaze at the 'blue crescent' of Venus and the moon through the telescope of Charles Pritchard, president of the Royal Astronomical Society.

Sunday 31 May was a golden day for Mary. 'Went to Tennysons. He read "Maud" "Wellington" & others – held my hand." she noted. As she was shy, quite unlike Ellen Watts had been when the laureate read to her four years earlier, the poet reached out to encourage Mary – 'Let me see if we can't get some sympathy out of that little hand'. How intensely moved she must have been as her most admired living poet held her hand while reciting his favourite poetry especially for her. *Maud* is a deeply personal monodrama. Surging with passion, it reflects the poet's grief on the death of his father, his brother's insanity and the poverty that had separated him from Emily Sellwood and driven him to despair early in their courtship.[132] The protagonist, distressed and angry at first, is elevated by love for his sixteen-year-old sweetheart. He watches Maud in her garden of roses but is excluded. Her father has become rich on ill-gotten gains and her brother wants her to wed a lord. In manic misery, the protagonist believes but does not know for sure whether he has slain her brother in the garden. He too seems to have been killed in their duel but rises above the fiery furnace to fight for the good of mankind.

To sit in such intimacy with the Poet Laureate gave Mary a heady feeling. She could doubtless scent the tobacco on his breath as he held his book close to his myopic eyes, chanting his favourite poem in a mystical, impassioned Lincolnshire burr. His voice, Carlyle recalled as 'musical, metallic, fit for laughter and piercing wail, and all that may lie between; speech and speculation free and plenteous.' Powerful one moment, soothing the next, it ebbed and flowed like the sea, and filled to breaking point with quivering pathos. When he recited *Maud,* which he had chiefly written on the Isle of Wight, Tennyson used to become so excited that tears poured down his cheeks. Listeners felt they were witnessing the scenes, sensing the madness, the joy or agony the poet was depicting. As he spoke of 'the scream of a madden'd beach dragg'd down by the wave',[133] Mary could see the shingle crashing back and forth. The sea and stars, the sense of distance as well as detail in landscape fascinated Tennyson. She accompanied him on his evening stroll over the downs and down to Freshwater Bay. Dressed as ever in his broad, wideawake hat and heavy black cloak and velvet collar, he cut a striking figure. 'Walked on the shore afterwards – in moonlight', she concluded. What an end to the day.[134]

Both Christina and Mary were incorporating their experiences into art. 'A Sea-Side Story' was one of six Christina was writing for publication by Hatchard's in *Sweet Violet, and other Stories,* with etchings by Mary (See page 76). Even if illustration was considered an acceptable amateur occupation for Victorian women, this was a bold move. Her Celtic-style monogram 'MFT' appears at a jaunty angle in a bottom corner of each of the six wood-engravings. The frontispiece captioned 'Everybody tells lies Sometimes', shows the narrator, her hair elegantly coiled, caring for two children in the night nursery, where a chubby infant is propped up on pillows, kicking away the upturned counterpane. The second illustration, a familiar ballroom scene for the sisters at this time, shows a moustachioed suitor tenderly receiving a rosebud from Violet's bouquet – 'I think he must have asked her to pin it in his button'.

A sense of loneliness imbues the next two, in which Margaret stands at an open window, and Lily leans against the doorway in the dark. Interestingly, Christina quotes the late poet Elizabeth Barrett Browning, whose family, the Moulton-Barretts, would later take over the lease of Westover. The chalk cliffs of Freshwater Bay frame the background to 'the old maid of Charlie's fancy', a nineteen-year-old girl, 'sparkling with the salt tears of the sea',

her golden-brown hair carefree in the wind, falling over her long striped cloak and down her back. She walks beside a bonneted companion, with dark hair, firm-set mouth, black eyes and cloak, creating the contrast Mary explores in each illustration. Finally, 'Beatrice, will you promise me one thing' shows one girl seated, comforting another, troubled by her absent love.[135]

In the summer sun at Freshwater, Mary sat on the lawn, drawing and reading 'Margaret' to her family.[136] Inspired by *Maud*, she found some 'perfect' passion flowers to paint, wondered whether she could do them justice and caught the spirit in a watercolour trailing exuberantly around a photograph of her youngest brother Will in her album.

Julia Cameron dropped in at half past nine that evening, surprisingly late, thought Mary.[137] But time meant little to the photographer, one of the most impulsive and irredeemably generous women of the age. Her rich Indian shawls and crimson and purple velvet robes would fly out behind her as she ran across the fields or drove her dog cart on a warm-hearted whim. She was known to rouse Tennyson from his sleep, to sweep him down to contemplate the moonlit sea for the good of his soul and poetry, as he himself had shown Mary. 'At Freshwater she commanded, and it was done', Mary would recall.[138] Her plump face eager and impulsive, Julia Cameron would flash her eyes to press her point. Aged 53, she was at the height of her photographic powers. The photographer needed a shield as a prop, and here was a keen art student who could make one for her. Mary set to work on it the next day;[139] and the day after, Saturday 20 June 1868, she noted, 'Went to Mrs Cameron to lunch. She took a group of us – met "Allingham". Mr Graham Mont & Smith came – we played croquet & danced –' Which did Mary enjoy most? Dancing with Mr Graham Mont or creating High Art?

Dimbola lay mid-way between Freshwater Bay and Farringford, with views down to the Bay. The distinctive odour of photographic collodion, familiar to her older sisters, would have overcome the sweet scent of briar roses before they reached the porch of Dimbola.[140] That day neither a captive genius, nor the beautiful parlourmaid 'Madonna' Mary Hillier would be modelling in Julia Cameron's dining-room studio, for the four Fraser Tytler sisters had come to pose for a symbolic group photograph unlike any other.

International acclaim for her innovative art photography had inevitably engendered criticism. Cameron's visionary style, her broad modelling of

form and colour, experimenting with light, shadow and tone, was comparable to the controversial abstract technique of Watts's symbolic painting. He encouraged her 'large heads', portraits with light illuminating the forehead – the mind – of her sitters, whether intellectual heroes, Tennyson, Carlyle, Watts, the poet Henry Taylor, her venerable husband Charles Hay Cameron, or of 'divine' or literary images immortalising her family and housemaids. For, like Watts and Tennyson, Cameron aimed to depict the soul of the age. Both set out to ennoble their art by experiment, to create modern images of intense poetic beauty, with a high moral purpose, which held intense appeal for Mary.[141] Many found sitting to Julia Cameron an odd, agonizing endurance. Not the Fraser Tytlers.

While the photographer began the demanding, messy and potentially dangerous process of preparing the glass plates, what a sensation it must have been for these highland girls to release their stays, hairpins and ribbons, dress up in loose robes, let their hair flow down their shoulders, and enter into the demanding poetic spirit of High Art. Each twelve-by-ten-inch plate had to be polished, covered with a collodion solution and in a dark room, dipped in light-sensitive silver-nitrate salts before it could be inserted into the camera. Immediately after exposure Cameron would have to pour developing solution over the plate, arrest the development at just the right moment with water and immerse it in potassium-cyanide, taking great care not to damage the negative, which must then be washed, left to dry and covered in liquid varnish. The photographer told Mary that she could lose a hundred negatives before she achieved a good result. For the print itself, Mrs. Cameron prepared her own silver chloride sensitised albumen paper and used nine cans of well water in its development.[142]

Her group photograph of the Fraser Tytler sisters as *The Rosebud Garden of Girls* was inspired by Tennyson's *Maud* and her own garden.

> Queen rose of the rosebud garden of girls,
> Come hither, the dances are done,
> In gloss of satin and glimmer of pearls,
> Queen lily and rose in one;
> Shine out, little head, sunning over with curls,
> To the flowers, and be their sun.

There has fallen a splendid tear
 From the passion-flower at the gate.
She is coming, my dove, my dear;
 She is coming, my life, my fate;
The red rose cries, "She is near, She is near."
 And the white rose weeps, "She is late;"
The larkspur listens, "I hear, I hear;"
 And the lily whispers, "I wait."[143]

Climbing roses were draped over a screen to provide a virginal backdrop for the Fraser Tytler sisters. Arranging them into position proved a mighty challenge for the photographer. One attempt with a fifth girl focussing on

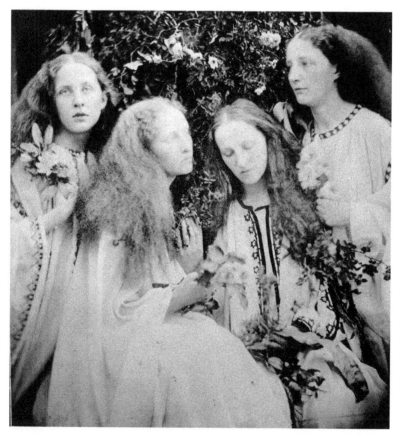

Julia Margaret Cameron
Rosebud Garden of Girls, 20 June 1868.

Mary herself, was a failure. The composition was a mess and the backdrop slipped, leaving the dining-room curtains visible above the screen. Julia Cameron printed the image, took another which she later cropped to show only Christina, Eleanor and Ethel, renamed the group *The Three Sisters: Peace, Love and Faith*. At last, with Mary restored, Cameron achieved her ideal.[144] Her harmonious composition showed the influence of Dante Gabriel Rossetti's painting *The Beloved*.[145]

Julia Margaret Cameron used to say that no woman should allow herself to be photographed between the ages of eighteen and 80, but in this Pre-Raphaelite group of the four Fraser Tytler sisters, each holding flowers from Maud's garden, only Eleanor was young enough. She stands on the left, with passion flowers at her shoulder; looking dreamily upwards at the viewer, in the pose of John Everett Millais's *The Bridesmaid*.[146] Ethel, standing on the far right, has a spray of lilies in her hand and an apprehensive expression, 'I wait'. Ethereally poetic, sitting in the centre beside Mary, Christina holds a red rose, symbol of martyrdom. Mary's strong jaw line seems to heighten her concentration as she looks down, a larkspur rising from the cluster of foliage and heart's tongue fern leaf stretched over her lap. Each girl seems to be absorbed in her role in the scene they are recreating to illustrate the combined genius of Cameron and Tennyson. The photographer has transmitted her profound sentiment to these more than usually receptive sitters, who undoubtedly appreciated the Christian iconography and maidenly purity of their flowers. As well as *Maud*, there is a sense here also of *The Princess*.

That day, the poet William Allingham arrived for lunch, only to suffer the fate of many visitors to Dimbola. Julia Cameron was oblivious of time when engaged in photography. He faced a riot of Fraser Tytlers dashing up the stairs in fancy dress, followed by the triumphant photographer, raising up the dripping glass negative, her hands black with collodion. 'Magnificent! she exclaimed in a voice loud and penetrating, 'To focus them all in one picture, such an effort!'[147] Indeed it was.

'No one in all the world . . . ' began Christina's inscription on the verso of the Fraser Tytlers' print. 'Mrs Cameron challenges all Europe to produce from life a June tableau equal to this'. She sent a print to Rossetti, who was not uncritical.

The Four Sisters is full of beauty, but in so large a group the interference in some degree of unlucky natural accidents in the arrangement is quite impossible to be avoided. Among a bevy of beauties one does not know I should say from the photograph that Nellie and Christina bear away the palm; but photography is not always a trustworthy reporter even in your hands as regards facts: over the beauty of general effect and arrangement you seem somehow to have acquired a degree of control quite your own.'[148]

Mary spent the next week visiting exhibitions in London. She travelled up to the capital with her parents and stayed in Putney, on the south bank of the river Thames. Joined by her cousin Ernest Torin, she went straight to the Royal Academy Summer Exhibition at Trafalgar Square and on to the Institute of Painters in Watercolours, now boosted by 'young vigorous blood' and leading British and foreign artists including Rosa Bonheur, Henriette Browne and John Everett Millais RA. Her first day closed with paintings by the French illustrator Gustave Doré at the Egyptian Hall in Piccadilly. There was *Dante meeting Ugolino in the Frozen Circle*, enlarged from his illustrated *L'Inferno* of 1861, on show with *Jephthah's Daughter* and *Le Tapis Vert – Baden-Baden* recently exhibited at the Paris *salon*. Mary would become increasingly drawn to Doré.[149]

Moved by Watts's contributions - a small evening landscape, a portrait of the British Museum librarian *Anthony Panizzi*, and *The Wife of Pygmalion* and marble bust of *Clytie* – she returned to Trafalgar Square early the next morning. Twenty-year-old Mary copied every word of the Academy Notes on his exhibition pictures by the poet Algernon Swinburne and William Michael Rossetti, a critic and brother of the artist. If to Rossetti, *Panizzi* was the portrait of the year, *The Wife of Pygmalion* and the writhing, undraped *Clytie*, were the most sensational. As in Ovid's Galatea, the artist had transformed a classical bust of great beauty on to canvas, where she is seen coming to life against ripening lily blooms. Blood begins to circulate around the nipple exposed by her chiton and is rushing to her lips. How exquisite for Mary, having let down her hair to recreate Tennysonian High Art, to follow Swinburne's description of her 'sweet majesty and amorous chastity' as the 'soft severity of perfect beauty . . . The eyes have opened already upon

love, with a tender and grave wonder; her curving ripples of hair seem just warm from the touch and the breath of the goddess, moulded and quickened by lips and heads diviner than her sculptor's.'[150]

Watts's marble *Clytie* was not actually finished, yet as the nymph twisted and turned with Michelangelesque *contrapposto* yearning for the sun god Apollo, she stirred Swinburne:

> Never was a divine legend translated into diviner likeness. Large deep-bosomed superb in arm and shoulder, as should be this woman growing from flesh into flower through a godlike agony, from fairness of body to fullness of flower, large-leaved and broad of blossom, splendid and sad, yearning with all the life of her lips and breasts after the receding light and the removing love . . . The bitter sweetness of the dividing lips, the mighty mould of the rising breasts, the splendour of her sorrow is divine . . . We seem to see the lessening sunset that she sees and fears too soon to watch that stately beauty slowly suffer change and die into flower, that solid sweetness of body sink into petal and leaf.[151]

It would be a couple of years before the Highlander could begin to stalk the artist himself. Social calls filled the rest of Mary's time in London, visiting Admiral Eden, brother of the Primus, the Gordon-Cummings and others, promenading and driving in Hyde Park. Her fourteen-year-old brother Charlie, in his first year at Eton, came up to meet them[152] After he left, Mary and her stepmother went to the South Kensington Museum, where Watts's weird reincarnation of the late philosopher *Jeremy Bentham* painted from his auto-icon, was on show, but did not merit a mention from Mary. As the dining room designed by Philip Webb and Edward Burne-Jones for William Morris's firm, Morris, Marshall, Faulkner & Co, was not quite finished, they would have lunched in James Gamble's avant-garde majolica refreshment room, with its high-relief frieze of cavorting, wine-making putti and double-height, double columned arches, covered in glittering, golden diamond tiles. Now was the moment for Harriet and Mary to enquire about enrolment to the Department of Science and Art's National Art-Training School, which was just along the corridor, up the stairs and counted Princess Louise among its clay-modelling students.[153]

The women walked across Exhibition Road into the Royal Horticultural Gardens, opened by Prince Albert as an auxiliary to the 1862 International Exhibition. Bordered by a tall arcade, the gardens were arranged on three levels, rising from the southern end and extending 1,200 feet to Prince Albert (now Prince Consort) Road. As well as the pleasure of wandering along the promenades, the gardens offered a wealth of imagery for Mary's designs. In the lowest terrace there was an arcade of twisted terracotta columns designed by Captain Francis Fowke, a double avenue of Atlantic cedars and tulip trees, octagonal tank and nymphaeas, aviary of songbirds and maze. The cinquecento-style middle and upper tiers were designed by Sydney Smyrke, with a 40-foot-wide central walk, flanked by parterres and trout streams, leading to a magnificent central cascade of water and the Great Conservatory at the northern end. Jets of water poured into basins at the foot of steps leading up to each level. Mary was fascinated by trees and the idiosyncrasies of nature.[154]

Having embarked on book illustration, she was impressed by the 'glorious etchings' of Dr Seymour Haden, who with his, albeit estranged, brother-in-law, the American artist James Abbott McNeill Whistler, led the etching revival in Britain, and had set up classes in etching and wood-engraving at the National Art-Training School.[155]

Mary spent a day at Eton with her brother Charlie, rowing on the river and after attending a service at St. George's Chapel, returned via Reading and Southampton to the Isle of Wight. Here she spent much of July drawing and sketching in watercolour with warm, breezy brushstrokes, dancing, playing croquet and charades, arranging theatricals, and assisting Mrs. Cameron at Dimbola,[156] an experience so extraordinary that Mary could only marvel. 'To all who knew her she remains a unique figure, baffling all description'. She possessed a lethal wit, which she chiefly directed at trumping the poet laureate. Mary, introduced to the photographer's other favoured poet Henry Taylor, witnessed the adulation that exasperated Tennyson: 'I don't know what you mean by his extraordinary beauty'– why he has a smile like a fish!' argued the laureate. 'Only when the Spirit of the Lord moved on the face of the waters, Alfred.' No great beauty herself, Julia Cameron worshipped the idea of beauty. Her eyes, Mary noticed, 'flashed like her sayings, or grew soft and tender if she was moved, perhaps when

reading aloud some fine poem with modulations of voice and change of countenance, to which no one could listen unmoved.'[157]

Talking more seriously of Tennyson, Julia Cameron told her how after he had read from *The Princess*:

> Tears, idle tears, I know not what they mean,
> Tears from the depth of some divine despair . . .
> Deep as first love, and wild with all regret;
> O Death in Life, the days that are no more

the laureate had given the impression that the poem had come to him so naturally as to be an almost unconscious creation. He would later describe the poem's transience as 'the yearning that young people occasionally experience for that which seems to have passed away from them for ever . . . the passion of the past.'[158]

The photographer's task was by no means natural. Mary learned how she would sometimes have to destroy as many as a hundred negatives in her effort to achieve the ideal image, 'her object being to overcome realism by diminishing just in the least degree the precision of the focus. So that once success was achieved, she could then imbue her work with a poetry and a mystery far removed from the work of the ordinary photographer'. To Mary, writing in 1912, no photographer achieved better. Julia Cameron gave her a print of *The Kiss of Peace* (now in the collection of the International Museum of Photography at George Eastman House, New York), and gave it an endearing inscription, 'My best photograph sent with a kiss to the beautiful artist & dear friend Masie', an apt nickname for the poetry-loving Highlander, after Sir Walter Scott's *Proud Masie*. The photographer's dedication showed their special rapport, underpinning their families' Highland links, for her husband, Charles Hay Cameron was a cousin of the Camerons of Lochiel at Loch Ness. Furthermore, the Fraser Tytlers and Camerons shared Anglo-Indian interests. Charles was the first law member of the Supreme Council of India; and he and his wife had been prominent members of Calcutta society.[159]

Mary was happily drawing, after a day in the studio at Dimbola, when Messrs Graham-Montgomery and Henry Cotton came to rehearse a play. They ended the evening with a dance. So successful was the play that the

photographer built her own Thatched House Theatre, which Emily Tennyson noted in her journal, opened at Dimbola on 1 September.[160]

The Fraser Tytlers exchanged visits with Sir John Simeon, squire of Swainston Manor, where Mary sketched and would have seen and very likely incorporated the great cedar that inspired lines in *Maud*:

> O, art thou sighing for Lebanon
> In the long breeze that streams to thy delicious East,
> Sighing for Lebanon,
> Dark Cedar, tho' thy limbs have here increased,
> Upon a pastoral slope as fair,
> And looking to the South, and fed
> With honey'd rain and delicate air . . .[161]

The American poet Henry Wadsworth Longfellow called at Freshwater on a rare European tour to meet the poet laureate and the naturalist Charles Darwin. The great and the good – from the Queen to the Archbishop of Canterbury and the novelist Charles Dickens – were keen to meet the celebrated author of *Hiawatha* and he had agreed to sit to Watts.[162] Tennyson planned to bring Longfellow to the Fraser Tytlers on Friday 17 July, but was detained by Darwin who had succumbed to the lengthy business of sitting to Julia Cameron.

Instead, the Tennysons gave an afternoon tea party for Longfellow at Farringford. Their forty guests seated gracefully on brightly coloured shawls and rugs on the lawn gave the impression of a floral parterre. Emily in mourning for her father floated around in a black silk dress, over her dark hair tied with black ribbon, white lace falling over her shoulders. As her husband, escort to the hero of the day, introduced Longfellow only to gentlemen, Cornelia 'Tiny' Cotton of Afton House complained to the laureate that men were monopolising both poets, 'keeping all the wit and wisdom' to themselves. Whereupon Emily took Longfellow by the arm, pointed out that the ladies were dying to shake his hand and introduced him to every guest. To Tiny, the American's apparent bonhomie seemed superficial. His long silver hair, whiskers and beard over a slick countenance made him appear venerable, but nothing like 'the furrowed lines of our bard'.[163]

The Fraser Tytlers made quite an impact on Longfellow. Mary and her friends had just finished playing croquet, Christina carrying a sprig of poetic Alexandrian laurel picked by sixteen-year-old Hallam Tennyson, when Longfellow collapsed into a chair and teased the women about the English mania for croquet. He was enchanted by the Fraser Tytler sisters and told his hosts, 'it was worthwhile coming to England to see such young ladies.'[164] He spent his final day at Freshwater at Westover. En route, Tennyson took him to sit for his photograph at Dimbola, warning as he left: 'You will have to do whatever she tells you'– before calling at Swainston and at last joining the Fraser Tytlers. 'Such a day!'[165]

Tennyson also arranged for seven-year-old Prince Alámayu – his name means 'I have seen the world' – the orphaned son of the late Emperor Tewodros II of Abyssinia, to sit to Julia Cameron. Three months earlier his world had exploded. Tewodros had shot himself rather than surrender to the English at the Battle of Maqdala, the conclusion of the British Expedition to Abyssinia. Alámayu's dying mother had agreed to Tewodros's demand to Queen Victoria that after his death she arrange for his son to be educated in England. The little prince was utterly traumatised. Not only had he witnessed his father's massacre of prisoners, gunfire, then rampaging soldiers plundering and burning treasures from the Imperial collection, but he had been displaced from his homeland, a mountain fortress overlooking a panorama of peaks and gorges for a foreign land.

Prince Alámayu travelled under the guardianship of Captain Tristram Speedy of the British Expeditionary Force, with their servant Casa. Bearing prized pieces from the Abyssinian collection – the gold crown, royal robes and seal – for presentation to Queen Victoria, they set sail for England on 11 June. In advance of his arrival, the prince appeared in the *Illustrated London News* and Mary was designing a shield for Julia Cameron. Landing in Plymouth, they travelled in the queen's mahogany-hulled yacht *Elfin* across the Solent to Osborne. Captain Tristram Speedy, quite a showman in his Abyssinian warrior robes, lost no time in courting and winning the hand of Tiny Cotton.

At first sight of the bearded laureate Alámayu called out 'Papa, papa' and warned Emily that an elephant might be hiding in the holly bush.[166] Mary was making crosses at Dimbola on 23 July when the prince arrived

58

Prince Alámayu of Abyssinia
Captain Speedy and Casa, sitting to Julia Cameron.

in the studio.[167] He was dressed in a purple shirt, which looks white in the photographs. Did the magnificent image of Speedy in his embroidered fez and lion-skin tippet appeal just a little too much to the photographer. Carrying a spear and sword that curves over Alámayu's lap, he dominates images of them both. Wisely, she took the prince on his own. Vulnerable and sad, he appears to be almost overpowered by his large teardrop necklace and by the lion's mane shield – was it the one made by Mary? Mrs. Cameron registered ten photographs. The *carte*-sized print Mary pasted into her album opposite the autographs of the prince and his guardian, may have been a trial photograph, unless she took it herself. Here Captain Speedy sits with his arm around the prince, Casa, the dominant figure, stands behind them with the shield. Mary set the photograph in the Abyssinian jungle, drawing a tiger

59

on a mountain ledge, chained to a coconut palm and protecting her cubs, with anklets ornamented with bells lying nearby, suggesting escape from bondage.[168]

Intoxicated by her induction into the heart of the Victorian literary and artistic world, Mary bade farewell to Mr. Montgomery and set sail from Cowes to study art on the Continent. These last months had marked the start of a lifelong friendship with the Tennysons. *The Rosebud Garden of Girls*, the pride of Hallam's dormitory collection of Cameron photographs at Marlborough College – Virginia Woolf later treasured a copy herself – was so admired that he felt he could sell celebrity portraits for the photographer. A gipsy had come to tell the Fraser Tytlers' fortunes.[169] As well as dancing and losing her heart to a dashing soldier, she will have heard the photographer endlessly praise Watts, her 'divine artist', friend and adviser and seen his pictures. More than Mary could possibly have imagined, she had been living, drawing and walking with his friends, enjoying their unconventionality and genius. 'I doubt if there is now any place where poets and painters can find the inspiration, let alone the fun, that Tennyson and Watts found at Freshwater', Lord David Cecil would muse over a century later. 'Jolly fun', concurred Mary.[170]

FIVE

Grand Tour

Dashing captains joined the Fraser Tytler sisters aboard the Cowes steamer as they sailed for the Continent, languishing on deck in the summer sun; and in the refreshing absence of their Mamma due to a headache, Christina and Mary were serenaded by an Italian tenor. For this latest adventure, Mary was reading Victor Hugo's *Les Travailleurs de la Mer*, and to satisfy her relish for disaster stories, she had with her *The Shipwreck,* the popular poem by William Falconer, the Scotsman whose ship sank off the coast of Greece; and John MacGregor's canoe cruise, *The Rob Roy on the Baltic* offered delicious insight into her travels through the German kingdoms of Prussia, Saxony and Bavaria. She also had with her *Art Forms in Heavenly Places: An Essay on the Poesies of Music* and *Anecdotes of the Upper Ten Thousand, Their Legends and Their Lives.* Mary would fall into the very trap The Honourable Grantley Berkeley outlines:

> There is no time in a woman's life at which she will do more, or risk more for one she loves, than at her very earliest stage of spring . . . There is no period of her chequered [youth] and, though pain and sorrow, happiness or contentment, beautiful existence, when her love, her first, real, sweet, romantic affection, is so splendid a gift as it is ere she reaches twenty years of age.
>
> Her heart may be captivated without even speech, without a word from the object that has fixed and engrossed her thoughts, and she may love her hero with a devotion that all the personal attention in the world could not have induced . . .[171]

Dresden, the cultural capital of Saxony set in the curving valley of the river Elbe, was renowned for its baroque architecture, its spires and fine and decorative arts treasures built up by the eighteenth-century Electors of Saxony and Kings of Poland, Augustus II 'The Strong' and his son Augustus III. The map of Germany was changing. The Prussian premier Otto von Bismarck, having ousted Austria and united the North German Confederation in the 1866 civil war, had engineered Prussian ascendancy and was working towards complete unification.[172] Mary would experience developments first hand. This visionary 'Florence of the Elbe' was to be the Fraser Tytlers' home for the first leg of their Grand Tour of Europe.

So eager were they to explore the city, that as soon as they arrived on Wednesday 29 July 1868, they drove straight out to the seventeenth-century *Großer Garten*, which had been modelled on the great French gardens of Versailles and Vaux le Vicomte. In the evenings they would promenade along the Brühlsche Terrasse, the grand balustraded 'Balcony of Europe' named after Augustus III's prime minister Count Heinrich von Brühl. Here they enjoyed panoramic views along the south bank of the Elbe, music and architecture.[173] The visionary quality of the city, its spires and symbolism were encapsulated by the Romantic landscapes of Caspar David Friedrich, (1774-1840).

The Fraser Tytlers took at a house in Christianstrasse. German tutors were organised and over the next six months Mary would explore, sketch and study Dresden's supreme fine and decorative arts and drive out to see gardens and castles, early among them Weesenstein, owned by John, King of Saxony whose translation of Dante's *Divine Comedy* was on display. She went to the opera, Donizetti's *Der Regimentstochter* (*La Fille du Regiment*) and saw a 'beautiful' production of *Hamlet* – the play was first shown in Dresden just ten years after the death of Shakespeare. The *Königliches Hoftheater* (Royal Court Theatre and Opera House) had been designed by the architect Gottfried Semper (1803-79) as a theatre for opera and drama in the royal seat of the Kingdom of Saxony. Inspired by the early Italian Renaissance, it was an impressive, innovative theatre building, rounded and arcuated at one end for the auditorium with two higher rectilinear floors over the stage and grand pedimented entrance. Semper, who had liaised with

Prince Albert over displays at the Great Exhibition of 1851, had also designed the *Gemäldegalerie Alte Meister* (Old Master Picture Gallery), the final wing of The Zwinger palace,[174] where Mary was to be found almost daily drawing and painting from its masterpieces. 'Now our dreams seem nearer'.[175]

Her first portrait was a head by Sir Peter Paul Rubens – (there being no single head by the Flemish master in the collection, *St Jerome* or a detail from *Diana returning from the hunt* seem more likely than the drunken Hercules). Mary turned to prayer, 'Oh make me humble, but prosper thou the work of my hands oh God!' She spent months on the picture, as well as etching and engraving at the gallery; she sent a specimen of her wood-engraving to Hatchard's of London, who were publishing Christina's first book of short stories.

Mary's lively eye would incorporate a rich range of decorative detail from her European tour onto the pages of her photograph album. Elaborate sixteenth-century golden pendant frames encrusted with diamonds, rubies and emeralds, strapwork, porcelain, flying cherubs, sculpture and other *objets d'art* would be transformed into exuberant watercolour surrounds, exchanging royal enamel portraits and cherubs for photographs of family, friends, officers and royalty, each painted with care and ingenuity. She visited the *Grünes Gewölbe* (Green Vaults) of the baroque *Residenzschloss* (Royal Palace), its strapwork display creating a sense of *gesamtkunstwerk*, and marvelled at the 'dazzling gems, crown jewels very beautiful'. Especially notable are her royal ciphers, her voluptuous decoration around the photograph and monogram of Lady Macpherson-Grant of Ballindaloch, its swirling foliage interlaced with fire-breathing dragons in a juxtaposition of Celtic illumination and renaissance jewellery the seeds of her Watts Chapel interior; and the ewer inspired by Johann Joachim Kaendler, the famous modeller of the Meissen Porcelain Manufactory, where she then spent a day looking at 'the lovely china works all over'.

Illness kept Mary from the Grand Review with the King of Prussia which her family witnessed, but on a visit in September to the magnificent park and gardens of the King of Saxony's riverside palace of Pillnitz – a late baroque extravaganza with Chinese pagoda-style roofs – both the King and Queen of Saxony stopped to talk to her.

Meissen ceramic decoration surrounds Dresden friends.

In between driving out, hunting, walking in forests, gathering ferns to draw, socializing with Saxon aristocracy, German generals and British officers at this transitory moment in Germany's history and listening to 'exquisite' concerts, Mary rushed to finish the blocks. That month her grandmother relayed news from England of the whirlwind engagement of 'Tiny' Cotton, the daughter of Tennyson's neighbour at Afton Manor, to Captain Speedy. After an 'exquisite concert' Mary dashed off a caricature of a monocled, moustachioed officer with large ears. Her callers the next day were the Highlanders Harry Grant and, notably, James Graham-Montgomery. Mary was at the *Gemäldegalerie*, but her diary entry about 'an awfully nice ball, enjoyed very much' the following evening, suggests that they are more than likely to have been among her dance partners.[176]

Her next portrait, of an old man in a red cap by Rembrandt's pupil Govaert Flinck, would be preserved to hang at Aldourie.[177] Adding painting on china to her portfolio, she hesitantly shared Christina's excitement on 30 November when Hatchards' advance copy of *Sweet Violet and other stories* arrived, its six wood-engravings each embellished with Mary's jaunty Celtic-style 'MFT' monogram – 'Better than I hoped!' Christina's tales of romantic

ladies and gentlemen suitors of their age, of gowns, footmen, carriages, ballroom scenes, bouquets, loneliness, children, quotes from Wordsworth and Tennyson, all relating to the lives of the author and illustrator. As a first

effort, Mary's draughtsmanship captures a range of emotions, for example, a sad young woman standing 'Alone – in the dark – for evermore?' outside the party where her favoured gentleman is eyeing up her rival. Freshwater Bay appears in the background to two strolling women, one 'full of health and happiness, with long golden-brown hair falling over her shoulders and still sparkling with the salt tears of the sea'. However, her final image designed to depict a young girl's distress, omits the eroticism of Correggio's penitent *Magdalen* mentioned in Christina's text.

'Alone in the dark – for evermore.'

Mary had acquired a copy of William Blake's *Songs of Innocence and Experience*, 'a precious book', which she would treasure all her life; and as the year closed wistfully thinking of home, she wondered where she would be next year, highlighting her copy of *In Memoriam*:

> This holly by the cottage-cave
> To-night, ungather'd shall it stand:
> We live within the stranger's land,
> And strangely falls our Christmas eve[178]

The Fraser Tytlers stayed a few more months in Dresden. Witnessing the huge December gathering for Bismarck to nurture southern support – 'splendid sight' – imbued Mary with a sense of history.[179] She had absorbed the city's wonders, its symbolism, craftsmanship, horticulture and architecture, but she had left before the 1869 September inferno that devastated the opera house[180] and would never know of the terrible conflagration of Dresden by RAF Bomber Command on the night of 13-14 February 1945.

There are no extant diaries for the last year of her travels, but family lore and Christina's next novel and indeed her own illustration work indicate that the Fraser Tytlers passed through Bavaria and the Austrian Tyrol as they journeyed towards Italy. Her grandson Ronald Chapman believed that she had been smitten by one of the most romantic figures of the nineteenth century, King Ludwig II of Bavaria, just four years older than Mary.[181] He was a great admirer of Mary Queen of Scots and had been unusually close to the Hungarian actress Lilla von Bulyovsky, who had played the martyred queen in Schiller's play *Maria Stuart* in 1866. Ludwig commissioned a portrait of Lilla in the role and after one performance had ordered a nearby church to be opened so that he could pray for the soul of the Scottish queen.

Ludwig was extremely tall and elegant, with dark brown curls and large burning eyes. An Adonis with the physique of a Greek sculpture, he was a magnetic figure, a man of eccentric contrasts. Prussian domination was threatening the independence of Bavaria, yet the young king, – despite his fascination for medieval knights in combat – wanted neutrality rather than warfare. Preoccupied with thoughts of the sublime, Ludwig was fired by the desire to build medieval castles. 'Oh! it is essential to create such paradises, such poetical sanctuaries where one can forget for a while the dreadful age in which we live.'

Women were magnetised by the Bavarian king – Mary pasted photographs of two who were particularly close to him into a fan decoration in her album – Elisabeth 'Sisi', the Empress of Austria, who would remain a friend for life, and her sister Duchess Sophie of Bavaria, to whom he was briefly engaged. Sophie was now married to Prince Ferdinand d'Orléans, duc d'Alençon. 'You have such pretty eyes', Ludwig told her, then explained that 'the god of my life is, as you already know, R. Wagner.'[182] It was to men to whom Ludwig was drawn, to Richard Wagner, above all, to the fantasy world evoked by his operas.

H.I.M. The Empress of Austria (lower right) within fan of Mary's family.

Dedication to King Ludwig II of Bavaria.

Ludwig had come into funds in 1868, on the death of his grandfather, and immediately set in train plans for a fantastic knights' castle to rise from a craggy peak with spectacular views over the Bavarian highlands. Within walking distance of his family castle Hohenschwangau, the capital of the Swan Country, Neuschwanstein was to be designed as a shrine to *Lohengrin, Tannhauser, Parsifal* and the age of German chivalry, decorated with imaginary scenes for Wagnerian operas, 'a worthy temple for the godlike Friend through whom alone can flower the salvation and true blessedness of the world.'[183] The foundation stone was laid on 5 September 1869; and notwithstanding strained communications between Wagner and his royal patron, *Das Rheingold*, the first opera of the *Ring* cycle, premiered at the national theatre in Munich on the 22nd.

How close did Mary get to the Bavarian king? She had met the King and Queen of Saxony, had learned German and would have been fascinated by Ludwig's plans for Neuschwanstein and of course loved music. In 1869, he was sitting for his bust carved in marble by Elisabeth Ney. Mary referenced these in her album page devoted to Ludwig, which she would complete in Rome. But where were the swans? For a symbolist such as Mary it is curious

that, though she loved to depict sinuous long-necked birds, no swans appear in her Ludwig decoration.

The King's Bavarian castle would inspire her illustration work, which she continued throughout her European travels, sending wood-engravings to *Good Words for the Young* throughout 1869. Her first illustrating a Tudor tale of 'The Boy in Grey', shows a young duke standing over a languishing prince, with voluptuous toy sea creatures at his feet. These were followed by another prince in a fairyland forest, a Bengal tiger in the jungle, riding an elephant, and a young Highlander in deerskin leggings with a plaid over his shoulders.[184]

Christina's protagonist in *A Rose and a Pearl*, adored by her younger cousin Charlie, who looks upon her as a mother ('Mary was his confidante, his guide, his counsellor, his guardian angel') reflects the affection Mary aroused in those close to her – here, her brother Charlie and cousin Lionel Maynard 'Leo' Torin, five years and two years younger respectively.

> As the spheres he moved in changed and widened, and as he felt himself leaving boyhood and growing into the man, even so did Mary seem to expand and widen her views also . . . taking up his everyday troubles as if they had been her own. If he had taken a step upwards, Mary had risen also . . . "However much I scramble after you, Mary, he would say, "your pedestal is always the same height above me!"

The fictional Charlie reads Tennyson's Arthurian *Idylls of the King* and his Tyrolean sweetheart sings in a plaintive minor key, yet with a full, rich voice, in moonlight, but Rose dies and he marries Pearl.[185]

Mary and her family spent surprisingly few days in Venice and Florence, the then capital of Italy. Giambologna's bronze *Flying Mercury* at the Museo Nazionale del Bargello – with his private parts discreetly painted out – fills one of the last pages of her album, as the handle of a scimitar, the blades formed of photographs of friends and her cousin Ernest Torin.[186] Flamboyant strapwork in the window reveals of The Baptistry would three decades later find their way into her mortuary chapel at Compton.

In the struggle for the unification of Italy, every state but Rome was now united, and Rome – poetic, elegant, lively and dilapidated, with new horse-drawn omnibuses and picturesque peasants herding cattle through the city's huge wooden gates – remained under French occupation.[187] As in Dresden, the Fraser Tytlers would have taken full advantage of the opera,

the theatrical, social and artistic opportunities, magnificent frescoed churches, palazzi and villas, galleries, churches, and sculptural fountains. The 1869 *Handbook of Rome and its Environs* provided an indispensable guide, even to baking ovens for painting on porcelain, as well as grand international artists' studios and advice about an audience with the Pope. A visit to the Caffé Greco, the artists' rendezvous in the Via Condotti, would have been irresistible.

Here at last Mary completed her dedication to the Bavarian king. A large roundel of his head, cut from a cabinet card, shows extravagantly crimped hair; his eyes are lustrous and upturned, and the regal lips pout sensuously. Ludwig's image is set at a jaunty angle, supported by female muses dedicated to music and poetry, beside building tools, lines of music and the marble bust. Painted in watercolour, these stand upon Ludwig's monogrammed architectural plinth. At its base, inspired by Canova's tomb of Carlo Rezzonico, the Venetian Pope

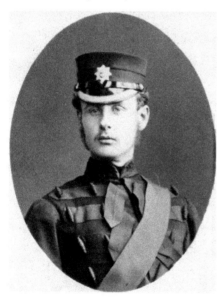

Lieutenant. James Graham-Montgomery

Clement XIII from the basilica of St Peter's, are the two lions of contrary spiritual significance, one ferocious, the other peacefully resting on its paws, both upon marble steps. Mary's lion was more ferocious.

Her ill-fated love for Graham-Montgomery became all-consuming. The son of a Scottish baronet, he was commissioned as a lieutenant into the Coldstream Guards in 1869, he led her on, quite how far we do not know, then he left her. By August Mary was suicidal. The lieutenant had seemed 'different from all other men I know'.

"Perhaps I shall be proud some day" you said
"At least, I know not, I may not, & I may"
And then in grave eyes that looked on mine I read,

"Of you shall I be proud that day?"
I turned away my head that I might hide
How that your words had made me proud & glad

I kept my face turned from you, & I sighed
I would not that you knew, what made me sad
Was it the hour that made you dream you loved?

Was it a jest that lit the love-look in yr face?
A look most like a pain, my soul that moved
That made my heart leap in its place.[188]

Her lover proved to be a scoundrel. For years afterwards Mary would lock suicidal thoughts into her black leather commonplace book: 'I sinned – I longed for rest' 'O Christ to die & be with Thee is best. How quiet seem the Dead & blest.' Her anguished writings, feeling of guilt: 'Did the birth pangs of this love born dead, atone / *That* sin & plead my frailty & my need of Thee' and that 'he, / I yet, made glad & satisfied' The absence of diaries concluding her Continental adventures suggests that she had given herself to her lover completely. Mary heard from him no more.[189]

For the devout Fraser Tytlers, Christmas at St. Peter's was surely a must, if not as early as two in the morning to hear the Shepherds' Song at the *Capella del Choro*, they would surely have witnessed the spectacular service in the basilica at eight. Silver trumpets struck up and echoed around the dome and as the bronze doors opened, Pope Pius IX was carried in on a fifteen-foot-high canopied chair of state, a silver and white apparition, with fans arranged to resemble wings, hovering over the crowds at the tomb of St. Peter. For spectacle, sound and silence, according to *The Times* correspondent, that Christmas ceremony was astonishing to witness. The Swiss Guards lowered their muskets, whereupon in what seemed an explosion of stalagmites, 700 bishops of all nationalities replaced their mitres. Many were in Rome for the momentous, controversial Ecumenical Council that would shortly accept the Pope's Decree of Infallibility.

While the Carnival spirit gripped tourists and Romans alike, with crowds thronging the Corso, flinging confetti, and ladies catching bouquets thrown up to their balconies, in January 1870 the Fraser Tytlers' adventurous friend George, Earl of Aberdeen, had been sailing for Australia when his schooner hit a tremendous storm, hurling him into the Atlantic Ocean. He was last seen in moonlight rising upon the crest of a wave.[190]

The merry-making sisters were as yet unaware, when one Saturday at the Palazzo Sciarra in Rome, Christina met Edward Liddell. The eldest son of Colonel George Augustus Liddell, Comptroller to the Duchess of Gloucester and grandson of the Earl of Ravensworth, Edward had recently graduated from Balliol College, Oxford. He was lodging at the Hotel de Londres with his cousin Adolphus 'Doll' Liddell and Watts's friend and patron Francis Charteris, Lord Elcho, who had sat to Julia Cameron at Freshwater after the Fraser Tytlers' departure. Edward swept Christina off her feet. She was enchanted by his wit, his rich tenor voice – deliciously erotic – and he loved to dance. They will all have enjoyed the *bal masqué* at the Palazzo Barberini, Mary too, despite her torment, loved to dance and warmly supported Christina's whirlwind engagement, beginning a celebratory poem. Woven into her joy, Mary's angst heightens her intense expression of sisterly love.

> It is come! that which I so often with such vehement beseeching
> On my knees, for me beloved, wrestling as Jacob did of old
> Crying, I will not cease my praying, except Thou altogether bless her
> Bless her, with all blessings, but with this a thousand thousandfold.[191]

During her Grand Tour, having witnessed Bismarck's gathering in Dresden, Mary will no doubt have been aware, as the family travelled home through Europe, of troubles that would lead up to the Franco-Prussian war in 1870, but was safely back in Britain before its outbreak.

Mary returned ever nearer to her favourite British artist, for by March she was back on the Isle of Wight, in Watts's milieu. Christina's fiancé sent merry verses based on William Cowper's *To Mary* to keep her dance-loving sister's spirits up. Emily Tennyson alerted the Poet Laureate. 'Thou has not remembered to answer about Hallam. Two of the Fraser Tytlers are to be at the dance this evening so it is rather a temptation to him to go.' Mary's entrée into international culture over the last year and a half had brought phenomenal experiences, cultural, social, political, seeing and studying unparalleled landscapes, architecture, fine and decorative arts. All would enrich her art. Far beyond 'jolly fun', the last two years had opened up her mind.

SIX

Painter of Painters

'Now at all modern exhibitions I acknowledged to myself that George Frederic Watts was the painter of painters for me,' Mary would recall in her memoir *Annals of an Artist's Life*.[192] So she must have visited his Royal Academy exhibition before making her pilgrimage to Little Holland House, the pivotal first step into the artist's sanctuary in the spring of 1870. His star was rising. The previous year Watts and his close friend and colleague Frederic Leighton had hung the Academy's inaugural summer exhibition at Burlington House. Their spectacular display of modern English Art had moved on from Pre-Raphaelitism to a broader idealistic approach to art and classical influences from the Continent. This spring, with John Everett Millais now as his co-hanger, they curated a sensuously controversial celebration of the idealised nude. Reviewers prized Watts's pictures as 'caviar to the general'. What Mary saw at the Academy were his languid nude *Daphne* and contrasting temptress *Fata Morgana, from Boiardo* fleeing from a knight who attempts to clasp her flying drapery. Opposite *Fata Morgana* hung Millais' shockingly unidealized naked girl with her *Knight Errant*. Also on show was Watts's portrait of his younger colleague Edward Burne-Jones, with whom one day she too would become a close friend.[193]

As propriety forbade young women to travel alone, even in a hansom cab, Christina accompanied Mary as chaperone, to Little Holland House. Naturally shy she may have been, but her approach to Watts was intrepid. His social reforming imaginative art forever controversial, the artist was seen as Carlyle's visionary 'Great Man' or 'living light-fountain . . . a natural luminary . . . of native original insight'.[194] The likeness Watts achieved in his portraits by offsetting the sitter against a dark background, throwing light

72

upon the face, the eyes watery – aimed to reflect the mind of his sitters. You can almost feel what they are thinking. Artists were keen to live close to him. Valentine Prinsep, his former student and second son of Thoby and Sara, and Leighton had built studio houses within view at Holland Park Road and an artists' colony would gradually build up around them.[195]

Little Holland House was a rambling gabled building with landscaped gardens and stately elm trees in the Kensington countryside. Twenty-year-old Mary was filled with awe as she stepped under its conical thatched porch, where the butler Joseph Dennis led her past paintings she barely noticed en route to her hero. Waiting in the anteroom, its blue ceiling starred with impressions of the planets, Mary's heart began to pound. If the artist's full-length self portrait robed as a Venetian senator hung on the red-baize studio door, she didn't notice it, but stared instead at the large label that read: 'I must beg to be undisturbed till after two o'clock'.

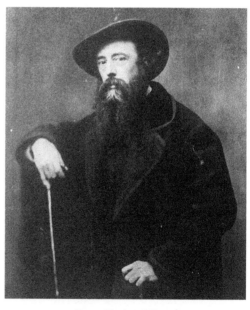

George Frederic Watts.[vi]

Suddenly the door swung back. 'Mr Watts' stepped forward to greet the sisters. He ushered them into his lofty light-filled studio. At 52, his fine brown hair was brushed back from his forehead, his beard tinged with grey. The Academician stood five feet nine inches high. Mary, a slight figure, shorter than he, was struck by his courtesy. There was no sign of frail health. 'I remember the painter much more distinctly than his work; but he nevertheless so distinctly suggested to me the days of chivalry that I believe I should not have been surprised if, on another visit, I had found him all clad in shining armour.'[196]

[vi] Inscribed 'Given me by H. T. Prinsep'.

Meeting the master at last in his artistic heartland was as thrilling for Mary as it had been for Watts when he first entered the Sistine Chapel in Rome, at about the time of her birth, and found the Michelangelo ceiling flooded with light. Ever since, his great desire had been to fill a British hall with monumental frescoes illustrating the progress of the cosmos, civilization and spiritual thought, much as the 'Poet, Painter, Man of Genius' for which Carlyle had called to unravel the mystery of Time.[197] Cosmic frescoes had seemed beyond the pale for the conservative art establishment. In any case, the London smogs were damaging to true fresco. So, Watts was now painting subjects for the scheme on to canvas. A fragment of fresco, a figure for the opening subject *Chaos* was inset into the wall.

Even if the intimacy of her first moment with the artist was all that she could remember, he would have shown the eager young student casts from the Parthenon marbles, whose supreme Phidian form influenced his Symbolist art. Studies for his series of Eve as the symbolic mother of mankind were in various stages of progress, some larger than life-size.[198] Watts had reinvented imagery of Time and Death. Rather than wizened old skeletons, his *Time, Death and Judgment* shows a staring-eyed youth bronzed by the elements as he marches in front of the sun for all Time, hand in hand with a beautiful pallid female figure, passive because Death will come. Above them a flamboyant, red-robed figure is passing Judgment. Among many as yet unexhibited pictures were ravishing mythological nudes and haunting images of *Love and Death* – the back view of a tall, robed figure approaching the door which a boy with broken wing attempts to shield.

How much of his art did Mary see? She would have been drawn to the extraordinarily powerful apocalyptic horseman, and to the portrait of the medievalist master craftsman William Morris. Now that he was completing his Chaucerian epic *The Earthly Paradise*, Watts had invited Morris to sit for his national portrait series. The two men shared an abhorrence of the dehumanizing effects of the machine age, but the craftsman had been reluctant to sit. The luscious atmosphere at Little Holland House was not to his liking, nor indeed was the idea of sitting for a Hall of Fame. But he was a public figure and the press were clamouring for a portrait. Morris had arrived on Good Friday with 'a devil of a cold-in-the-head' and given a single sitting, so at this stage, Mary probably saw just his head on the canvas, the luxuriant, leonine red hair, flushed face and warm concern in the eyes.[199]

Watts's disinclination to exhibit self-portraits may explain why he did not remove from his stack of canvases *The Eve of Peace*, in which he appears in healthy middle age, in contemplation as a medieval knight. How different Mary was from his usual visitors. No outstanding beauty, her eager response to each picture would have affected Watts. He relished the excitement of imaginative young ladies. Indecisive himself, Mary's directness seems to have enchanted him. The Academician offered her the encouragement he gave to many aspiring students and, like them, Mary felt elevated by the intimacy of their meeting.

> From this time forward I received the greatest kindness and help from him. His patience with amateur work, his appreciation of anything that was a natural expression in any art, is so well known that nothing further need be said. I was one of the many who brought their efforts to show him, and who, coming to learn something to enable them to draw better, went away feeling they had also learnt how to live better.[200]

The loan exhibition of fans at South Kensington Museum would have been of interest to Mary at this time, promoted by the Department of Science and Art for the Art Instruction of Women, to reinvigorate fan design, from a mass-produced adornment to an avant-garde object of fine art. The finest examples had been lent by the Queen and royal family, by the Empress Eugenie of France, the Countess of Paris, Lady Charlotte Schreiber, Baroness Rothschild. Amongst the 413 fans from Japan, China, India, France, Spain and England, were designs made by students in the Female Schools of Art, to which Mary was about to enrol.[201]

Up in the Highlands, away from the art world, Mary was in turmoil. She ripped her watercolour of Sanquhar at sunset from her commonplace book in which she cried out in verse and prayer, feelings that veered between heartbreak and joy for her sister's happiness. Yet she wrote tantalisingly little about developments in her artistic life, not even her first meeting with Watts.[202] Riddled with guilt and despair over her lieutenant, she wrote, 'Do not listen to Satan if he tell thee again "It is hard",' quoting an unforgettable sermon by Professor Edward Pusey, a leading light in the Oxford Movement. 'It *is* hard to resist sin & it is hard not to follow thine own will – it *is* hard to save thy soul but it is harder far & unendurable to love it, & the sight of God.'[203]

In daylight Mary threw herself into art, working up a portrait of Christina, without thought of her lost love, until nightfall. Then she yearned for her painting to impress him.

> All day long, I work without a thought of you
> God be thanked! He keeps me from vain dreaming
> Only in some evening hour, when there is nought to do
> I hold your hand again, in seeming –
>
> Only when some sketch, or touch, has pleased me well
> Sometimes the thought comes . . .
> – perhaps, he will be proud of me one day –[204]

Her future brother-in-law Edward Liddell was struck by typhoid so virulent that he suffered a life-threatening relapse. Mary shared Christina's distress. She persuaded her sister to keep writing. For although as Victorian aristocrats, the Fraser Tytler women considered themselves amateurs, each was characterised and strongly motivated by their art. Mary determined to protect Christina from worry, prayed for her and read to her under their ilex tree.[205] At last, Edward was well enough to prepare for his ordination in Winchester Cathedral. He would be appointed curate, responsible for the large workhouse at Alverstoke, near Gosport.[206] Meanwhile Mary, still desperate, and as if challenging God, demanded in prayer:

> God! Because of the darkness I cannot order my speech
> Order it Thou! I can pray if Thou teach.
> Guide my yearning, - & I can beseech –
> Thou knowest my longings, & the way that I shall go.
> My dreams, & their breakings, don't Thou know –
> I know nothing, & it is best so –
> I have nothing, save what thou has given' [Her art?] & this I bring
> Praying "Bless the increase of this thing
> I work, - Crown Thou the gath'ring in.[207]

Her lover had attacked her faith, using her love of nature to rip her soul apart. 'A sudden damp cold mist clung round my heart which stopped and leapt on & stopped . . . they say that sorrow makes us know' In this troubling age questioning God and evolution, Mary was herself riven with doubt.

> "What do I know" oh me a weak weak woman . . .
> How can I answer to a strong mans reasoning
> What wit have I to appraise or condemn –
> How can I judge them these men of great learning
> Men with great brains and high thoughts . . .

Mary clung to her faith, finding consolation in her spiritual guide rather than her lover.

> Only could my heart disclose what it knoweth
> Of an hour of misery & bleak desolation
> How close he held me in His arms of pity
> Made me strong with his sweet consolation. . . .
> 'Christ! Give us darkness that we may see Thy light'[208]

The antonymous conflict between light and dark, the love of shadow, would find expression in her art. By her birthday, 25 November, Mary determined that she had forgotten her sadness: 'No shame. I think he loved', she composed a poem to Christina, and as her sister read it by the firelight,

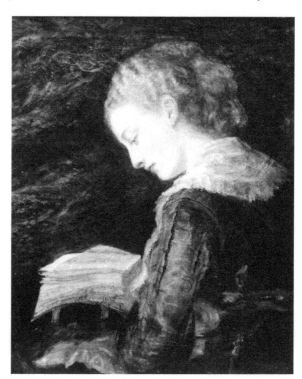

Christina.

flames flickered crimson over her face and her eyes began to glisten. Silently, she turned to kiss Mary.[209] 'Her joy, & at *my* love, doth move her unto tears – Catch them oh heart! Clasp & close over as a vice.'

The painting of Christina gazing down at her manuscript was Mary's first original portrait in oil. Her best and most Wattsian portrait, it is a huge advance from her copies of masterpieces in Dresden and the Scottish masters' portraits of her ancestors. She has captured the poetic contrasts in her sister's life. The swirling abstract background of blue suggestive of heather, offsets her highland rose complexion. Mary has thrown light on the face, celebrating Christina's beautifully crinkled auburn hair as in Watts's rare Pre-Raphaelite-style portrait of Jeanie Senior, the tender treatment of the neck and especially the symbolic literary reference. She has learned from her admired artist the use of free paint-handling in the shadowed brown silk dress, deep delicate white collar, achieving an overall sense of poetry in the soft, sensitive eyes, fine eyebrows and sensuous lips.

Alice Balfour invited Mary to Whittingehame in East Lothian. Alice, an amateur artist and naturalist, who would become one of the earliest pioneers of the science of genetics, was assisting her elder brother, the future prime minister Arthur, in his entomological studies. At Whittingehame Mary copied out passages of famously provocative philosophy from *Ecce Homo* by J. R. Seeley, Arthur Balfour's history professor at Cambridge.[210]

Her sense of purpose restored, Mary exhibited three subjects for illustration at the Royal Scottish Academy in Edinburgh,[211] then moved south to Kensington, to study at the National Art-Training School and after weeks of preparation, for her social debut at the Queen's Drawing-Room at Buckingham Palace on Thursday 23 February 1871, which happened to be Watts's birthday. Presentation at Court opened the London Season of social gatherings for upper-class girls to encounter future husbands. That Mary, at 22, was older than most debutantes may suggest reluctance and that she ultimately gave in to her stepmother, though she did hit the jackpot. For, unlike Christina's launch, the entire royal family was present for Mary's presentation. As a debutante, she would have dressed in a long white gown with full train, a long veil and feathered headdress. Fully au fait with fans, slippers, tea-dresses and carriages, she would now have learned the art of walking gracefully, to glide across the room and keep her balance while curtseying deeply on one knee, close enough so that the Queen could

kiss her hand, then back away without tripping. Harriet introduced her stepdaughter. Among the glamorous debutantes was her lieutenant's sister Lucy Graham-Montgomery.[212]

Days later disaster befell Edward Pretyman, the cousin with whom Mary had loved riding and dancing at Freshwater. He broke his neck diving in Bermuda and would be commemorated by a nautical stained-glass window of *St Peter and Christ on the Sea of Galilee* in the church of St Mary, Aylesbury.

How much of the Season Mary engaged in is not recorded. No grand fiancé transpired. It mattered so much more that her new London home, at 9 Queensgate Place, was near the Art-Training School, to her paternal relations in Cornwall Gardens[213] and just fifteen minutes' walk from Little Holland House. Her hosts, Vice-Admiral Charles Eden and his wife Fanny had a calming influence on her troubled soul. It was an exciting time to be at South Kensington, where buildings dedicated to art, music and science were springing up, under plans set in train by Semper and Prince Albert and supervised by Henry Cole, the head of South Kensington Museum and Department of Science and Art, under whose auspices the art-training male and separate female schools were run. If teaching was uninspired, there were opportunities for female as well as male students to work on the dynamic ceramic and terracotta decoration of the new buildings. While female convicts from Woking Prison laid mosaic floors, some students were setting in mosaic life-size portraits of old masters, designed by leading contemporary artists – Watts had supplied a study of Titian – and others were enlarging and executing in mosaic designs for the new Bethnal Green Auxiliary Museum.

In the spartan studios of the Female School, with windows blackened by smoke from a steam engine and blacksmith's forge, Mary put her Dresden experience to use, painting symbolic designs by Professor Edward Poynter on to Minton tiles for the Grill Room. His female personifications of the seasons and months, painted largely in blue and white, with fountains and peacock motifs, anticipated the Aesthetic movement later in the decade. Mary was particularly concerned to achieve the yellow-gold contrast. This novel decoration, in line with Semper's idea of linking art with industry, impressed the *Graphic* as a 'most interesting means of occupation for young women'. Male students, meanwhile, experimented with more physically demanding sgraffito decoration on the pediments of the new Schools of Naval Architecture and Science.[214]

The Royal Albert Hall, the circular terracotta building erected at the instigation of Prince Albert 'for the advancement of the arts and sciences and works of industry of all nations' was opened by the Queen on 29 March. Terracotta was increasingly *de rigeur* at South Kensington. With porch decoration by Poynter representing countries that had participated in the 1851 International Exhibition, the hall was built to face the Albert Memorial to the north; and the Royal Horticultural Society Conservatory to the south was available for use as a crush-room.[215]

Parts of the hall were being used for the 1871 London International Exhibition, but it was in the Horticultural arcaded West Gallery that Mary exhibited fan mounts alongside designs by Alice Balfour, the Montalba sisters and Princess Louise. The queen's fourth daughter, newly married to the Marquis of Lorne, had set a royal precedent when she persuaded her mother to allow her to attend modelling classes at the government-run National Art-Training School. The princess, who had since studied suspiciously closely with the Hungarian sculptor Joseph Edgar Boehm, was also exhibiting a plaster equestrian statuette of *Edward the Black Prince*. Ten paintings and the marble *Clytie* by Watts were on show in adjoining rooms; and Mary herself could be seen in Julia Cameron's display of nine photographs, notably, of Charles Darwin, Tennyson and *The Rosebud Garden of Girls*, each print on sale for thirty shillings.

Like Watts, Cameron and the Princess, Mary exhibited as an 'Artist' not under the auspices of the Art-Training School. She chose a Shakespearean theme 'Here Sleeps Titania Sometime of the Night' and a symbolic, up-to-the-minute 'The Land East of the Sun and West of the Moon (page 99) inspired by Morris's *The Earthly Paradise*.[216] In the East Gallery, avant-garde landscapes painted in the open air by two French refugees from the Prussian bombardment of Paris, 29-year-old Claude Monet and the elder Camille Pissarro, explored the effect of light on London's fog, mist and snow.[217]

Back on the Isle of Wight, Julia Cameron had linked her two cottages with a castellated tower.[218] Mary picked fragments of moss from the riverbank, sharing her sister's concerns for Edward, 'That very pain, how sweet it makes all this now', she thought. 'How it lightens for Christina the great weight of the long engagement'. Edward was with them, gregarious one minute, depressed the next, not unlike Mary's inner self. 'Such a lot of romance and purple hazy colour has gone away'. Even thoughts of her lost

love were pictorially tinged, except in black moments. 'I am groping so, & dreadfully out.'[219] Christina's *Song of a City*, dedicated to their time in Rome and with a nod to Christina Rossetti's *Goblin Market*, reveals the sisters' yearnings, their roller-coaster strivings for love and art, still unresolved. Moved to paint herself, she presented both picture and poem to Mary.[220] In June, Christina and Mary were invited to stay with the Tennysons at their new summer retreat, Aldworth in Sussex, and accompanied the laureate on his stroll over the North Downs. Hallam came to join them, fresh from his examination to Trinity College, Cambridge.[221]

After a couple of weddings – Henley Eden to Amy Frances Lennox-Kerr (the niece of Watts's late friend and patron, the Marquess of Lothian) and cousin Hugh Milman to Katharine Jardine – Christina and Edward were married at Sanquhar on 26 September. The tenantry and townsfolk of Forres gathered to present a diamond and pearl bracelet to the bride, with a speech hailing her literary achievements, continuing family tradition. In the evening, the Fraser Tytlers joined Highland friends – 'the grand turn-out of fashionables' – at the Northern Meeting at Inverness. Its write-up in the *Forres, Elgin, and Nairn Gazette* was superseded with an even grander flourish by details of Christina's wedding, the event of the season.

A floral triumphal arch, emblazoned 'Long Life', spanned the road from Sanquhar; flags flew above the coachworks, cabinetmakers, drapers, brewery, the station and the Inn along the route to St John's Episcopal church at Forres, where Bishop Eden, now Primus of Scotland, presided. As bridesmaids, Mary, her sisters and new sister-in-law Geraldine Liddell were dressed in luscious white muslin robes *à la polonaise* over embroidered silk and lace, with pink tulle bonnets. The bride wore clouds of tulle and lace flounces over her ruched satin gown. Her dazzling array of gifts included a Roman bracelet, Venetian mirror and Minton china bag and clock, all from Mary.[222] But as Christina settled down as wife of the rector of Wimpole in Cambridgeshire, a living offered by Edward's uncle Lord Hardwicke,[223] Roman angst pierced Mary's thoughts, however hard she prayed or gaily played.[224]

Mary lived for art and referred to her designing as 'work' yet described herself as an amateur. She had private means and did not need income from

employment. Her illustration work, for which she would not have been paid, was seen as an acceptable occupation for Victorian women. Ruskin's view that 'woman's true place and power' was in the home still remained the norm. But the campaign for women's right to vote was advanced in January 1872 with the first meeting of the Central Committee of the National Society for Women's Suffrage.

She had three illustrations for short stories published in the *Good Words for the Young Annual*: a pastoral scene, a young woman writing by candlelight and a blood curdling image of knights on horseback, one raising a sword above a prisoner tied by his neck. The Pre-Raphaelite artist Arthur Hughes was a fellow illustrator in this enterprise.[225] Mary advanced to become sole illustrator of *Fantastic Stories* by Richard Leander, the nom-de-plume of the German surgeon Professor Richard von Volkmann who

'Morning Tide'.

was later to achieve international acclaim for anti-septic wound treatment. Leander's tales of spiky heroism and romance, turning evil acts to good account and dreamed up at field-posts in war-torn France, deserted chateaux after the siege of Paris – had an Ossianic tinge that would have appealed to Mary. There is greater vigour in these designs and her figures fill the frame, but she needed greater understanding of the human form. Never a neat artist, she would not easily produce the painstaking copy from an antique cast required to study from life at South Kensington[226]

Mary found a telling poem for the title page of her commonplace book, 'Blue Wings' by George Eliot, the nom de plume of the novelist Mary Ann Evans, whose novel *Felix Holt, The Radical* had so impressed Watts that he

gave her a bronze cast of *Clytie*, delivered to her astonishment, by Burne-Jones and Rossetti:

> Warm whisp'ring through the slender ilex[vii] leaves
> Came to me, a gentle sound –
> Whisp'ring of a secret found
> In the clear sunshine mid the golden sheaves
> Said it was sleeping for me in the morn
> Called it gladness, called it joy
> Drew me on, "Come hither boy"
> To where the blue wings rested on the corn
> I thought the gentle sound had whispered true
> Thought the little heaven mine
> Learned to clutch the thing divine –
> And saw the blue wings smelt within the blue.

[vii] Mary substituted Eliot's original 'olive' leaves, for the ilex at Sanquhar.

SEVEN

I Felt a Hand

In October 1872, Mary joined the buzz of female and male students designing together at The Slade, the avant-garde Fine-Art School at University College in Gower Street, London. Their professor, Edward Poynter, was introducing the *atelier* practice he had learned with Charles Gleyre in Paris. Life study was encouraged from the outset. Watts's idealized nude paintings shocked prudes. But he saw the nude in art as supreme. Above all Titian, whose *Sacred and Profane Love*, which Mary would have seen in Rome, painted the sinful figure clothed, leaving Sacred Love exquisitely nude. Poynter's opening lecture encouraged students to enjoy freedom of expression, never to be swayed by 'the vulgar criticism of the ignorant'. With study from the living model paramount, Poynter changed the pose each day, setting a rigorous challenge to students. 'Do not copy, express form!' he urged. His guidance that 'Breadth and freedom come first and detail will follow' would inspire Mary's craft lifelong. Exhilarating stuff after the constraints of the national art-training system.[227]

Joined by one of her closest friends, Jane-Eliza 'Janey' Gordon Cumming, Mary may even have been lodging and travelling with Janey from Half Moon Street, off Piccadilly. Evelyn Pickering, a willowy seventeen-year-old, was determined to outwit her chaperone. Her hat flew off, releasing her hair to the wind as she ran down Gower Street to reach the Slade the moment the doors opened. Evelyn was one of the merriest, most talented students, among whom were her cousin, the sculptor Gertrude Spencer-Stanhope, Hilda Montalba, Mary Stuart-Wortley, Dorothy 'Dolly' Tennant, John Collier and his future wife Mary Huxley, Caroline Vyvyan, Mary Kingsley (Charles Kingsley's daughter and herself the future novelist

'Lucas Malet'), the cartoonist Leslie Ward, Mrs Emilie Barrington, whom Dolly described in her journal as a hideously ugly woman but very bright and clever,[228] and Kate Greenaway. Kate, two years Mary's senior, was already exhibiting her earliest watercolour images of children.[229] As young bloods flirted with daringly pretty girls behind their easels, Poynter's deputy, Francis Slinger slunk round 'Cupid-hunting'. For one lovesick youth, the girls prescribed a hearty game of rugger, so long as he did not break his painting arm.[230]

So amorous was the atmosphere that the sight of the late George Heming Mason's idylls of the Roman *campagna*, on exhibition at the Burlington Fine Arts Club in Savile Row, sent a thrill through Mary. 'I felt that extraordinary sensation, that some few pictures can give me . . . It is a physical impression, as well as a mental one'. Mason had painted his final masterpiece *Harvest Moon* in Watts's studio.[231]

Mary's hero appeared to her in a strange dream in June 1873. She was kneeling alone in a cathedral, when a vision of an angel appeared and seemed to lead her up to a high clerestory, almost level with the vaulted roof. The view was breath-taking: 'Down its long vista I looked & saw not form, though it was there, but the most marvellous harmonies of colour – only to be dreamt of – & could not help, from pure wonder going down upon my knees! – & the moment I had done so – I felt a hand – & it was yours, behind me *you*!', Mary would tell Watts during their marriage. In her dream, her hand reached out to his. She perceived love in his eyes, and they stood together in silent communion.

> Next day midst crowds you found me
> And I – I know whose bound me
> Heart, soul & all before God, even
> Be our parting here present
> Just this remain forever.[232]

By July she was back at Freshwater, seeing the Tennysons, lunching under the trees, riding in the dogcart with Thoby Prinsep's niece Annie and enjoying the spectacular Naval Review by The Shah of Persia, the first formal visit to Europe by a Persian monarch. His Majesty joined Queen Victoria, the

Prince and Princess of Wales, First Lord of the Admiralty aboard the Royal Yacht steaming up and down rows of flag-bedecked ships, the forts fired guns and the air was filled with smoke, a deafening historic sight.[233]

After her grandmother Dorothy died in the autumn, Mary spent a week with her sister Ethel in Bournemouth. She had very likely learned in Freshwater that Watts would be holidaying there too with the Prinseps, to recuperate from overwork. Little Holland House was to be demolished to make way for the new Melbury Road. He had chosen William Morris's Arts and Crafts architect Philip Webb to design a house at Freshwater for the Prinseps, and with studios for himself. Building had begun on The Briary, as it was named after the roses flourishing in its hedgerows, and Watts had been painting portrait commissions to pay for it. At the same time, he was carving monumental sculpture, advancing his national works and painting a portrait of John Stuart Mill, the social reformer hailed by the women's suffrage campaigner Millicent Fawcett. The *Globe*, if unconvinced by his symbolist work, hailed Watts's 'cunning' poetic imagination and stature as the portrait painter of the age. 'Art to him has been a mistress, not a slave and he has given to her at all times the best gifts.'[234]

No wonder that in *The Annals of an Artist's Life* Mary describes feeling very shy and proud when Watts came to visit her and Ethel to take them for a walk. Bolder now, Mary called on him at Trinity Lodge, 'I came to him with my tongue cleaving to my mouth with awe'. Like Tennyson, Watts was excited by artistic young women. He delighted in drawing their attention to the beauties in nature, poetry in the bare branches of the trees in villa gardens, and in the sea and sky. Mary marvelled at the sense of being in his unusual presence.[235]

In February 1874 the Prinseps took possession of The Briary, where Watts stabled his Arab mare and would ride over to the coterie and to Mary. He commuted, because although he liked to escape the winter fogs, as an artist working to commission and with Academy commitments, he needed a London base. For just another year he was allowed to work on in his old studios, while Little Holland House was pulled down around him. Val Prinsep sublet part of his large new garden for him to build a new Little Holland House at number 4 Melbury Road.

Mary's state of mind swung to and fro. In June she was still holding a candle for her lieutenant 'as different from all other men I know', yet she wrote in July that her days, seldom sad, were filled with work, her aspirations soaring as she quoted *In Memoriam*, 'Men may rise on stepping-stones of their dead selves to higher things.' Just months later, she writes that her heart is unsatisfied, her life unfulfilled.[236]

Her younger half-brothers Charlie, aged twenty, and Ted, nineteen, set out for India in March to start a coffee plantation at Ootacamund in the Neilgherry Hills. Before they left, Mary walked with Charlie up the hill at Sanquhar and he talked for the first time of her mother, held his half-sister in his arms and kissed her. 'Do you know Molly I love you so. If you had been my own sister ten times over I could not have loved you one bit better.' He gave her a ring of two hearts intertwined and said, 'Never take it off'. She prayed that her mother would watch over Charlie from Heaven. She would never see Charlie again.[237]

On holiday in Norway in August 1875, Mary determined that 'what I have learnt in a wasted past to make up by a fruitful future.' She would stay single and dream no more of happiness and love 'which was never meant for me.' Mary and her Slade colleagues were more than aware of their challenge as aristocratic single women expected to marry, rather than focus on their individual artistic careers. Watts and Leighton welcomed them into their studios. Watts invited them to revisit for guidance.[238]

Mary set about consolidating an informal apprenticeship with him. Her father had conveniently established new homes for their family close to him, both in London and in Freshwater for August and September, where she noted happily that she had seen 'Mr. Watts' several times lately. So too had Dolly Tennant, who had arrived at Little Holland House in April in an open carriage filled with her sketches to show Mr Watts, whom she too regarded as the greatest of all artists. Dolly called again in June. Each time he encouraged her to revisit; and Emilie Barrington called in July.

He came to see Mary at work on the portrait of her eldest sister Ethel, painting her in profile, sporting a jaunty hat for the Aldourie collection. Her frills and furbelows are loosely painted, to achieve Wattsian focus on the sitter's face. You can almost feel Watts standing by, offering guidance. The expression in Ethel's eyes hints at an inner warmth, but this portrait lacks the

real affection and literary strength of Christina's. Watts had now taken to wearing the famous red velvet skullcap made for him by Annie Prinsep to protect his head from draughts.[239] He generally dressed in grey, with a silk shirt, pleated frill at the wrist and a red ribbon tie, knotted in a loose bow and spoke in a quiet, clear voice. His unpretentiousness impressed Mary. 'It must be a wonderfully refined nature that can come to such greatness & remain so humble of his power – He speaks as if he were the merest beginner.'

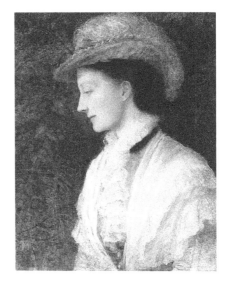

Ethel.

It had long been his habit to rise with the sun, to paint and sculpt until sunset. Watts would gaze out of the window, waiting for the sun to rise. 'He gets up at three, four or five in the morning & works almost all day. To Mary's astonishment he had begun and almost finished three portraits in the last week. No wonder he had been 'very fagged' when she last saw him, insisting, as ever, 'What is there to live for but work?' How sad, she thought. 'There is an excitement in work, one must restrain how closely a bad thing, lies by a good'. Watts was indefatigable.[240]

At the end of the month, Mary spent an entire morning in The Briary studio, where the Academician gave up valuable painting time to talk to her for hours on art. He explained his colour theories, the transparent colour that imbued his pictures with rare luminosity and discussed artists he particularly admired, always 'marvellously humble' about his own art. However, he dented Mary's enthusiasm for Gustave Doré whose theatricality he felt overpowered imaginative intent.[241] 'He thinks the mode of expressing mind through art – [the essence of his own work] is now dead'. It saddened Mary that the machine age had cast aside the concept of beauty in hand-crafted design. 'Wonderful as photography and many mechanical art productions are,' Watts argued 'to the human mind there is lacking something that makes them touch sympathy, something human, that the mark of the hand, the mind of the artist

leaves in a perhaps very inferior work of art'. Mary wanted it all. 'Men . . . have mastered comfort and convenience to the neglect of beauty may there not be a more complete state when both will be equally considered'.[242]

'All Freshwater was wailing' in October, when Julia Cameron uprooted her family to live in Ceylon. Until now, wrote Mary, 'Life seemed to hum like some big wheel round the Cameron household'. The photographer's invalid husband Charles, magically portrayed by Tennyson as 'a philosopher with his beard dipt in moonlight', yearned to return to his coffee estates. When called upon by his wife to pose as Merlin for her albums illustrating Tennyson's *Idylls of the King and Other Poems*, the velvet-robed octogenarian used to explode into giggles, creating havoc with the photographs. For years, he had never walked beyond his garden, until, all of a sudden he had commandeered his son's coat and walked longingly down to the seashore.

Dimbola bristled with Cameronian turmoil. The photographer provided for every possible contingency, including a brace of coffins. Mary's family had already left, but she heard of the crowds and chaotic scene at Southampton docks, with railway porters carrying away large, mounted photographs of Carlyle or the 'quite divine' Madonna Mary, pressed on them by the photographer. 'I have no money left but take this as a remembrance' – 'no mean tip!', observed Mary. With chocolate dark sitters in Ceylon bringing a timeless dimension to her oeuvre, the prescient photographer died just over three years later, her last word, 'Beautiful!'[243]

Mary sat under a beech tree and reassessed her emotional life in verse, her Roman candle flickering out at last.

> Oh past! I pray thee stir not in thy sleep . . .
> Lie with those leaves, red curl'd & crush'd as they,
> Where frosty silence binds regret away . . .
> . . . question no more my heart . . .[244]

An invitation to stay at The Briary in November drew her into the heart of Watts's intimate circle, the bosom of his gregarious extended Freshwater family who all called him 'Signor'. Sara Prinsep presided at the head of the luncheon table. With her plaited coils of dark auburn hair and rich loose robes, she looked to Mary like a modern-day wife of a Venetian

Doge – indeed, Watts had named her portrait *In Time of Giorgione*.[245] Her husband Thoby sat beside her, huge, erudite, laughing heartily. He had long been a stimulating companion for Signor. The two men would play billiards in winter evenings, though Thoby was now almost blind. Tennyson called every day to see him. Resting her hand lovingly on Thoby's shoulder was Julia Duckworth, the widowed, much photographed daughter of Sara's sister Maria. Next to her was Annie Prinsep's younger sister May and her stockbroker fiancé Andrew Hichens, then Annie herself, who was closest in age to Mary. 'And there was Signor, with a child on each side, as he could not be parcelled out to all the children clamouring to sit beside him too. He loved their company. There were Julia Duckworth's children, George, Stella and Gerald, the Prinseps' grandchildren, Rachel and Laura Gurney – and Blanche.

Signor had adopted Blanche, the orphaned daughter of Sara's widowed niece Mary and her late husband Herbert Clogstoun. Nine-year-old Blanche, her long blonde hair flying, had run across the room onto his knee, thrown her arms around his neck and won his heart. Naturally Sara supervised her care, but Signor would ever after consider Blanche, now thirteen, as his special charge. He encouraged her tomboy antics and despite working every daylight hour, loved to join in her romps.[246]

After luncheon, he adjourned with Mary to the studio. Less in awe now, she tuned into his 'serene sense of noble thought', watching the painter's concentration and his light movements as he worked on one canvas, then another, for the stimulation of variety. How she watched. When Sara's drawing-room visitors asked politely but with little interest to see the studio, Signor opened the door for them, but drew back behind it to hide 'a distinct shudder'. He returned Mary's sympathetic glance with a secret, wicked half smile. Her heart had leapt when he called out 'Mary', only to find that he meant Blanche's little sister, Mary Clogstoun.[247] Signor would still refer to her as 'Miss Tytler' and he was 'Mr Watts'. This first moment of intimacy entered not her heart, but Mary's artistic soul.[248]

EIGHT

You Do So*!*

'I think it is worthwhile marking down that last month in Edinburgh I made the acquaintance of a great man'. For a spell-binding moment in March 1876, Mary was diverted by one of the most mercurial members of the Royal Scottish Academy, George Paul Chalmers. Courteous, sensitive and impulsive, his emotions veered from elation to depression, depending on the state of his art. At five foot six, he was not much taller than Mary. His expression of eager, childlike innocence was enlivened by clear blue eyes, a long wavy moustache and hair flying about his bald crown. Chalmers could not paint in placid contentment. He adored women and habitually fell in love with his sitters. This all-embracing, Platonic love was linked to their beauty, but as he bared his soul to them, he worked himself up into such rhapsodies that one young lady refused to sit.[249] Not Mary. How could the spiritual, passionate highlander fail to respond to the Scottish Academician just sixteen years her senior? She sat for her portrait in his studio at 51 York Place in Edinburgh, sitting five or six times, beneath its golden half-dome and was transfixed from the first.

> I have known a feeling like it, after a meeting with one person, (there is I suppose only one in the world for each, who could excite it) – I was exhausted – happy, out of myself. It is a curious mystery how strong the similarity is between Love & Art – I believe a picture must be specially poetical to have this influence, it is so for me certainly. I have never known a picture of Millais give it to me.
>
> Mr. Chalmers has two exquisite first thoughts for pictures, they felt to me like songs of Keats or Shelley – some marvellous portrait one of a woman (*Miss Paton*) better painted than any modern female portrait

I ever saw, but of course it is difficult to draw just comparisons unless one saw them hung together – Millais is the only man that it occurs to me to compare to him.[250]

But it was the *chiaroscuro* and loose brushstrokes of Rembrandt that inspired the Scotsman, who would concentrate delicate brushwork on the beauty of ageing heads, ringed with wisps of silver hair and transfigured by light, as in the portrait of the Dundee jute merchant *John Charles Bell* which Mary saw in his studio. She herself sat in three-quarter profile on a red velvet bench that appears to melt into the brown background. She is muffled from head to toe in black, with a red scarf loosely falling from her neck. The artist softened the line of her chin. One can sense the passion with which he laid on the impasto, to focus light upon her brow and spikes of auburn hair escaping from her fur hat, while her face radiates inner joy and contemplation.[251]

Mary began to compare Chalmers' male portraits to those by Watts and Titian versus Van Dyck. Inspired as ever by Signor, she did feel strongly drawn to the Venetian, yet objective enough to be critical. 'I feel in them a dignity and refinement and such colour as I can see in no other school. Watts does not always succeed as they do in colour but he has their other elements.' Unlike her growing relationship with Signor, Mary knew that her new-found intimacy was purely that of a sitter to the Scottish Academician, who was himself naturally drawn to her ancestral portraitist. She was making copies of the Raeburn portraits of her ancestors at the time. As much as his artistic intellect though, the Highlander appreciated his healthy enthusiasm for golf.

> 'Of course I do not know him but he gives me the impression of having a finely sensitive nature, great enthusiasm, strong likes and dislikes, but with no prejudice, a large and liberal mind, a man with high theories about his life and acting up to them. His physique seems in good balance with his mind'.[252]

The warmth of her feeling for Chalmers, as indeed for Watts at this stage, was not amorous, but the emotional and intellectual uplift these master artists inspired. As it happens, both men enjoyed healthy sporting activities that appealed to the highlander. But within two years, Chalmers was dead, aged only 45, amid rumours of murder – or was it? At an Academy dinner he was

92

heckled during his toast to the late French landscape painter Jean Baptiste Camille Corot, took offence and dashed out into the night. He was later found unconscious, with head injuries, and lying in a pool of blood at the bottom of a flight of steps in Charlotte Square, half a mile away. His hat, watch and money were missing. Chalmers never regained consciousness. As news of his death flashed across Edinburgh, colleagues dashed from studio to studio to find out whether he had been pushed, mugged or murdered. A question was asked in Parliament, the mystery never resolved.[253]

Mary had designed an unusual gift for her first visit to Signor's new Kensington studio on 24 May. Signor had commissioned the architect Frederick Pepys Cockerell to build the new studio home, also named Little Holland House at 4 Melbury Road. Here tall windows reached up to the gabled roof of the double-height studio, heightening the luminosity of his pictures. And at the end of his 49-foot painting studio was a special place for the Pre-Raphaelite painter Edward Burne-Jones. There was no dining-room or drawing-room, just three bedrooms. He did not care for fancy wallpapers or decoration – all he wanted was a large workshop to house art.

Until now Mary would have brought paintings, in oil or watercolour. What had changed? She left no detail as to what aspect of her artistic progress surprised Signor. 'Dear Miss Tytler, I did not half express my thanks for your very beautiful present, indeed I did not know how admirable it was till I came to examine it.' As he also said to her Slade colleague Dolly Tennant, 'I hope you will let me do anything I can that may be of use to you and that you will come and see me as often as you may feel any interest in what I may be about'.[254] Mary's gift coincided with a dynamic new development in her art.

The French sculptor Aimé-Jules Dalou had been a curator at the Musée du Louvre under the naturalist painter Gustave Courbet, the modernising member of the Paris Commune Federation of Artists and had fled as a political exile to London. His comrade Alphonse Legros had set him up with lodgings and introduced him to a network of artist friends and patrons. Dalou had instantly made an impact, from his first experimental terracotta sculpture, *French Peasant Woman Nursing a Baby*[viii] exhibited at the Royal Academy in 1873. This monumental version was bought by the stylish

[viii] 1873, Victoria and Albert Museum, London.

wealthy artist Sir Coutts Lindsay; and two smaller replicas were bought by South Kensington Museum and the future Tsar Alexander III, who came to his studio at 217a Glebe Place, Chelsea.

Dalou brought a new contemporary realism to sculpture. He was a virtuoso modeller. Electrified by his demonstration at the Slade or privately, at Glebe Place, students felt liberated by his methods. Dolly found his studio lowly, but very rich in genius. Dalou was the most dynamic sculptor of the day. A striking figure with a long fine nose, he spoke little English, and so communicated with his hands. 'You do *so!*' he would cry, rapidly building up sculptural forms and waving his arms around with Gallic passion, to show how sculpture came from the heart of the clay, rather than the surface.

He had been creating a series of terracotta statuettes of peasant women praying, nursing babies or cradling children, when Mary grasped the opportunity for private lessons with Dalou. The tender expression of his peasant women is apparent in her own terracotta statuette *Mother and Child*. Her smooth vividly shaped flesh contrasts with heavily squeezed modelling creating shadows in the drapery behind, which make the piece particularly interesting. Unusually, it is not signed with Mary's 'MFT' mark, which could suggest the hand of another creator, the master demonstrating to his pupil as she modelled the clay. Her composition of a seated young woman resting her chin in her hands combines the influence of Signor – multiple drapery folds contrasting with a clear expressive face – and of Dalou, working the clay, as it were, from within.[255] This new medium may well have been the artistic advance that encouraged Signor's invitation to Mary visit as often as she liked.

Mother and child.

Guiding starstruck young women artists in the privacy of his studios provided joyful distraction for Signor, who was belatedly negotiating terms for his divorce from Ellen Terry. His wife had been living in the country with the designer Edward William Godwin, with whom she now had a daughter and son. She had returned to the

stage and as she rose to fame he left her. The actress wished to remarry.

Marriage was dominating family life for Mary. Her sister Christina was combining her literary career with Edward's new living as rector of the factory-blackened former pit-village of Jarrow on the foetid waters of the river Don, in County Durham – a far cry from his family estate Ravensworth Castle[256] and the wedding of the youngest Fraser Tytler sister. Eleanor's marriage to Lieutenant James Kellie McCallum of Braco Castle in Perthshire took place on 12 July. Echoing the pretty bride in ivory, Mary's dress as bridesmaid was of muslin trimmed with silk damask and wreaths of brambles and berries; and on her head she wore a 'Charlotte Corday' mobcap with pleated frill, reminiscent of the French eighteenth-century assassin of the revolutionary Jean Paul Marat.

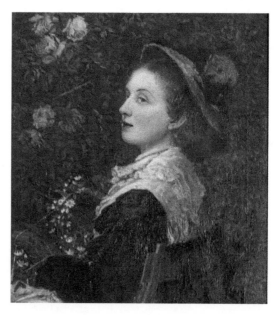

Eleanor.

Her portrait of Eleanor displayed in pride of place among the wedding gifts won Mary her first critical success. The bride was painted in half profile in the garden. Eleanor, her face flushed brighter than the roses behind her, wears a jaunty straw bonnet over her golden hair, heavy leather gloves and an amber necklace lies loosely over her gossamer fichu. To the *Forres, Elgin and Nairn Gazette*, the portrait's 'admirable and truthful

execution reveals the hand of a true artist.' The reviewer was struck by the sitter's speaking likeness, the delicate yet rich colouring and overall glow of the picture. 'Such studies would be well worthy of an honourable place along with the productions of many of our Royal Academicians'. Mary, barely able to contain her excitement, simply quoted Cardinal Newman, 'Keep thou my feet; I do not ask to see'[257] – until her phantom re-emerged from the shadows in December.

Mindful now of Hannah, the barren woman who prayed for a child and gave him to the synagogue, Mary cried out into her commonplace book, praying 'for the one special selfish desire of my life.'[258]

> As Hannah was not upbraided with the selfishness of her desire, nor even told to turn her eyes from her own small sore spot, to the great mounds of others, I too may trust the same pitying Love. Only, I would fain pray Thee for courage to bear the answer. Grant not my prayer in anger. Hold my weak heart in Thy strong hand, so that neither the greatness of joy, nor the bitterness of disappointment, render it incapable of doing its work for Thee, & filling its place in Thy great schemes –

Whether Mary's despair concerned the discovery that she could not now bear children – was her Roman philanderer the cause – or was she perhaps praying for Christina who had not given birth, it would take months to lay the ghost. Art was ever her most effective distraction. What better than the wondrous opening of the Aesthetic Grosvenor Gallery, the harmonious display of fine and decorative arts set in Sir Coutts and Lady Lindsay's Italianate *palazzo* at 135 New Bond Street. Designed to counteract exhibiting conditions of the Royal Academy, the Grosvenor opened on 1 May 1877.

The first day its Palladian doors opened to the public, 7,000 people walked through the green marble vestibule and to find in the first-floor galleries 'a series of modern pictures never before so seen'. Mary marvelled at the revolutionary arrangement that enabled viewers to appreciate the significance of each painting. Unlike the Academy's 'conflicting voices', each artist's works hung in a harmonious, spacious group on walls of crimson silk damask from Lyons, separated from the next by pilasters from the old Paris Opera House. Minton glass globes and Japanese china stood on marble

tables and there were exotic plants and sumptuous velvet couches, all displayed with exquisite taste. Mary felt privileged to be there, grateful that *avant-garde* English art was at last being revealed to the public. Happy to acknowledge that the star of the show was Burne-Jones, she was thrilled that 'those who had cared to search the Academy walls, season after season, for the work of George Frederic Watts, usually to find a portrait here and a portrait there [now] hailed their master for the first time to a larger public.'[259] Rossetti, though a friend of both Watts and Burne-Jones, had refused to exhibit with Academicians.

Signor's portraits of Burne-Jones, of Blanche Lindsay playing the violin and of Madeline Wyndham standing in a sumptuous sunflower dress, a pot of magnolia at her feet, characterized the cultured atmosphere that would epitomise the Grosvenor and its sparkling aesthetic clientele. The magnolia symbolised Madeline's superabundant nature. She herself painted in watercolour and with her husband Percy collected contemporary art. They had just commissioned Webb to design Clouds, their famous palace of art in Wiltshire.[260]

Mary's trophy as she entered the Grosvenor's West Gallery, was to find Signor's *Love and Death* dominating the room. In this compelling picture – so different from the usual skeletal images – a tall, robed figure in grey is seen from behind with head bowed, climbing the steps into an open door which a naked broken-winged boy attempts to shield, but he cannot prevent the inevitable and roses are falling at his feet. Twenty-two-year-old Oscar Wilde, astonished by Watts's 'marvel of conception' saw *Love and Death* as a masterpiece 'worthy to rank with Michael Angelo's "God dividing the Light from the Darkness."'

Among the women artists exhibiting were Lady Lindsay, Princess Louise, the Countess of Warwick, Evelyn Pickering and Marie Stillman, née Spartali, these last two painting in the Pre-Raphaelite style. Marie, having modelled for Julia Cameron and Ford Madox Brown, was now sitting to Rossetti. Evelyn's *Ariadne in Naxos* showed the influence of Watts and his former pupil, her uncle Roddam Spencer-Stanhope. Princess Louise, who had trained with the Hungarian sculptor Joseph Edgar Boehm and recently with Dalou, exhibited her Arthurian clay group *Geraint and Enid*.[261]

While Mary herself did not exhibit at the Grosvenor, she was spreading her wings. Painting on porcelain had become a craze amongst amateur and professional artists exhibiting at Howell and James Galleries in Regent Street. Mary designed a circular portrait of Christina holding a lily, against a background of passionflowers.[262]

Records of Mary's life at this stage are limited to private torments and family tragedy. She was in Paris, staying at 55 Avenue Josephine with her stepmother and brother Will who had just left Eton, when on the morning of 24 September, Harriet received a heartrending telegram from Ted in India, saying that 22-year-old Charlie had been struck by typhoid fever and was dangerously ill. Advances in telegraphy were speeding up communications. Almost at that moment, Alexander Graham Bell was demonstrating his new electric telephone in Bishop Eden's drawing-room at Hedgefield House.[263] Thanks to the new telegraph cable, the Fraser Tytlers were able to share hopes and fears across continents at this critical time. Bell's telephone would be on display at the upcoming Paris Exposition Universelle, in preparation for which Mary would have seen Juste Lisch's colourfully tiled and glazed railway station, flanked by passenger pagodas, rising in the Champs de Mars.

But for worry about Charlie, her family would have felt compelled to see the actress Sarah Bernhardt perform Racine's *Andromaque* at the Comédie Française. In November, the month Signor's divorce was finalised and Ellen Terry married the actor Charles 'Kelly' Wardell, Bernardt's landmark performance in Victor Hugo's tragedy *Hernani* established her as the foremost actress of her time, sketched in the role by Gustave Doré.[264]

News came that Charlie had died. The funeral was to take place immediately, even more tragic for his mother and Mary who could not possibly attend. Stupefied by shock, Mary felt neither pain nor love. She took some comfort from the spirit world: 'Is he not nearer to us than ever – he will not change or face – we shall meet him still . . . & look into his beloved eyes'. In her moving record of Charlie's last days, she describes how their cousin Leo Torin is with them staying at Silks Hotel. They had been to the Viceroy's reception and as Charlie stood buttoning on his great coat, he said to his fiancée Edith Selwyn, 'I think I am going to be very seedy, darling, but I know you will pray for me, so I shall be all right.' Ted and Leo had looked after him to the last.

'East of the Sun and West of the Moon.' Detail of fan 1871-77.

Mary designated her fan *East of the Sun and West of the Moon* to symbolise her late brother dreaming of his fiancée. In a richly painted woodland setting, with a glimmer of sunlight on the left and greater moonlight to the right, a medieval highlander lies at the feet of the bride. He appears to be asleep, but the inscription reads 'waking to the life full satisfied'. Her composition shows the cosmic influence of Watts, with hints of Burne-Jones, Puvis de Chavannes and Gustave Moreau. Ted arrived back from India in March 1878, with the double-heart ring from Charlie's hand and a sprig of heather from his grave, which Mary sewed into her commonplace book. She designed a surround for the ring, inscribed it 'God encompass thee' and wore the ring over her heart.[265]

Aldourie became Mary's father's chief residence after his brother Bill's death in September; and he would bring his family up to London for the Season. At some point in her early career, according to her niece, Mary put aside her art to care for a sick nephew. This may account for the gap in her records.

'My darling new brother', she wrote in November 1879, very likely meaning Leo to whom she was giving sisterly love after the loss of Charlie and showering him with blessings in her commonplace book. Leo was a

keen golf player. He kept a yacht on the Beauly Firth, played golf and went
hunting in winter. Just how close Mary was to her younger cousin continues
to raise questions in her family. With this declaration she doubted that he
would maltreat a loving young woman:

> But not that you betrayed a trust
> Broke some girls heart & left her to her shame
> Rose by deceit on credulous mobs to wealth & fame
> Waxed rich while good men waned by lie & cheat
> Cringed to the strong oppressed the meek
> When men say this may some find voice to speak
> Though I am dust – [266]

Is this what happened to her in Rome? Certainly James Graham-
Montgomery had led a louche life. Mary's affection for Leo was warm and
loving, but fraternal, transcending the complexities of her Roman experience.
His letter to Mary a week later, signed 'Lot' and preserved by her, recognises
that sweet as she is towards him, she cannot return his deeper love:

> My Sweet & Bonny
> I meant to answer your letter before, but the grand principle of my
> life intervened and I put off doing so till I could send you your ring,
> – I hope you will like it. I think it uncommon and I liked the twist idea
> (intertwining not appetite) but I fear that it is in no way appropriate, for
> you wont love me as I most wish to be loved, and as regards the metals
> neither typify me, some valueless and corroded substance should have
> been introduced but I know it would not blend with your sweetness –
> God bless you my darling. – I don't know if knowing you makes me a
> worse or better man, worse I fear
> Your loving
> Lot

Always a dear friend and cousin, Leo left for Ceylon to start the Aldourie
Tea Estate. The next we hear from Mary is of her father's death from a throat
abscess on 30 January 1881. 'At a little before eleven o'clock my darling Father
left this earth.' She had shared his spirituality, his social conscience and

multi-cultural interests, upon which she would draw, as well as his apocalyptic theories, for her future decorative work. Meanwhile, her cousin Katharine Fraser Tytler, continuing family links with Scotland's literary heritage, carved a figure of Constance from *Marmion* for the Scott Monument in Edinburgh.[267]

Mary's studio at Sanquhar was crowded with canvases, mostly portraits, a richly carved chair towering above an oriental nursery chair, tables of ceramics, jugs with dynamic handles, a vase of flowers, a small sculpture of a woman and rugs from India. Photographs in the family game book show light flooding in through the open glazed door towards the adjustable mirror, which stands as an aid to her art. On the easels in one photo are pictures of a young girl and a country scene; and in the other are a monumental basket of wildflowers and her own aristocratic self-portrait painted that year in oil (front cover), showing Mary in a soft, loose-fitting white dress, with briar-roses at her back and breast, within an ornate Aldourie frame.[268]

Mary kept an eye on Aldourie while Harriet lived at their London home, 68 Cornwall Gardens in Kensington, with their growing family, Ethel, Eleanor, her husband James and their daughters, three-year-old Dorothy and Gwendoline, two. Mary made Aldourie 'bonny' for Ted's homecoming. 'I put flowers on Pappy's grave, & felt as if when I put flowers in the house, they were on the grave of my beloved's need of me … God bless them both.'[269]

Studio at Sanqhhar.

News of the new laird of Aldourie's engagement to Edith Selwyn, Charlie's former fiancée, brought gifts of a goose, an old spoon and a pot of magic gruel from their highland witch Nean-a-Charier. Mary was to be a bridesmaid for the third time at their wedding at Edith's family home, Selwyn Court in Richmond, Surrey. Her late father Sir Charles Selwyn had been Lord Justice of Appeal.

There was a glittering lack of decorum at the church, with guests standing on seats, sending hassocks flying for a better view of the wedding party and the latest fashions – cloaks, gowns and bonnets in stunning silk and velvet of ruby, claret, gold and dark peacock blue. Mary wore a lace coiffe and gold satin brocade Watteau gown, over a lace skirt. The stupendous array of wedding gifts at Selwyn Court included a C-spring brougham, diamond earrings, an ivory parasol and girandole from Ethel, Christina and Mary and a couple of polo ponies from Edith's brother.[270] Ted and Edith would name their first-born son Charles. Mary was now spending more time in Kensington, to take full advantage of artistic opportunities and Signor's unprecedented celebrations.

NINE

Mary Declares

Watts's visionary pictures were so unlike the art of the day that the Academician extended his house to display them to the public. From the summer of 1881, Little Holland House Gallery was open every Saturday and Sunday afternoon, so that strangers or friends could wander in after their stroll in Kensington Gardens.[271] Mary seized every moment to absorb what she felt to be the best influence on life; and when 'The Collection of the Works of G. F. Watts, RA' – the first major retrospective exhibition of a living artist – opened at the Grosvenor Gallery on Saturday 31 December, she was thrilled to see his reputation soar. The grandeur of his pictures *en masse* made an astonishing impact.

Whether his 'painted poems' addressing issues of Life and Death aroused admiration or suspicion, Watts was seen as England's most visionary modern artist. Mary was drawn back again and again to the Grosvenor, making pencil sketches in her catalogue, of his portraits of Lady Garvagh and of Joseph Joachim playing his violin by moonlight. Surrounded by his paintings, she felt invigorated and proud. Mary introduced friends to Watts's works. She longed to congratulate him and even called at Little Holland House, only to find the Academician away, escaping the winter fogs. On 14 March 1882, writing from Sanquhar, she sent an intimate declaration of happiness and wellbeing in the presence of his art.

> My dear Mr Watts,
>
> I was so very sorry that twice when I have been in London lately for a few days this winter, I found that you were at Brighton, and I hope you won't mind my troubling you by writing to say so, because if I had seen you I should have tried to tell you a little of what my pleasure has been in seeing your triumph of the Grosvenor Gallery –

Besides having the happiest hours myself there, learning to know your work, and love it even better than ever, I have also had the pleasure of taking others there, and seeing it become known and valued by them in a degree that could only be from such an exhibition as this.

I have long perceived that whilst before some great master's pictures I feel wonder, before yours I always feel *better*, and lately they seemed to me more full than ever of those things which ought to do one most good –

It is rather conceited my venturing to say even this to you, when you must have had all the greatest of England thanking you worthily for your great and good work but I have also a feeling that you are too great not to be pleased to give pleasure to the least, and so I have told you of mine.

Always yours gratefully

Mary Fraser Tytler[272]

Watts, who was by now back in Kensington, replied in kind, with growing familiarity, and invited her to show him her latest work.

My dear Miss Tytler

I think I am old friend enough and certainly am old enough in years to say My dear Miss Mary, or indeed, My dear Mary without the Miss! Your charming letter has given me great pleasure. To accept all that you say as deserved is out of the question but I can accept it as felt by you. You say that which is most flattering and delightful to me, viz that my pictures awaken higher thoughts and feelings than is always the case even with some of the best. This is indeed what I would hope, not that I intend to be didactic but simply to affect the mind seriously by nobility of line and colour even as music that one does not put definite words to is capable of moving the hearer, this has hardly been the aim, I mean the self-acknowledged aim of any painter as far as I know, and so may be considered as a line of my own. Though I dare not flatter myself that my success is very complete, still I have many pleasant proofs that I have not altogether failed, I regret not having been able to do more and feel sadly disheartened and find that even the comparatively trifling efforts I have been able to make sadly knocked me up.

I am very sorry that I was not in town when you called, but hope you will be coming to town later and that you will bring me something to see.

Yours affly

G. F. Watts[273]

104

Mary would have taken full advantage of this 'priceless' invitation. Her self-portrait painted in watercolour, signed and dated 31 March 1882 (see page 111) is more workmanlike than her earlier decorative floral portrait. She presents herself in her brown painting jacket, a serious working artist.

Her brother Will was set to join the expeditionary force under the command of Sir Garnet Wolseley in the Anglo-Egyptian War, when victory was declared at Tel-el-Kebir on 13 September. The Highland Brigade had approached Egyptian positions under cover of darkness. There was a blaze of gunfire, the bagpipe players struck up and the Scots regiments, among them Major James Graham-Montgomery, charged the Egyptian defences. The Battle of Tel-el-Kebir was decisive. Noting in her commonplace book that 'The war is over or almost so – already everyone's heart but the few poor stricken ones is happy again', Mary added that:

> In mine I feel certain thoughts dropping slowly to their grave at the bottom of my heart. Something stirred from the depths of a well. I return there – he forgotten again. I am glad, for they don't come to the top without bringing me much pain.

She sprang into action. 'No one I think could guess my thoughts, for I was strong, though weak enough to obey an overpowering longing to send one message – without name or trace & so it went on a knife "God encompass thee" – I don't know how I dared do it but the hope that it might raise one better thought made me.'[274] That impulsive gesture exorcised her demons.

Little Holland House gave Mary a spiritual uplift, higher than she had ever known. She became increasingly drawn to Signor, his visionary ideas of Love, Life and Death transcending formalized religion to embrace all creeds. He lived in the care of his housekeeper Emma Graver and valet Alfred Coleman, in an atmosphere of elevated simplicity that could seem quite awesome. Haunted by the shame of his marital breakup, he had endeavoured to avoid Society except in relation to art, and so was seen as an almost reclusive sage. A new formal portrait by Alexander Bassano now presented the Academician as a commanding figure, his head crowned by the Italianate velvet skullcap. Here he sits upright, his wide-open cloak giving the impression of an expansive figure, while slightly bushy silver eyebrows, moustache and beard give a jaunty touch to his fine features.

Cannily, Signor allotted female visitors specific timeslots so that each – whether it be the Prince of Wales's mistress Lillie Langtry or the Academician's proprietorial assistant and neighbour, Mary's erstwhile Slade colleague, Emilie Barrington enjoyed special private attention. Of real significance to both, he had resumed secret communication with Ellen Terry, who had risen to become Britain's most celebrated actress. She dearly valued his communications yet refused his desire to meet. When Mary asked to see Signor, his reply on 25 October 1883 was warm, but calculated: 'My dear Mary, I shall be charmed to see you on Saturday morning, but let it be as soon after 10 as possible as I have an engagement at 11. I shall be ready to see you any time after 9'.

Charles Fairfax Murray,
Emilie Barrington.

Every day thereafter that autumn and winter, Mary could be found copying a portrait at the Little Holland House Gallery. James Beadle, the Prinseps' cousin and future military painter, was also in the gallery, preparing his first Royal Academy picture. It was an exciting time to be around Signor as he experimented with broken prismatic colour to achieve ever more mystical effects. Mary reveals her joy at working closer to the master, in a quirky letter to Hallam Tennyson, warmly reminiscent of their Freshwater camaraderie. Writing on 5 December from her stepmother's new residence, 68 Eccleston Square in Pimlico, she congratulates the poet's son on his engagement. 'I am not quite sure that I am very glad that you are going to be married and shall always think of you as quite nice enough as you were (single or unique).' She has heard that his fiancée Audrey Boyle is 'charming' and thinks Hallam *'very* uncommonly lucky'. Mary compares their happiness to her own, having 'somehow wormed myself in to the Gallery at Little Holland House' visited by Signor two or three times in a morning. 'I ought to go back to my own studio a good deal wiser, & certainly for the present it is most delightful.'[275]

She was in the Gallery when a wealthy young American walked in. Impressed by Watts pictures on show at the *Exposition Nationale de Peinture* at Galerie Georges Petit in Paris, Mary Gertrude Mead had come to persuade Signor to exhibit his work across the Atlantic.[276] What Mary Fraser Tytler didn't see was how the American used her female wiles on their hero; and while Gertrude wooed Signor with flowers, he was struck down by rheumatism and neuralgia and so arranged for Emilie Barrington to entertain her.

Mary was becoming daily more enraptured, 'I think my fear is all gone, what I feel now is only reverence'. Boldly, she declared, 'Signor, I think I have been looking for you all my life'.[277] Whatever did he think? The realisation that she had found her perfect partner in life was momentous for Mary. On New Year's Eve she thanked God and prayed to use this gift for 'the highest possible good'. The thought of 'standing in the light of its full radiance' after all her struggles. She would never let it go.

> I have longed often for what seemed unattainable, a human sympathy to lean upon both so sure & steadfast . . . a Love strong & deep yet absolutely pure & unselfish – A wise adviser, because absolutely in perfect sympathy – I have found this longing satisfied . . .[278]

Watts was a giant of the age, friend and colleague to the greatest thinkers of the day. He loved to advise, share philosophical thought as her father had done. He was free to marry, but to Mary? Signor was adored rather than desired by women, not least his protective assistant and neighbour Emilie Barrington. Mary's declaration must have taken him aback. Her religious fervour cannot have been to his liking. She was attracted to his spirituality, but if he described himself or his art as religious, he meant in the universal sense. Ever a gentleman, Signor did not disillusion her, though, aided and abetted by Mrs Barrington, his interest was directed across the Atlantic. Gertrude Mead was determined that his art should be introduced to the Americans, where Ellen Terry was now touring with Henry Irving and the Lyceum Company. While Gertrude ramped up her endearments and efforts on Signor's behalf from New York, Mary remained resolute. Her longing was satisfied. Signor had the qualities she needed for a life partner.[279]

A human sympathy to lean upon so sure & steadfast, it frightens me to feel how much I lean like the strength that should only come from the Divine, is what I feel – A mind so broad & insight so far reaching that there is no small or great difficulty in my life that I should have to tell him, & for which he would not have some simple words, so true, so direct & to the point, that they would become a power in my life . . . And the love? That I give, great & strong, out the depths of my heart.

That Mary Fraser Tytler, an 'amateur' artist of aristocratic birth, with social reforming zeal in her blood, as yet unfulfilled, considered herself as a loving life partner for the Academician shows visionary pluck. She knew only too well, that she was 'just one amongst the great stream of human hearts . . . on whom he looks with a great impersonal love, whose sorrows & cares he would like to soften with infinite tenderness . . . Ah me, I shall never look upon another human being at all like him – it's *genius* all that that great word includes, & with what it rarely joins, a most lovable personality'.[280]

J. P. Mayall, *G.F. Watts in his Gallery*
at Little Holland House, 1884.

In February 1884, Mary brought her sister-in-law Geraldine Liddell to Little Holland House, to play the piano to Signor. Sunlight streamed in through the studio window over the glowing colours of his canvases. Music flowed through his life and work. Having been born above his father's musical instrument workshop, he infused his art with a sense of musical harmony and line. The finest musicians of the day had played and sat to him, and he was famously photographed by Julia Cameron with his violin in *The Whisper of the Muse*, though he no longer played himself. Gerry began with Beethoven and Bach, and at the first pause, he dashed across the studio, crying, 'She's full of music, she's full of music.' To please Mary, she hummed 'My Faithful Johnnie'. Signor liking her unaffected sound so much better than the bravura of vibrato, invited Mary to bring Gerry back. They brought violinists, a quartet, and he welcomed them all to 'Paradise Row' as Gerry merrily called Melbury Road.[281]

Gerry was a bridesmaid at Hallam Tennyson's wedding to Audrey at Westminster Abbey on 25 June. It is more than likely that the huge congregation headed by the Poet Laureate, the Prime Minister William Ewart Gladstone and the poet Robert Browning, will have included Mary, Signor and, though separately, Ellen Terry who was now back at the Lyceum, starring in *Much Ado About Nothing*.[282]

Making a mark across the Atlantic, Mary's golf-loving cousins George Grant and Leo had returned from Ceylon to set up what was to become the first golf course in America, Oakhurst Links in West Virginia;[283] and Gertrude's momentous efforts for Signor had paid off. On 1 November, the Metropolitan Museum of Art in New York opened their 'epoch-making' first exhibition of a living artist, *Paintings by G F Watts RA*.

Mary, as an unmarried woman with no real social role, would have been regarded with pity by some Victorian contemporaries. But now that she had found Signor – even though he did not reciprocate her love – her angst vanished from her commonplace book. She had established a studio in Bloomfield Place in Pimlico. Her note in July reflects Watts's seminal universal subject *Love and Life*, in which the angel of Love guides the fragile naked maiden up the rocky path of Life. As the figures climb higher up the mountain, the atmosphere is bathed in golden light, or as Mary put it – perhaps quoting Signor – 'the air is purer, we are nearer heaven'. For now, he was but the Spirit of Love guiding her towards the light?[284]

TEN

Emerging Craftswoman

By the winter of 1884 Mary had found a social purpose for her design work in London's East End. To cheer and educate impoverished parishioners in the slums of Whitechapel, the Reverend Samuel Barnett and his wife Henrietta had been holding art exhibitions in the schoolrooms of St Jude's Church throughout the eighties. Watts was a major exhibitor. The revival of interest in craftsmanship inspired by Ruskin, Morris and urged by Signor had led to the foundation of the Art-Workers' Guild as a meeting place for architects and designers to encourage the unity of fine and applied arts; and also to the new design aesthetic espoused by *The Century Guild Hobby Horse*, the journal of the guild founded by the architect and designer Arthur Heygate Mackmurdo. Morris had designed a radical colour scheme for the interior of St. Jude's scarlet pillars – apple-green stencilled walls, and curtains of red and gold, recently completed under the direction of the architect Charles Harrison Townsend.[285]

Mary went with a friend who ran a mosaic class, while she herself started teaching clay-modelling in the evenings at a boys' club in Whitechapel. The idea was to stimulate the boys' interest and experience the pleasure of making things in their leisure hours. Her students were chiefly 13-16-year-olds who had spent all day blacking people's shoes.[286] Since the 1870 Education Act, school boards were obliged to provide free elementary education for 5-13-year-olds. Even so, starving, abandoned children would evade school to beg or earn in order to survive.

Shoe-black Brigades were founded for the opening of the 1851 Great Exhibition, initially to clean the shoes of overseas visitors. Destitute boys from the Ragged Schools were given uniforms and equipment and sent out to earn their living by cleaning shoes. Under the umbrella of the union

headed by the Earl of Shaftesbury, the Ragged Schools provided free education and sanctuary for abandoned children – 30,000-40,000 were reported in London alone in 1885. Their object, to elevate wild children out of poverty, introduce them to the Gospel and inspire a constructive, self-reliant spirit, impressed a burglar, who urged Lord Shaftesbury to 'keep hold of the little 'uns; you can't help us, we're too far gone, but save the little 'uns.'[287]

This was just up Mary's street. The Shoe-black Brigades saved hundreds of boys from a life of neglect, crime and prison. They worked hard to earn not only their keep, but savings for the future. After the age of sixteen, they were expected to move on. Businessmen having their shoes blacked would notice, even take on an eager, useful lad. The sixty boys at Mansell Street, the old Shoeblacks' Home now run as a self-governing hotel, wore blue jackets and brought in over £2,000. They rose at six for breakfast and prayers, worked all day at their blacking stations, returned at six in the evening, washed, had tea and classes from half past seven until nine.[288]

Mary was a natural teacher. How the boys must have felt as she explained not only how to model the clay but opened their minds to the symbolism, to the meaning of each object or pattern they were modelling. A socialist with a passion for adventure. the idea of awakening deprived lads to the joys of creativity, gave her a vital sense of purpose. Twice a week, she left her elegant Pimlico house and travelled with a friend who ran a mosaic class, to the grim, overcrowded slums of the East End, past beggars, ragged children and prostitutes, to model clay with her lads.[289] Their classes soon came under the umbrella of the amateur craft revival enterprise, the Home Arts and

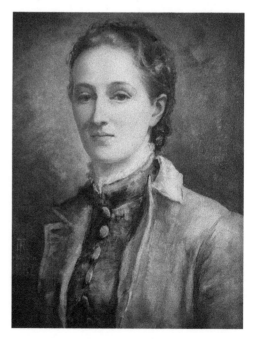

Self-portrait, 1882.

Industries Association, the name chosen to embrace Art, Recreation, Education and the Home. At the congress of the National Association for the Promotion of Social Science in Birmingham, Walter Besant had hailed the Home Arts as 'the great voluntary movement of the present day', a fresh channel for the energies of volunteers, 'the noblest thing . . . the world has ever seen', to open the eyes of the poor to beauty and steer them away from debased or criminal activity with enriching recreation.[290]

The Home Arts council met for the first time under the presidency of Earl Brownlow, on Thursday 20 November 1884, at the Association of Chambers of Commerce of the United Kingdom in Westminster. Formerly known as the Cottage Arts Association, the enterprise was the brainchild of an Irishwoman named Eglantyne Louisa Jebb, who had been appalled to find a crippled youth employed all day picking up stones on her husband's estate, The Lyth, at Ellesmere in Shropshire. Whether or not he had attended school, there would have been no instruction in handwork. Eglantyne, realising that the ability to create something with their hands could offer boundless opportunities and even tame wilder lads, had started wood-carving lessons for local boys aged ten to twenty in her servants' hall. Her wider aim was to equip agricultural labourers with a second string to their bow, should they lose their jobs, and to establish recreational training as a counterattraction to the public house. She had enlisted a network of women to run local handicraft classes for boys and girls throughout England, Scotland, Wales and Ireland, in the evenings or on Saturday afternoons. 'We have long talked of Woman's Rights and Woman's Work – surely this is our first right and our best work, to aid the men of our generation in bringing up a happier and more prosperous race.'[291]

With support from Charles Leland who had organised craft training for the poor in Philadelphia, the Cottage Arts Association had burgeoned, uplifting not only pupils but teachers. Ladies for whom it was not seemly to work for financial benefit, could now, with a little training, achieve fulfilment from teaching. The decision at the November meeting to train paid, as well as voluntary, teachers was seen as revolutionary. 'Why, Mrs Jebb, you have invented a new profession!' There were now forty classes nationwide, teaching clay-modelling, embroidery, flax-spinning, leatherwork, mosaic-setting, repoussé work in brass and copper, woodwork and other crafts.

The original council members included Adelaide, Countess Brownlow, her sister Gertrude, Countess of Pembroke, the metalworker W. A. S. Benson (painted by Burne-Jones as Pygmalion),[292] Alfred Harris, with the novelist and social reformer Walter Besant as treasurer and Annie Dymes as Secretary. Eglantyne wrote in her journal that evening that a printed circular was in preparation for 'the great national work we may do – raising hundreds & thousands to a higher level of existence & showing how education may be reformed & made practical.'[293]

Watts allowed a mosaic of his symbolic subject *Time, Death and Judgment* to be made by Salviati of Venice and set into the wall above the drinking fountain at St. Jude's. He chose the poet and social reformer Professor Matthew Arnold to inaugurate the mosaic because of their mutual aims to stimulate the working classes through art and poetry. On 29 November, Mary will have heard Arnold's address at Toynbee Hall, the Barnetts' new University Settlement nearby, in which he extended the symbolism of *Time, Death and Judgment*, using the image of Judgment to attack the idle rich. Signor was stepping up his own campaign against the evils of greed, painting a grotesque personification of *Mammon (Dedicated to his Worshippers)*, a fat frowning figure in ill-fitting golden robes, crushing nude figures representing mankind.[294]

Refreshing body and soul beneath Time Death & Judgment *at St Jude's.*

Struck by bronchitis, he was unavailable to Mary. Without his inspiration, she felt wretched and could see nothing but 'hideous and vulgar faces' as she walked to her Pimlico studio – 'the revelation of the soul behind the face was failing me.'[295] When at last she managed to see the Academician, she burst out, 'O Signor, when I am with you I grow', but let him believe she meant to remain an old maid. He left for his winter break in Brighton. Mary found herself nursing her brother Will, a stockbroker and healthy

horseman. He too was ill with bronchitis, but cheerily calling out to her for a 'Watts-cycle'.[296] Feeling outcast from Little Holland House, Mary poured out her heart in a letter to 'My very dear Signor', or so her draft dated 26 January 1885 began. He appears to have discarded her letters. Was it true, Mary asked, that he was going to be away from London all winter. It seems that she had provoked Emilie Barrington, whom Signor had then scolded. 'Do not allow conscious rectitude to make you prompt in suspicion and harsh in judgment.' Emilie admitted in her memoir how indignant she felt at having by his person been most unnecessarily dragged into this disturbance'.[297]

Striding forward regardless, Mary wondered whether being at church or with Signor was better. 'I have grown a great bit since I knew you, and have proofs. You said that it was fancy. But if it was a good fancy it was all right. It is *good*, a fact, really.' She signed the draft 'Always yours Mary'.

'My dear Mary', Signor began an incredibly patronising letter the next day, suggesting that she join her brother on a convalescent holiday in Madeira and that he must return to work as soon as possible and scolded her for misinterpreting his enthusiasm.

> You are a silly child, & confound a certain atmosphere in my Studio arising from the intention of my work acting upon your artistic temperament with me the artist. I would not leave this so for as it is an unreal thing it cannot be good. If you must have ideals, find them where no disappointment is possible, Epictetus, & Marcus Aurelius, & even with those there is a certain danger for you may come to expect too much.

He hoped she would drop her plan to be 'the old maid Aunt', that one day she would tell him that she was getting married and advised that in the meantime that she should make the best use of the present, both through work and – [here he included himself, and one can see his enchantment to young women alone in his studio] –

> our ideas, intentions, & even of our day dreams for it is a pity ever to outgrow the pleasure of this indulgence. But I feel myself to be but a stammerer in all that I can say or do. My dim perceptions are so far above,

& my aspirations so far beyond *my possibilities*, that I could almost give up attempts of any kind but of course that won't do.

Signing himself 'Signor' with a swift suggestion of a palette, he invited her to write again with news, as he would not be back for a fortnight. But his sharp reply (now lost) when she asked to visit him in April so disillusioned Mary that wisely, she kept her distance.[298]

The Home Arts were advancing in leaps and bounds. In the spring of 1885, a central London office and studios were rented at number One Langham Chambers, Langham Place and instruction leaflets printed for woodcarving, clay-modelling, brass repoussé (hammered) brass and leather work. Leland gave a paper on 'Education in Industrial Art' to the Society of Arts. There was great excitement when Princess Louise came to open the East London Industrial Exhibition in Whitechapel on 4 May. Banners and trophies hung from Venetian masts and flags of every nation lined the route from Aldwych to the Drill Hall. Residents cheered from their windows and slum dwellings were draped with gold-fringed crimson cloths. The princess toured stalls and invited a young lad to design door panels for Kensington Palace. There were some 800 exhibits. £18 17s 6d was given in prize money and 30 certificates were awarded to the Ragged Schools.[299]

The first annual exhibition of Home Arts classwork, available for sale, was held at Lord and Lady Brownlow's town house, Six Carlton House Terrace on 7-9 July. Pale-faced youngsters pointed out their creations with pride. Of the 28 classes, most exhibited woodcarvings, but hammered brass from Cumberland, made by the Reverend Hardwicke Rawnsley's Keswick School of Industrial Art, painted pottery, chalk carvings were popular, and, thanks to Henrietta Barnett's sister Alice Rowland Hart, leading light of the Donegal Industrial Fund, there was 'Kells' embroidery in hand-woven flax on hand-woven linen in Ireland. Specimens of *cuir bouilli* leather and mosaic were shown to encourage new classes and leaflets were distributed giving helpful instructions to class-holders. Among the visitors were the Princess of Wales and Princess Louise, who both subsequently started classes, as well as Samuel Barnett.[300]

Mary's later note that she had been a 'Slum Sister' suggests that her activities in the Whitechapel slums went beyond clay-modelling, that she was involved with the Salvation Army. The Cellar, Gutter and Garret Brigade,

saving distressed souls in Whitechapel – drunkards, outcasts, violent men and fallen women – offered a challenging outlet for Mary's intensely caring nature and her need to love. So self-conscious was Mary of her devout nature that she kept this secret. The Salvation Army was founded in 1865 by William Booth to rescue the destitute from sin and persuade them through kindness, prayer and song to embrace cleanliness, goodness and Christianity. At the women officers' training home cards declared 'Sin is horrid, chuck it up!' 'Give the devil the slip'. Generally, women evangelists wore plain dresses with small Quaker bonnets tied under their chins, but in filthy Whitechapel, duty bound to find the worst possible cases to inspire salvation, they dressed as the slum-dwellers, except that their clothes were clean. A Slum Sister described her initial approach to a woman standing outside her door, a babe in arms. She would play with the baby and be invited in to see the other children.

> Once we're inside we're all right, for we love them and they know it. At first, of course, they rage and swear at us, in a good many places … then we only give them a few kind words and go on. Next day, when we come back, they'll be better, and finally we get in and get to talk. Some of them is that dirty, and live things creepin' about them. At first we shrunk so, but when one gets to *love* them, you can't think of the dirt.[301]

That week W. T. Stead, editor of the *Pall Mall Gazette*, published a sensational exposé 'The Maiden Tribute of Modern Babylon' of investigations into the Salvation Army's claims that child prostitution was rife on the streets of London. The social reformer Josephine Butler, who had established homes for work-girls and fallen women and campaigned against the Contagious Diseases Acts, revealed that thousands of children as young as thirteen – the legal British age of consent (compared to 21 in France) – were being procured. So horrified was Signor that he drew furiously for three hours an image of *The Minotaur* crushing an innocent bird in his hand. As he was transforming the image into paint Henrietta Barnett brought parishioners from Whitechapel to see his studio.[302]

It was not until December that he renewed contact with Mary, asking for news. For a man who chose his words carefully, Signor struggled over his

letter to her on 13 March 1886. He was expecting her on Monday 'as soon after 11 as you like' and encouraged her to confide in him.

> Until you marry or engage yourself I ~~should feel that~~ want you to feel that you may speak to me on any subject you like & give me any confidence you please, sure that I should neither misunderstand nor betray it, & that I will always see you whether I expect you or not when I am not engaged.
>
> It is a great pleasure & advantage to me to breathe an unconventional atmosphere.[303]

Her slight eccentricity now as a social reforming craftswoman, seemed more appealing. The letter is unsigned. Signor called her 'Mary' or later 'darling', but to her family, she was 'Molly' (and in Compton at the end of her life 'Donna'). His exuberant flirtations with artistic young ladies would not stop, but from then on, his letters show an increasing desire for involvement in her life, and hers in his. He had just finished a picture of *Hope*, of a blindfolded figure in a luminous robe that fell in Phidian folds to her bare feet. Seated on top of the world, she is bent double trying to make and hear music from the one string left on her lyre. 'It is only when one supreme desire is left', he explained 'that one reaches the topmost pitch of hope'.

Signor was at last setting in train his lifelong ambition to present his celebrity portraits to the National Portrait Gallery – though there was no building yet available – and his major symbolic pictures to South Kensington Museum. Mary's hope to exhibit at the Grosvenor was disappointingly dashed. However, Signor, having promoted the revival of handicrafts throughout the decade, agreed to be a vice-president of the burgeoning Home Arts. As the London Board Schools' new recreative evening classes teaching handwork – inaugurated by Dr John Brown Paton – were run by the Home Arts, Mary had become affiliated to the association.[304] Signor helped her, approaching colleagues specializing in decorative art – Walter Crane and Frederic Shields – for 'used' designs for the Home Arts classes. Though he had long exhibited at St Jude's, Signor consulted her about the safety of sending his national pictures to Whitechapel, and he urged her to bring her work: 'it is long since I have seen any'.[305]

There was mutual sadness at news of Lionel Tennyson's death. Mary, who had not seen the family for years, commiserated fondly, if eccentrically, to Hallam, revealing that she had dreamed about his mother 'radiant with joy at having Lionel with her again – I shall not forget her look – the dream seemed the truth when I awoke & the truth a dream'.[306]

Since Ronald Chapman published *The Laurel and the Thorn*, his mother – the artist's ward Lily – destroyed parts of the correspondence upon which he based the artist's courtship. Signor had at last expressed affectionate respect for Mary in April, but her apparent wish to show him a portrait of a man she was thinking of marrying and to bring the sitter sent Signor into a spin. 'What Genl Cotton?' a fragment of his letter of 6 May reads. He wished to talk to Mary urgently but was misguided. Major-General Frederic Conyers Cotton was 80 years old and married. 'You had better let me know. There are some things I should much like to say. Do come'.

He visited her studio ostensibly to give critical advice, writing on 14 May to give notice that he would arrive in advance of the general and wished to consult her about drapery. This was quite exceptional, because he worked frantically from sunset to sunrise every day to complete his national work. He made lunchtimes available for her alone – 'You are the only person I see at that time of the day'.

Signor still longed to hear from Gertrude in New York and was anxious that his exuberance had deterred her. On 20 May he apologised to the American, 'I am afraid now I really *did shock* you by my unconventionality.' That day, he told Mary her letter boy was charming and that he wished 'you had the bringing of him up'. Doubtless, so did she. This would have been the enterprising lad who sat to her for a few shillings holiday money. Perched on a high chair in her studio, the eight-year-old had piped up, 'Do you know what I calls Mr Watts?' adding with pride, 'I calls him pynter to the Nytion'.[307]

To her delight, she had a new niece Hester, born to Edith and Ted at 50 Chester Square. Mary usually spent her Sundays with Christina and Edward, at his new living, the workhouse chapel in St Albans and may have been teaching clay-modelling to inmates.[308] At a Home Arts garden party hosted by May McCallum in Pembroke Road on 20 June, she stayed to meet Eglantyne Jebb. The two women forged an instant rapport. For Eglantyne, meeting Mary was the highlight of her afternoon:

notably – & to be recorded – Miss M Fraser Tytler – a slightly made figure, a sweet thoughtful face – rather regular features – young [Eglantyne was four years older] – now here is a friend – how these joys come wholly unexpectedly! . . . This meeting is perhaps the chief event of my visit to town this year – for I feel here is a treasure come into my life.[309]

They met again several times that week, firstly at the Home Arts annual exhibition at St. Andrew's in Bethnal Green, where William Morris had given 250 yards of fabric to decorate the iron parish room. Mary joined Eglantyne, May McCallum and the philosopher Bernard Bosanquet, 'a funny looking party clasping green pots, etc (to adorn the Ex)', travelling part of the way by hansom cab, and then by underground. How thrilling it must have been for Mary's shoeblack boys to see – and, hopefully, sell – their clay at the exhibition. There were grand speeches by Earl Brownlow and the Bishop of Bedford, in the presence of the Queen's daughter, Princess Christian of Schleswig-Holstein. To Eglantyne, Bethnal Green was 'inexpressibly ugly & dreary but not half so squalid or unhealthy as I expected' and the exhibition had been a great advance in its variety of crafts.[310] The next day, 25 June, she had a rendezvous with Mary at the Grosvenor Gallery summer exhibition.

'I met Miss Fraser Tytler at once – and she took me straight to Watts pictures and I looked at *nothing else* during our happy brief hour there.' He was showing two visionary works, *The Soul's Prism* and the instantly popular *Hope*. Mary happily explained that Signor had painted them as a gift to the nation. To Eglantyne, it seemed horrifying that his paintings should hang 'among poorer things, to be stared at foolishly criticized by a crowd – yet he who painted them wills it so'. As they stood talking quietly in front of *Hope*, a woman asked them to explain it. Eglantyne reported, unlike any commentator since, that light was streaming down on Hope, which the blindfolded figure could not realize, thus heightening her desperate state. This, like her description of *The Soul's Prism*[ix] as 'the consciousness of all time looking forth with starry eyes', was probably Mary's interpretation. Meeting her at this climactic moment impressed the Irishwoman.

[ix] Later renamed *The Dweller in the Innermost*.

'Now this is a great thing to come into my life that I should know and see and understand these glorious pictures and hear about the artist from his friend, who is my friend too.' The women parted with a kiss, and Eglantyne went on to a meeting at Langham Chambers, at which Mary was elected to the Home Arts council; and a fortnight later she was appointed on to the Design committee.[311] On Saturday 3 July Signor declared himself to Mary. He closed secret communications with Ellen Terry and sent her 'all good wishes now for ever more'.

ELEVEN

Rivals

Mary did not immediately accept. It is one thing to admire an artistic genius and share his ideals, but to marry the obstinate, fine-tuned, flirtatious, notoriously divorced, world-famous Academician, so driven that he had refused the first baronetcy offered to an artist, required hard-bitten stamina. Exotic women had long worshipped and flirted with Signor, mesmerized by his metamorphic nature – a man of visionary power one moment, sweetly intimate the next. But, apart from his teenage muse Ellen Terry, they would not dream of marrying an artist of modest birth. A series of married women had nurtured his life and art. Devoted patronesses, they had never had to tie themselves completely to him. Even the proprietorial Emilie Barrington could find Signor maddening. On larger issues, with the glory of inspiration he was fine, but 'scarcely ever' on a small mundane problem. 'There is a tendency to a species of mental inebriation in those possessed of the creative faculty'.[312]

Mental inebriation struck again. Mary let him think his rival for her hand was an impoverished young widower. 'I want you to tell me very distinctly when you are engaged or consider *that* to be within distance, or decided *probability*,' he wrote. 'I do not think it should depend upon the question of money! That is not nice'. Nor was it likely in Mary, a socialist with a private income and dotty about Signor. If she did plan to get engaged, he continued, 'we should become strangers.' All she had written in her commonplace book was 'He said "I want you".'[313] Signor deluged Mary with daily letters. Leaving no clue as to the suitor's identity, if indeed there was one, she inked out part of his next missive which began 'I think I quite understand' and suggested that the mysterious suitor was still in play.

All his life Signor had been afflicted by precarious health, but judicious diet, bed rest at the onset of trouble and the care of protective women had kept death at bay. His chief fear was that he might die leaving unfinished his work for the nation. He laid his cards on the table. At 67, why should he fear his health would jeopardize completion of his national work? His monumental work seems to have strengthened rather than weakened him. Calling on her power as a carer both of his health and artistic ambitions, he invited Mary to 'read between the lines', proposed a helpful role sorting his papers and acknowledged respect – if not passion – for her:

> I have always believed that I shall only just have strength enough to carry out my intentions with regard to the pictures to be completed for the nation & my hope is if I can do this, *to go away!* But a dread has come over me that I may have a few years to pass of regretful weakness when I could only be a burden excepting to someone who could have a sufficiently strong affection & interest in helping me to complete what remained to do, (rather in the way of putting notes together than any thing else) & bear with perhaps impatience & tediousness . . . since I found how much I value & respect your great qualities & find how very dear you would become to me. I do not profess a passionate thing! But you must be well aware as one can stand with me where *you* do!

Couched within his need for care, strong affection and interest in his work lurks a desire for intimacy. Or why would he press her, or indeed why cease private contact with Ellen Terry, especially if he dreaded the prospect of an empty future once his national work was complete.

On practicalities, Signor planned to sell Little Holland House and move, perhaps to Wimbledon. He expected to live on £1,000 to £1,500 (worth over £150,000-£226,000 today), chiding Mary about financial consideration, while using it as a counteroffer, 'if I were young enough'. He had feared debt since as a teenager he had had to support his father, with earnings from portraiture. Signor became obsessed that she might choose the other man, in which case, he pointied out how unhappily narrow her life would be, but

> if our intercourse (not our recollection – affectionate friendship) comes to an end . . . I want you to know that I have come to feel for you

the most profound & tender respect, & the most absolute trust in the qualities of your nature . . . I do grieve to lose the much that might have been Thought, & done, & seen together . . . if I can be useful at any time I need not say how great my satisfaction would be'.

Mary had no idea of the depth of his feeling. Perhaps she had been away. The next day, he had convinced himself she had decided to marry his rival and would if possible cease to regret. 'Why? Beloved Signor Why?' He invited her to come next Saturday '& after never! unless your prospects fall through. – I shall always feel you are the one in whom I have felt the greatest confidence'. Mary went and he proposed. She still held reservations but allowed Signor to hope she might sweep him away, if just for a time. A trial run?

At 69, the artist was three decades older than Mary, at nearly 37 He said,he could offer 'no passionate fancy'. Even as his wife, would she still be in effect an 'old Maid' nurse? To assist the Academician, she considered giving up her own art – a supreme sacrifice. Privately, she feared that her strong Christian faith might disconcert him. Signor agreed to leave her alone until she had made up her mind, but he could not help writing. Rather than inhibit the advance of her own art, he hoped to put her in touch with a new teacher. He offered artistic guidance encouraging her to produce in oil the purity of tone and precise outlines of her watercolour drawings, and in so doing landed his prize.[314]

On Sunday 25 July Mary agreed to marry Signor, her guiding light. 'I went to tell him my *life* was his. There are no words for an hour like this – only tears of joy – The noblest heart all mine, all mine'. After years of torment over a love whose memory only her art could obliterate, Mary had secured a partner whose ideals she wholeheartedly embraced and whom, at last, she could freely love and admire, a greater reward:

> What can I write of this wonderful day?
> To God only & my book can I open my heart . . .
> A strange wonderful light has come into my life . . .
> I had thought that my Holy of Holies had been filled & closed
> long years ago & instead I have a Holier still!
> Infinite Father . . .Give me yet the power to serve –[315]

Signor worried that Mary did not appreciate the enormity of her role as his wife. He was anxious not to announce their engagement just yet because at the same age as her late father, their union might arouse surprise and comment, which indeed it did, not least among his women friends. Of deeper concern to both was the notoriety his first marriage to a younger bride had caused a quarter of a century earlier. Signor refused to discuss it, except to say that the divorce 'was not suggested by me, nor ever would have been so'. How her family would take to her marrying a divorcé did worry Mary. That the couple had not actually talked through the relationship would affect her.

The Academician lived simply, with just his housekeeper Emma and valet Alfred for company. His closest friend and colleague Sir Frederic Leighton, the president of the Royal Academy, lived nearby; and Emilie Barrington, who saw herself as guardian of his art, called almost daily from next door. Having lost touch with his family, his 83-year-old half-sister Harriet in Long Ditton and her brother Thomas's cabinetmaking descendants, Signor preferred to regard Sara Prinsep and her family as his own. Whereas Mary's relationship with her warm, aristocratic Scottish family was extremely close. The Fraser Tytlers, with their long history of service to the country, headed estates and cared for their tenants and communities. Signor feared they 'would find me nothing but a jarring element', except that in the wider context he was in sympathy with the thinkers of the age, as indeed he was.

> My mind has kinship with Tennyson, Browning, Matthew Arnold and their fellows, who are led by Thought, and by whom Thought is led. You will see how far this is likely to be in harmony with those you most care for; and will ponder well *even now*'.

If her family disapproved, he wrote, they could call off the marriage. This so alarmed Mary that she wondered whether he was sure. 'Don't be a Goose!' he replied 'I thought it was understood that we should trust each other *utterly*. I shall always so trust you. Do not let us have either doubt or fear.' Nor need they. Of course, her family was delighted. Will wrote from Scotland, 'Let us know the day, and Ted and I will be there to give you to the

Nation.' Sadly their old friend, the Primus of Scotland, died on 26 August, and so could not officiate.[316]

In September, as Watts began to hand over some of his national pictures to the South Kensington Museum, Mary went up to Aldourie to stay with Ted and Edith. Happily tuning into Wattsian thought, she wrote to her fiancé

> The roots of my heart are very deep in here … I walk about & try to let it all know what a happy woman I am & that I am going to a life that is quite as beautiful though it is in London – I think of the work going on in the garden or in the studio & feel its spirit in harmony with all I love here … I think myself I have grown to see the spiritual side of nature, & find it is of the same kind as the spiritual side of man'.

There was no one quite like Signor for contemplating matters of the mind, life, death and the universe. He was calm, brilliant and reflective. But as he faced the enormous change in his personal life, he became anxious and excitable.

At Little Holland House, Signor confided their 'very great secret', or so Emilie Barrington reported in *G. F. Watts Reminiscences*, staking her claim to Watts scholarship soon after his death. 'Lie!' scrawled the newly widowed Mary, appalled. Surely his assistant did need to know. He insisted though that she must not pass it on. His secrecy doubtless also shocked Emilie. Mary's indignant response to her charge of secrecy – three heavy exclamation marks – suggests a wicked sense of triumph. That he had managed to keep the two women largely apart for almost a decade was quite a feat.[317] They were fiercely jealous of each other, and Mary would make access to their beloved artist as difficult as possible for Emilie.

Signor set in train plans to prepare his Iron House studio for Mary's design work and she could use the gallery to entertain friends and sit in 'when you are not painting,' except at weekends when it was open to the public. For the marriage settlement, he planned to transfer to Mary the outstanding 38-year lease of Little Holland House, which 'as the neighbourhood is improving ought to leave you comfortable'. He asked her to haggle, and would have left everything to her, but, as she knew, he must

consider Blanche, who was now married to Herbert Somers Cocks. Mary did not actually need a settlement, nor would she haggle. She hoped he would not think her imprudent. 'I have of my own enough to keep me from great poverty anyhow'. Nor did she wish him to be troubled by her future, in which event she could pool funds and live with Christina. How well Mary understood Signor's anxieties.

> I want when you take me on – to be just a sort of pillow, that helps you to rest, & perhaps something more too, but *not an anxiety* - & I think I can promise you to do without any luxuries, even comforts if it is necessary, for getting into debt is worse than having too little to eat! It will be best to begin as if we are much poorer than we are, it is so easy to increase expenses.

Within days of her arrival at Aldourie, three-year-old Charlie fell from his pony. There was little sign of severe harm, at first. Mary sent grouse for Emma to prepare for Signor's luncheon with Ruskin. She painted word pictures for Signor of sundown over Loch Ness, the high hills beyond and the 'bonny sight and sound' of the herring fleet sailing by. He wrote of her as 'a braw Scotch fairy . . . independent of mists & rain', evoking, perhaps, the reverse of his ethereal *Uldra* and longed for her to recover her highland bloom, and after the strain of the last two years, to 'feel that peace that confidence brings'. Gerry kept Signor entertained, hugging him, playing to him. She called him 'Lamb', even when he lost his patience, 'Don't be a goose, Lamb!' Gerry suggested that he ask his fiancée to practise an easy accompaniment for a song he used to sing – Emilie Barrington played for him at present. Mary was amused to hear how Gerry had been 'making great love to you' and warmed to his growing friendship with her sister-in-law. But 'I won't promise that everybody shall be able to make such love to you without a twinge of jealousy!'

All was not well with little Charlie. Fever had set in. Mary, acting as nurse and confidante, busied herself arranging flowers. She reflected on a few lingering doubts 'about what I can be to you' and closed her letter 'wondering much what I shall find on the canvases when I am next with you – Good night beloved Signor Your loving Mary'. He added a private postscript

'willing to give up half a life & probably enjoyment of social pleasures to look after a mere mammal in seclusion & watching & obscurity.'

Signor was delighted that she was building up her health and wrote that she would need it for two. 'I shall be disappointed if you do not bloom out like a flower that is transplanted into favourable soil.' He wanted Mary to feel that 'if I do not profess the passionate feeling which would not be becoming to my age, I can love you very much with the love that twines itself closely round goodness & has its roots deep down in perfect trust . . . the door of your cage shall be wide open & there shall be no wires, but silver films instead!'[318] By 'cage' he meant creativity. At the time he was painting *After the Deluge*, the power of the sun radiating over the sea as 'the hand of the Creator moving by light and by heat to recreate'.[319]

> Thank you my beloved Signor for all you say. What you give me – I mean the kind of love – is . . . just what I want. I do want to be perfectly trusted. I do better when I am – if I am held cheap I become so. I hope and believe you will find me though *very* imperfect, very ignorant, and very different from the clever women you have had for your friends, at least as big hearted, and as true as any . . .
>
> I am a good deal dependent on the atmosphere I live in, and years seem only to make me more aware of its effects for good or for evil. I think it has been one reason to prevent my accepting a sort of medium happiness in married life, for I knew I should be deeply impressed by the intimate life, and have had fears of taking an impress from a lower type than my ideals. I have no fears now.
>
> Goodnight.
>
> Your loving Mary
>
> You see I have broken out into saying 'loving'. I am that chiefly and it ought to include a very great deal. You don't mind do you as it is quite true?[320]

'My loving Mary', Signor replied, sending grapes for Charlie 'from your vine' and added that the garden had produced three ripe peaches. 'I don't think I have ever been so proud of anything in my life'. Ted sent a gift of game to express his joy and pride in Mary's 'prince of painters', while she

searched for an appropriate box in which to pack a graceful, grey thistle, and complained to her fiancé that 'No one seems to have an old 'corset' box & yet we all wear them!' Ah, but did she know of Signor's famous abhorrence of corsets for distorting the human body which had inspired the ladies of Norwood to appoint him president of their Anti-Tight-Lacing Society? He found the thistles so beautiful that were he in Scotland, he would paint the purple mountains in the deepening twilight with just the thistles in the foreground. 'Would it be very scotch? You might try it!'

Tragically, on 3 October Charlie died, the *Inverness Courieer* report headed 'Death of the young heir of Aldourie'.[321] To help the family through their grief, Signor offered to create a design which she could model as his memorial, 'The Angel of Death with a child in her lap on whose head she is placing a circlet, if he was not too intrusive, at which Mary asked, 'Do you *believe* I love you?' He did not doubt her affection, but wanted her to question the whole idea 'in the most fierce light of truth, while the sacred atmosphere of Death around you'.[322] 'I am [not] frightened by your telling me how disappointed I am to be. I expect nothing! Will that do?' replied Mary, adding that she longed to lay her head on his shoulder.

Signor, who would describe Death as 'the sublime visitor' and had revolutionised its depiction in art to appear tender rather than terrible, shared her grief as he worked on Charlie's memorial design. He asked Henry Cameron – the son of their late friend Julia – to photograph *Death the Angel Crowning Innocence* and sent a tender red chalk drawing to Edith. On the day of the funeral he suggested to Mary that they worked on the monument together. 'You might make the carrying out of it a definite & consoling object.' Indeed she did and the idea of celebrating death 's beauty in decorative art would have increasing

Aldourie Memorial.

resonance with Mary. Her triptych modelled in clay and cast in bronze from Signor's three subjects, with *Love and Death* and *The Messenger* flanking the central *Death the Angel Crowning Innocence*, would stand at the entrance to the Aldourie cemetery for over a century.[323]

Meanwhile, an old photographer was stirring up the crofters. Mary recognising 'quite a smouldering fire of the artistic spirit', wanted her family to help redirect his talents and arrange commissions for him at Aldourie. Only recently, the Third Reform Act of 1884 granting the franchise to all male householders, had increased radicalism amongst manual workers, small farmers and agitation for the rights of crofters. Despite the Crofters' Holdings (Scotland) Act passed in June to curb landlords' power and provide their small tenants with security of tenure and fair rents, there was still friction in the Highlands. Mary, sensitive to the difficulty on both sides, felt her photographer was not 'a bad kind of radical' because he spoke gratefully of his landlord.[324]

'Loving Mary & dear Wife! For so I always think of you nor could 20 ceremonies make you more so to me. . . I wish you could come away, that all could come away. I think an entire change would be the best possible thing.' The Iron House Studio was ready for her. 'The Gallery & house & indeed all matters outside my studio will be turned over absolutely to you. I wish the time were come', he wrote on 18 October. 'Emma says "you are the only person to whom she could give me up!"'[325]

Mary ticked him off for doubting her love. Was she St Peter? 'I think I have been questioned more than three times, "Lovest thou me?" and he was grieved.' Signor replied in kind, that the answer could be found in the Sermon on the Mount[326] and Paul's epistle 'Though I speak with the tongues . . . of angels'.[327] So enigmatic was he about shaping their lives free from unnamed puzzling conditions with which we will have nothing to do, that his worries probably concerned sex. Whatever he meant, during their long, secret wait Mary had grown confident.[328] On the train down to London on 24 October, she wrote firmly, 'I love you enough to feel all details unimportant by the side of the one, that I am going to live with you – and if you think of that as my supreme delight you will know that with it as the outcome of love I shall probably learn to be what you need'.[329]

Assured at last of Mary's determination to marry him, he broke the news to Blanche, to Sara Prinsep and her niece Julia, who after the death of her husband Herbert Duckworth, married the founding editor of the *Dictionary of National Biography,* Leslie Stephen.[330] 'So you see a big stone is laid'. To minimise the shock or impression that he was deserting the family with whom he had been identified for so long, he stressed his 'selfish' need of Mary's services to his health and art. He hoped this 'ridiculous step' at his age would not vex Blanche. 'It is as I told Grannie simply a matter of life or Death'. Sara, now widowed and an invalid, had fallen on hard times. As impulsive and imprudent as ever, she was staying with May and Andrew Hichens. Signor asked Mary to write to Sara, offering to be looked upon as a daughter. All were delighted, heartily relieved. 'Thank God' replied Andrew, who had heard much about her from May's sister Annie. 'No other woman I know deserves or is fitted for the trust she undertakes. It is a serious, solemn, and sacred thing which she has to do.' Julia urged Signor not to delay. 'Persuade Miss Fraser Tytler to marry and carry you off out of the fogs.'

Mary found her fiancé in poor health – 'I am sadly in want of a good deal of petting and coddling' – longing indeed to escape the London fogs. As his doctor Thomas Bond advised a honeymoon in the sun, from her mother's new home Mounthill, in Epsom in Surrey, Mary booked a cruise to Egypt, Signor's most ambitious journey since his expedition to the Halicarnassus excavations three decades before.[331]

His greatest friend and opposite neighbour was the gregarious president of the Royal Academy Sir Frederic Leighton. Created a baronet that year, he entertained in style, held sparkling musical soirées and saw that international exhibitions represented Britain's finest artists, while still finding time to produce perfect, monumental painting and sculpture. Sir Frederic never married. Signor feared he would disapprove of the step he was about to take. 'You will feel doubtless that at my time of life the thing is out of harmony'. Mary felt that the announcement very likely did surprise and even distress him. 'Signor was too precious a friend to give into unknown and untried hands without anxiety.'[332]

Their most long-standing mutual friends were the Tennysons. 'So that is what he meant by a mysterious word'. Hallam wrote to Mary on 11 November. 'Dear Signor, I shall always think of him as the most loveable of men - & for you, you are one of my oldest friends, & I can only thank God for your great happiness.'[333] Anny Thackeray Ritchie, whom Mary met at Freshwater before her marriage to Richmond Ritchie, was *thrilled*. 'I do feel so happy for one does feel the marriage of true souls matters . . . I have always thought her – what this proves her to be – a sweet woman & a true artist appreciating the best & dearest things in those whom we all look up to & love – some of us a little more than others'. When Anny added that she was going to choose a gift, Signor replied that their best presents were the trust and affection friends were showering upon them – 'no burglar can carry them off', but they would love one of her books. 'Let Mary choose.' His best excuse, he told Mary, was that he was bringing her into an atmosphere of love and appreciation. 'Take your biggest moral Pallette knife & spread my love around where you are . . . Best & most permanent colours!'[334]

Mary was happier than she could possibly believe. 'There are sort of harmonies going on in my life now, that I thought did not belong to this world at all.' She reminded Signor of her dream of the colour angel, which she had never forgotten and must have been a good omen. Such harmonies, he replied, would resound in the unity of their aspirations. 'We are prepared to approach hand in hand in a nascent spirit & desire for light'. He told her of a mysterious experience at his Mayfair studio long ago, at about the time of her birth. Woken by a strange sound one night, he went out to the landing above his studio to investigate. In the darkness he sensed a quiver of wings flying around and whispering '*anima mea*'. 'You are touched by my dream! which was no dream! An impression who knows, who knows of how much reality! . . . Was it think you your soul seeking its fellow?'[335]

In naïve hope, he assured Emilie that she and Mary would become 'great friends', because they had similar interests and tastes. 'You will perhaps find her a little shy and reserved, but I don't think you will have any difficulty. We are both to have perfect confidence and freedom, and none of my habits are to be changed.'[336] Mary was already acting as his secretary, answering communications with regard for 'Art for Schools' and the Kyrle Society, with which Emilie was involved.

There was an almighty clash when, according to Chapman, she met Mary in the hall at little Holland House and told her that Signor would die on the long voyage to Egypt. As guardian of his muse until now, her nose severely out of joint, Emilie could intimidate even Leighton, who complained to the artist Luke Fildes, 'I scarcely dare to go to bed'. Fildes advised both him and Signor to marry. Sir Frederic would never escape her clutches. The two women argued furiously. Mary remained resolute, unswerving. She had the measure of her greatest adversary. But Emilie stoked up the fire and Signor became anxious that his health might fail on honeymoon. So he asked his fiancée to ensure their travel plans were elastic, even if he had to forfeit the fare. 'I know you will be the best wife any man ever had & unless I lose my senses I will always do what you wish but you must let me keep my eye on my cherished projects.' Nothing would induce him to go until he had shaken off his chill. He had no wish to leave her a widow, nor fail to complete his national designs.

> I cannot . . . disguise from you the dread I have of the ordeal I have to go through & you must not ask me to move afterwards till I feel up to it. You must not fear that I shall be morbid on the subject. I know it is necessary to run no possible risk. By & bye [sic] I shall get into better health I believe & be able to do as other people do. At present I am conscious of a terribly relaxed vitality.
>
> I consider that I do not belong only to you. I have dedicated myself according to my lights & power to the nation, who wrote, "I could not love thee dear so much, lov'd I not honour more"[337]

The day before the wedding, Mary's family gathered at Mounthill. Gerry arrived with the bridegroom. He had a coughing fit. To ease his nerves, Mary took him for a walk. She had a tearful tussle with Emma in the evening, getting him ready for bed, as both women tried to undo his bootlaces. They made up with a kiss. Such was Signor's desire for secrecy that, unlike the widespread, glamorous celebrations laid on for her siblings, Mary had a very discreet wedding. We know nothing about her dress – very likely made of aesthetic Liberty Art Fabrics, from Liberty & Co's new costume department in Regent Street, London.

Early on the morning of Saturday 20 November 1886, bride, groom and family walked down the lane to Christ Church. The local vicar Archer Hunter performed the marriage ceremony and with Mary's stepmother Harriet and Ted and Will as witnesses, quietly gave her to the nation. The wedding party took the train to London for luncheon at Chester Square with Andrew and May Hichens, Annie Prinsep and Gerry. Mary and Signor returned for their wedding night to Little Holland House, 'to *my* home with *my* beloved'.

It was not until after their marriage that the Wattses notified their wider circle. Most important perhaps was Augusta, Lady Holland, his sensual sitter and hostess in Florence in the 1840s, as wife, now widow of his highly influential patron Henry Edward Fox, Fourth Lord Holland. Signor wrote to Lady Holland of Mary's first-rate intellect and beautiful character. 'She is still young enough to make the office of nurse (for it wont be much else) a sacrifice, but she believes that sympathy with my work and objects will compensate for much'. As a wedding present all he wished from Lady Holland and from the Countess of Airlie was 'an increased amount of the regard & friendship you have so long shown me', explaining to Blanche Airlie, chatelaine of the beautiful castle of Cortachy in Angus:

> The Lady is Scotch, Miss Mary Fraser Tytler, considering the elasticity of Scotch cousinship perhaps there may be some far off touch! If I am thought very selfish, I shall be sorry; if very foolish I shant mind, I shall have the companionship of an excellent intellect, & a beautiful nature . . . I have prepared the lady for sharp limitations at which she laughs. All those who know me best are more than pleased. I hope you will be among them[338]

The philosopher Bernard Bosanquet hoping for an introduction to Mr. Watts – 'One is under some awe of great men' – sent Mary a book on 'the hardest & greatest of philosophers' Georg Wilhelm Friedrich Hegel, his new translation of *The Introduction to Hegel's (Aesthetik) Philosophy of Fine Art*.[339] William Holman Hunt, who had designed Ellen Terry's first bridal gown, gossiped to a friend that a woman who had been courting Signor for years was so distressed by his remarriage that she had taken to her bed.[340]

Signor's embarrassed excuse that he needed Mary as nurse and assistant hid the depth of his feeling for her. The artist's wedding gift to his bride was a ravishing, physically charged painting of *Orpheus and Eurydice*. Their upper bodies are close together and fill the canvas. Almost nude, the Thracian poet holds the lyre of Hope in his left hand. Yearning to bring his wife back to life, he stretches his right arm across the picture to grasp her shoulder, but she is slipping back to the underworld. This was quite a start. Mary had at last, in the words of Tennyson's *The Princess* 'set herself to man / Like perfect music unto noble words'.[341]

The following morning, Signor summoned Emilie, who had charge of the studio in his absence. She found him longing for his Egyptian honeymoon, but fearful of travelling – 'the unaccustomed was ever a "bogey" to him'. She made sure she was in place before the wedding. He refused to say goodbye – 'so unnecessary between real friends!' – which should have told her that Mary would on their return replace her as guardian of his muse. Emilie's husband Russell Barrington was charged with keeping an eye on adaptations the architect George Aitchison was making to the house to accommodate Signor's bride. Mary's first duty was to draw a figure, marking the Canon of Proportion for one of her husband's oldest friends, the tenth Earl of Wemyss, who was carving a nude Venus in marble.

Both women were wary. They saw each other two or three times. Mary had a nightmare that Signor had remarried a staid excellent woman with brown curls in combs. Bitterly, she wondered 'why this Nemesis had overtaken me – & she was so much better than me too, that was the worst of it.' Fortunately, the Barringtons were otherwise engaged when the Wattses set out on honeymoon.

Sir Frederic saw them down to the docks. The president stood with tears in his eyes as Signor's audacious bride swept him aboard the P & O steamer.[342] Did he have real cause to worry for his dear friend? Mary and Signor came from very different worlds. He was an influential Academician of international renown yet modest birth, while the aristocratic highlander was a passionate if as yet 'amateur' artist. It had taken Mary years to find her identity as a social reforming craftswoman with a serious social purpose and this had given Signor the confidence to see her as a partner in his aims to uplift the nation. Mary had long been familiar with his Freshwater circle.

If her religious depth was alien to his aversion to formalised religion, Mary had an extraordinarily imaginative Celtic spirit. Signor too saw himself as a Celt. Both shared universal spirituality and mutual interest in the use of arts and crafts to elevate their countrymen and women to appreciate the beauty of art. Two pioneer artists were now embarking on an extraordinary journey, a 'two-celled' heartbeat wherein 'true marriage lies', perfectly expressed by Tennyson in *The Princess*:

> Nor equal, nor unequal: each fulfils
> Defect in each, and always thought in thought,
> Purpose in purpose, will in will, they grow,
> The single pure and perfect animal,
> The two-celled heart beating, with one full stroke,
> Life.[343]

EPILOGUE

Lady artist of the day

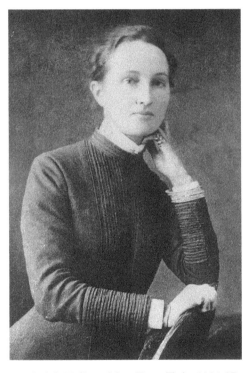

Frederick Hollyer, *Mary Fraser Tytler,* 1886-87.

Marriage to the Academician whose vision had long been a magnet to thinkers of the age would bring Mary into the epicentre of the art world. Living with Signor enabled her inventive decorative art to flower and energised her creative vision as a social reforming pioneer to raise the status of craftswomen on both sides of the Atlantic Ocean. As *Valiant Seton*, published on the 175th anniversary of Mary's birth, celebrates her influences and experiences leading up to their union, here are glimpses of her achievements during and beyond their remarkable creative partnership.

Visitors to the Wattses' homes in Kensington and Compton were struck by Mary's flamboyant gesso designs, especially, Signor's golden reading niche, a giant illumination interwoven with beasts, men, women, angels and birds. It was inspired by *The Book of Kells*, as well as her husband's art and, notably, prefigured the spiritual animalist painting of Franz Marc and the German Blue

Rider group. In calm contrast, the ceiling decoration above his head was white and symbolised his motto THE UTMOST FOR THE HIGHEST. 'She has a genius for symbolic decoration', Signor wrote to the artist Briton Rivière.[344]

Supreme happiness, such that Mary could not possibly have imagined, came into their lives when a golden-haired thirteen-year-old orphan named Lily was brought to Little Holland House by Una Taylor. Una worked as an embroiderer for William Morris's daughter May.[345] Lily loved visiting the Wattses. Mary, overjoyed at being asked to act as her guardian, came to care for Lily as a beloved daughter.[346]

Before the mortuary chapel was conceived, depressed by the ugliness of her aunt's grave, Mary had dreamed of teaching people to design their own gravestones.[347]. What a woman! She motivated the people of Compton – boys and girls, servants and aristocrats – to model symbolic terracotta tiles for the chapel. The Compton Terra Cotta Home Arts class of teenage boys came to Limnerslease, ostensibly to absorb the genius of the Royal Academician while they worked under Mary's direction. This was no small inspiration as Watts was presenting his Hall of Fame portraits to the opening of the National Portrait Gallery in 1896 and vast Symbolist paintings to the new National Gallery of British Art (Tate Britain) in 1897. Every year the Compton boys would see their work on display at the Home Arts and Industries exhibitions at the Royal Albert Hall in London, admired by the Queen and the royal family, singled out for praise by the art press and ultimately awarded the Home Arts Gold Cross.

The circular, interdenominational Watts Mortuary Chapel is one of the most exotic buildings in England, standing among trees in the hillside above the Pilgrims Way at the village of Compton. Highly symbolic inside and out and startlingly red in its day, it is a masterpiece of arts and crafts architecture. The idea of Home Arts classes was to instil a sense of beauty into the lives of the servant classes and the ideal was to equip them to become creative professionals. The Watts Chapel achieved this. Even before its consecration in 1898, Mary, who for nearly half a century considered herself an amateur, horrified her husband by deciding to turn professional, to run a pottery business, designing Celtic-style terracotta tombstones, sundials and jardinieres. 'He told me he foresaw nothing but misery – I had not head for

business no nerve for extra work, writing and worry, that I would probably go mad, or he would go mad & die – knowing that he would leave me to a miserable impoverished old age.'[348]

Mary pressed on, while entertaining poets, painters, curators, international visitors as interested in her designs as his, providing support for his work and fielding lectures from Cecil Rhodes, the 45-year-old imperialist who was determined to build a railway from the Cape of South Africa to Cairo. In 1898 Rhodes imposed himself as a sitter to her reluctant husband who insisted that his aim was to record 'the prominent who perhaps may be said to make – or mar [England] – I don't know which you are doing'. Mary had neither time nor desire to engage with the imperialist. Try as she might to leave the pair to pose and paint in the studio, Rhodes commanded 'Don't go away Mrs Watts, I should like to talk to you', then he wooed her, clearly hoping to appease her husband.

> I did stay to talk & *stand* from nine till eleven! - & learnt to know the spell of a man who can lead – Never have I known such a sudden conversion from all my former idea of a man – I went in thinking I should not have anything in common. I stood there finding the minutes too short for all we had to talk about – I expected a man of the world, with a head full of enterprise. I found a man with all the simplicity of Mammon & language that one finds in the ordinary sporting laird – with imagination added to it, a quick fine spirit easily touched by what is fine . . .He cannot *do* with Signor's pessimism. "England extinct!" he said. "No. I say she is only just beginning to live."'[349]

Mary was planning to set up Potters' Arts Guilds at Compton and Aldourie. Meanwhile women artists were at work in the Limnerslease billiard room, colouring her Tree of Life gesso decoration for the chapel interior, silver roots swirling through a golden girdle of the Trinity to pairs of winged messengers above.

> Where many a trumpet-twisted shell
> That in immortal silence sleeps
> Dreaming of her own melting hues,
> Her golds, her ambers, and her blues,

Pierced with soft light the shallowing deeps.

But now a wandering land breeze came

And a far sound of feathery quires;

It seemed to blow from the dying flame,

They seemed to sing in the smouldering fires.[x]

Mary's multi-faceted designs in terracotta, textiles, bookbinding, bedheads and architecture represented England, Scotland and Ireland in International exhibitions and the St Louis World's Fair in America at the turn of the century. Her work regularly featured in *The Studio*. An article on 'Lady Artists of the Day' at the time describes the gallery being decorated with 'blood-red arras cloth, upon which Watts's paintings hang to inspire the boys with the spirit of the master, though it is his mistress's spirit that pervades the enterprise.' The *Country Life* journalist, witnessing evidence of Mary's teaching, wrote of the 'astonishing' progress her teenage apprentices were making, their intelligent interest as they learned to model sundials and intertwine mouldings on the 'wide, sweet curve' of a vase, all the while absorbing the beauty of line in nature around them, in creative engagement far from poverty. Their potter's mark, emblazoned with the motto, 'Their work was as a wheel in the middle of a wheel', symbolises the wheel of labour, winged by human hand and thought for the spiritual flight into the unseen.[350] Compton terracotta pots encircled the Tate's Central Hall.

'Never before, in this country at least, has the Garden Pot been treated as an item, *per se* of decorative skill,' declared Liberty & Co, in its first *Book of Garden Ornaments*. That the company name was internationally recognised for its decorative arts style was due in part to its policy of keeping designers anonymous. An exception was made for 'Mrs G. F. Watts the talented wife of our greatest living artist'. She had written at length explaining the symbolism of her modern Celtic-style Pelican Rug, a personal letter to the weavers who hand-tufted it in a Donegal hayloft in 1900. Their rug was displayed with her garden ornaments in landmark Liberty & Co exhibitions *Founding a National Industry: Irish Carpet Exhibition* and *Modern Celtic Art*.

[x] W. B. Years, *The Wanderings of Oisin*, 1889.

On display in the latter was the cinerary casket that would contain the ashes of her husband who died on Friday 1 July 1904.[351]

After his death, Mary did her utmost to preserve and secure his legacy through the Watts Gallery. Arguably perhaps, she was more successful at advancing her own work than upholding interest in his as twentieth-century taste in art moved on. She published *George Frederic Watts: The Annals of an Artist's Life* (1912), a two-volume biography, with a third devoted to his writings.

Mary created a huge silk banner as a gift to Earl Grey, Governor-General to inspire the people of Canada. 'The Spirit of the flowers of the nations' (1907) hung at Government House in Ottawa and became the first of a series he then commissioned to hang on college walls. Mary's 'Our Lady of the Snows' – known as 'The Queen's Banner' – was presented on behalf of Queen Alexandra to hang at McGill University's Royal Victoria College for women. An active suffragist, Mary marched and hosted women's suffrage meetings in the Gallery. She became president of the Godalming Women's Suffrage Society, of the Healthy and Artistic Dress Union and of the new Women's Guild of Arts; and in 1917 she was appointed an Associate of the National Gallery of British Art.

After a suffragette slashed Velasquez's nude *Rokeby Venus* at the National Gallery in 1914, Mary sprang into action to protect her husband's Symbolist nudes from similar damage, and closed Watts Gallery; and when the First World War broke out, the nature-loving Scot had their Limnerslease horses shot to protect them from being conscripted into battle. The Cambridge Military Hospital at Aldershot commissioned her to design a huge frieze and altar decoration for their mortuary chapel, all carried out under her direction by her potters. As well as designing war memorials for Compton and Inverness-shire, one of her more interesting memorials designed at this time was a fountain at Glen Prosen dedicated to Captain Robert Scott and Dr Edward Wilson, of the ill-fated Antarctic Expedition.

Her wooden pottery building was devastated by fire in January 1923, prompting a letter of sympathy from Queen Mary's lady-in-waiting.[352] Miniature versions of Mary's pots, commissioned by Gertrude Jekyll for the Queen's Dolls House were exhibited at the British Empire Exhibition at Wembley in April 1923 and are displayed today at Windsor Castle.

The activist in Mary never died. Her husband had founded a rifle club for the men of Compton. How could his widow not found the Ladies Watts Rifle Club. At the end of her life, she persuaded Winifred Coombe-Tennant, a collector of Modern British Art and owner of a rare nude version of *Hope*, to encourage the National Portrait Gallery to accept their first female portrait by Watts, of the social reformer Josephine Butler.

As she aged Mary became quite a red-faced tartar, a woman to be reckoned with in the village of Compton. She had her chauffeur hold up the traffic in Guildford High Street to allow her to pass. In 1933, the indomitable woman lobbied the architect Sir Edwin Lutyens and succeeded in having crosses erected each side of the new A3 to mark the Pilgrims Way beneath and to have the road itself to curve away from Limnerslease. Richard Jefferies reveals just how persuasive she was: 'Beware how you set your heel on the soul of an artist!'[353]

These are just a smattering of Mary's activities. She died on 6 September 1938, her ashes buried in a casket beneath a Celtic-style birdbath atop her horizontal memorial, beside her husband, all made by her potters. Her chapel, cemetery, memorials and cloister attract increasing interest and her characteristic terracotta garden ornaments and coloured ware, as vivid as the paintings of the Scottish colourists, are eagerly collected at auction today.

Acknowledgements

Warm thanks to Lady Verey for her Foreword as longstanding Trustee of Watts Gallery. To Richard Jefferies, devoted curator of Watts Gallery since 1985, I owe profound thanks for encouraging me to bring Mary to life 35 years ago and for his Foreword on the anniversary of her birth. It was thanks to Richard Ormond, as Chair of the Trustees and his namesake that Mary's work was first exhibited as *Mary Seton Watts (1849-1938) Unsung Heroine of the Art Nouveau* (1998).

Her descendants have given tremendous help. It was a privilege to stay at Aldourie, stepping on to her *Pelican* carpet as the new day began and to research family archives with Mary's great nephew Colonel Angus Cameron and photograph their collection and that of Mary's great niece Lady Erskine. Warm thanks to Iain Cameron and Sir Peter and William Erskine for images from the family collection – and to my research colleague in Scotland, Claire Craig.

Descendants of Mary's ward Lily Chapman, the late Ronald and Teresa Chapman generously shared memories and opened their library. Anthea Chapman kindly allowed me to photograph Mary's beautiful fan and Edward Chapman was assiduous in passing on research. Many thanks are due to James Hervey Bathurst for generous access to Blanche Somers Cocks' papers at Eastnor Castle.

For access to Watts papers over the years, I should like to thank the Earl of Wemyss, the Countess of Airlie, Denis Lanigan and Michael Meredith, Librarian at Eton College. The late Lionel Jebb's superb hospitality at The Lyth in Shropshire, enabled access to Eglantyne's Home Arts journals. Thanks are due to Dr Kedrun Laurie for generously sharing her transcriptions of Dorothy Tennant's journals, to Colin Ford and Tim Lindholm for their magnificent guidance on Julia Margaret Cameron.

Special thanks to my daughter Lucinda, son James and brother Nigel for their editorial and technical wizardry, to Hilary Calvert for her indefatigable editing and guidance, to Lucy Ella Rose, John Hammond and to Hilary Underwood for sharing expertise. Deep gratitude to Watts Gallery for permission to quote archival material and lend images that bring Mary's decorative skill to life as never before.

Image Credits

Warm thanks for generous permission to reproduce images from their collections, courtesy of:

Brooklyn Museum, New York. Gift of Mrs. Arthur Lehman, 53.141: Figure **3.**

Coldstream Guards Arcchives: Figure **26.**

Harvard Art Museums/Fogg Museum, Bequest of Grenville L. Winthrop: Figure **40.**

Private collections: **Front cover**, figures **2, 4-10, 16-18, 20, 29, 31-33, 38-39.**

Reading Museum (Reading Borough Council): Figure **19.**

The Royal Borough of Kensington and Chelsea Culture Service (Leighton House Museum): Figure **34.**

Victoria & Albert Museum, London: Figure **11.**

Watts Gallery Trust: **Back cover, frontispiece**, figures **1, 12-15, 21-22, 24-26. 30, 35-36, 41.**

Grateful thanks for support of
the Marc Fitch Fund

Illustrations

Front cover: *Self-Portrait*, 1881, oil on canvas.
Back cover: *Cartes-de-visite album title-page illumination*, c. 1866-67.
Frontispiece: *Cartes-de-visite album Tennyson frontispiece*, c.1866-67.

PREFACE

1 *Mary reading to Signor in the niche at Limnerslease.*

1 VALIANT SETON

2 Archibald Skirving (1749-1819) *Alexander Fraser Tytler*, 1798, pastel.
3 Sir Henry Raeburn (1756-1823) *Lady Woodhouselee*, c.1804, oil on canvas.
4 Margaret Sarah Carpenter (1793-1872) *William Fraser Tytler*,1841, oil on panel.
5 Margaret Sarah Carpenter (1793-1872) *Margaret Fraser Tytler*, 1841, oil on canvas.
6 Benjamin Richard Green (1807-76) *Charles Edward Fraser Tytler*, 1850, watercolour.

2 HIGHLAND MARY

7 *Aldourie Castle.*
8 *Harriet Jane Pretyman*, c.1850, chalk.

3 SANQUHAR

9 *Sanquhar House, Forres.*
10 Alicia Henning Laird (fl. 1850s-80s) *Mary Fraser Tytler*, 1864, watercolour.
11 Julia Margaret Cameron (1815-79) *Christina Fraser Tytlerr*, 1864-65, albumen.
12 *Mary reading.*
13 *Charles, William and Edward Fraser Tytler.*
14 *The Primus of Scotland, Archbishops of Canterbury, York, and Dublin, Rev/ E.H. Owen.*

15 *Harry Fane Grant.*

16 *Family group at Sanquhar, 1866. William Eden, Christina, Harriet, William, Eleanor, Mary, Ethel, Leo Torin, Edward.*

17 *Family grouped around the iron staircase at Sanqhuar, ud.*

18 *'Give and Take'* William Eden, Mary, Lady Macpherson-Grant, Primus of Scotland, 1867.

4 ROSEBUD GARDEN OF GIRLS

19 Oscar Gustave Rejlander (1813-1875), *Alfred and Emily Tennyson and their Sons, Hallam and Lionel in the Garden at Farringford*, 1863, albumen print.

20 Julia Margaret Cameron (1815-79), *Rosebud Garden of Girls*, albumen, 20 June 1868.

21 *Captain Speedy, Prince Alámayu of Abyssinia and his servant Casa, sitting to Julia Margaret Cameron,* July 1868.

5 GRAND TOUR

22 *Meissen ceramic decoration surrounds Dresden friends,* 1868.

23 *'Alone in the dark – for evermore!', Sweet Violet,* 1869, etching.

24 *H.I.M. The Empress of Austria* (lower right) *Fan and Mary's family members,* 1868.

25 *Dedication to King Ludwig II of Bavaria.* 1868-69, watercolour.

26 *Lieutenant James Graham-Montgomery,* 1869, albumen.

6 PAINTER OF PAINTERS

27 Henry Thoby Prinsep (1836-1914), *George Frederic Watts,* albumen print.

28 *Christina Fraser Tytler* 1870, oil on canvas.

29 'Morning Tide', illustration to story by Christina Fraser Tytler, *Good Words for The Young,* 1872.

7 I FELT A HAND

30 *Etheldred Fraser Tytler,* 1874-75, oil on canvas.

8 YOU DO SO!

31 *Mother and child,* c. 1875-76, terracotta.

32 *Eleanor Fraser Tytler,* oil on canvas, 1876.

33 *'East of the Sun and West of the Moon',* detail of fan, 1871-77.

34 *Studio at Sanquhar,* c 1881.

Bibliography

Adam, Frank, *The Clans, Septs and Regiments of the Scottish Highlands*, 1924.

Allingham, William, *The Diaries*, eds. H. Allingham and D. Radford, 1907, 1990 edition.

Anderson, W. E. K. ed., *The Journal of Sir Walter Scott*, 1972.

Anderson, W. M. ed., *Adomnán's Life of Columba*, 1991.

Anthony Ashley-Cooper, Earl of Shaftesbury, *Ragged School Union Quarterly Record*, July 1885.

Arnold, M. *On the Study of Celtic Literature*, 1867.

Baker, M. and Richardson, B., *A Grand Design: The Art of the Victoria and Albert Museum*, 1997.

Barnett, H., *Canon Barnett: His Life, Work, and Friends*, 2 vols, 1918.

Barrington, E. I., *G. F. Watts: Reminiscences*, 1905.

Beattie, S., *The New Sculpture*, 1983.

Berkeley, G., *Anecdotes of the Upper Ten Thousand, Their Legend and Their Lives*, 1867.

Beveridge, H., *The Sobieski Stuarts: Their Claim to be Descended from Prince Charlie*, 1909.

Blunt, W, *The Dream King: Ludwig II of Bavaria*, 1970.

– *England's Michelangelo, A Biography of George Frederic Watts*, 1975.

Booth, W., *The Salvation War*, 1884 and 1885.

Brown, Ivor, *Balmoral: The History of a Home*, 1955, 1966.

Bruce, R. V., *Bell: Alexander Graham Bell and the Conquest of Solitude*, 1973.

Burgon, J. W. *The Portrait of a Christian Gentleman: A Memoir of Patrick Fraser Tytler*, 1859.

Burne-Jones, G., *Memorials of Edward Burne-Jones*, 2 vols., 1904.

Burns, R., *The Works of Robert Burns with an account of his life, and A criticism on his writings to which are prefixed, some observations on the character and condition of The Scottish Peasantry*, 4 vols, 1800.

Carlyle, T., *On Heroes, Hero-Worship and The Heroic in History*, 1907 edition.

Carr, W., *A History of Germany 1815-1990*, 1969 (1991 edition).

Chapman, R. *The Laurel and the Thorn: A Study of G. F. Watts*, 1945.

Cox J. and Ford C., *Julia Margaret Cameron: The Complete Photographs*, 2003.

Dakers, C., *Clouds: The Biography of a Country House*, 1993.

Dalrymple, W., *White Mughals*, London: Harper Collins, 2002.

De Courcy, A., *The Fishing Fleet: Husband-Hunting in the Raj*, 2011.

Devine, T.M., *The Scottish Nation: 1700-2000*, 1999, 2000.

Diperna, P. and Keller, V., 'Oakhurst: The Birth and Rebirth of America's First Golf Course', 2002.

Dreyfous, M., *Dalou: Sa Vie et Son Oeuvre*, 1903.

Duff, D., ed., *Queen Victoria's Highland Journals*, 1980.

Duffy, C., *The '45: Bonnie Prince Charlie and the untold story of the Jacobite Rising*, 2003.

Egremont, M., *Balfour: A Life of Arthur James Balfour*, 1980.

Elliot, D. B., *A Pre-Raphaelite Marriage: The Lives and Works of Marie Spartali Stillman and William James Stillman*, 2006.

Emboden, W., *Sarah Bernhardt*, 1974.

Engen, R., *Kate Greenaway: A Biography*, 1981.

Exhibition of Modern Celtic Art at the Grafton Gallery, Bond Street, exh. cat. 1903.

Founding a National Industry, Grafton Gallery, London, Liberty & Co, 1903.

Franklin Gould, V., *G. F. Watts: The Last Great Victorian*, 2004.

Fraser, Antonia, *Mary Queen of Scots*, 1969.

Fraser Tytler, C E, 'Report on the Experimental Revenue Settlement of Certain Villages in the Broken and Hilly Country Forming the Kownaee Talooka of the Nassick Sub-Collectorate,' 1841, in *Selections from the Records of the Bombay Government No 1*, 1853.

– *A New View of the Apocalypse, or, The Plagues of Egypt and of Europe Identical*, 1852.

– *The Apocalyptic Roll: the Title Deed of the Church, The Seals: The Mystery of Good and Evil Contending for the Mastery, with a new Apocalyptic Chart*, 1867.

Fraser Tytler, C. E., *Sweet Violet and Other Stories*, 1869.

Fraser Tytler, Sir J. M. B., 'The Fraser Tytlers' (typescript), 1904.

Fraser Tytler, N., *Extracts from Tales of Old Days on the Aldourie Estate*, 1925.

Fraser Tytler, P., *Historical Notes on the Lennox or Darnley Jewel: the Property of the Queen*, 1843.

Frayling, C., *The Royal College of Art: 150 Years of Art and Design*, 1987.

Good Words for the Young, Norman Mcleod, ed., 1868-69.

Gordon Cumming, Constance Fredereka, *Memories*, 1904.

Gaskill, H., ed., *The Poems of Ossian*, 1996.

Giebel, Wieland, ed, *Insight Guides: Dresden*, 1992, 130 and 139.

Greig, J., *Sir Henry Raeburn RA: His Life and Works, with a Catalogue of his Pictures*, 1911.

Gruner, L., ed, *The Green Vaults Dresden: Illustrations of the Choicest Works in that Museum of Art*, 1862.

Hallé, C. E. and Marie, eds, *Life and Letters of Sir Charles Hallé*, 2 vols, 1896.

Heavens, A., *The Prince and the Plunder: How Britain took one small boy and hundreds of treasures from Ethiopia*, 2023.

Herman, A., *The Scottish Enlightenment: The Scots; Invention of the Modern World*, 2002.

Hibbert, C., *The Great Mutiny India 1857*, 1978, 1980 edition.

Holmes, N., *The Scott Monument, A History and Architectural Guide*, 1979.

Hoge, J. O., ed., *The Letters of Emily Lady Tennyson*, 1974.

– *Lady Tennyson's Journal*, 1981.

Home, J., *The History of the Rebellion in the Year 1745*, 1802.

Hume, D., 'Of National Characters' in *Essays Moral and Political*, 1748, 1753.

Lang, C.Y. and Shannon, E.F., eds., *The Letters of Alfred Lord Tennyson*, 3 vols, 1981-90.

Leander, R., *Träumereien an französischen Kaminen: Märchen*, 1871, translated by P. V. Granville, *Fantastic Stories*, 1873.

Leslie of Balnagieth, W., *A Manual of the Antiquities, Distinguished Buildings and Natural curiosities of Moray*, 1823.

Liddell, C. C., *A Shepherd of the Sheep*, 1916.

Lockhart, J. G., *Memoirs of the Life of Sir Walter Scott*, 1837.

London International Exhibition Official Catalogue: Fine Arts Department, 1871.

Longfellow, S., *Life of Henry Wadsworth Longfellow*, 3 vols, 1886-87.

MacCarthy, F., *William Morris: A Life for our Time*, 1994.

MacDonald, M.A. *By the Banks of the Ness*, 1982.

Mackay, J.A., *The Complete Letters of Robert Burns*, 1987.

Mackenzie, H., 'A Short Account of The Life and Writings of William Tytler, Esq, of Woodhouselee, F.R.S. Edin' from the Transactions of the Royal Society of Edinburgh, *The Works of Henry Mackenzie*, 1996, vol. 7, 137-75.

Macpherson, J., *The Works of Ossian: The Son of Fingal*, 2 vols., 1765.

Macrae, K., *Highland Handshake*, 1954.

Maitland of Lethington, Sir R., *The History of the House of Seytoun*, 1827.

Mallgrave, H., *Gottfried Semper: Architect of the Nineteenth Century*, 1996.

Mansbridge, M., *John Nash, A Complete Catalogue*, 1991.

Martin, R. B., *Tennyson: The Unquiet Heart*, 1980.

Mary Seton Watts (1849-1938) Unsung Heroine of the Art Nouveau, Franklin Gould, V, ed, exh cat., Watts Gallery 1998.

Mason, A. and Marsh, J. et al, *May Morris: Arts & Crafts Designer*, 2017.

Maude, F., *Memories of the Mutiny*, 2 vols, 1894.

Metropolitan Museum of Arts, *Loan Collection of Paintings by G F Watts RA*, 1884.

Miller, C., *A Childhood in Scotlqnd*, 1981.

The Monarch of the Glen: Landseer in the Highlands, Richard Ormond, ed., National Galleries of Scotland, Edinburgh, exh. cat. 2005.

Ovenden, G., ed., *A Victorian Album, Julia Margaret Cameron and Her Circle*, 1975.

Owen, P., *My Double Life: The Memoirs of Sarah Bernhardt*, 1907, 1977 edition.

Physick, J. F., *The Victoria & Albert Museum: The History of its Building*, 1982.

Pinnington, E., *George Paul Chalmers RSA and the Art of His Time*, Glasgow, 1896.

Poynter, E. J., *Ten Lectures on Art*, 1879.

Allan Ramsay 1713-1784, exh. cat., Scottish National Portrait Gallery, Edinburgh, 1992.

Raeburn: The Art of Sir Henry Raeburn 1756-1823, exh. cat., SNPG 1997.

Raeburn's Rival: Archibald Skirving 1749-1819, exh. cat., SNPG, 1999.

Reports of the Science and Art Department of the Committee of Council on Education, London, 1866-68.

Robertson, J.L. ed., *The Poetical Works of Sir Walter Scott*, 1904, 1967 edition.

Ricks, C., *The Poems of Tennyson*, 1969.

Ritchie, J., *The Pageant of Morayland*, 1932.

Thackeray Ritchie, A, *Alfred Lord Tennyson and His Friends*, 1893.

– *From Friend to Friend*, 1919.

– *Records of Tennyson, Ruskin and Browning*, 1892.

Lord Romsey, *Broadlands; The Home of Lord Mountbatten*, 1989.

Rose, L. E., *Suffragist Artists in Partnership*, 2018.

Royal Academy of Arts, *Notes on the Royal Academy Exhibition*, 1868.

The Royal Horticultural Gardens, South Kensington, 1865.

Ruskin, J., *Sesame and Lilies*, 1865, *The Works of John Ruskin*, vol II. 1871.

Science and Art Department, South Kensington Museum, *Catalogue of the Loan Exhibition of Fans*, exh. cat., 1870.

Shaw Sparrow, W., *Memories of Life and Art Through Sixty Years*, 1925.

Simier, A., 'A French Demonstration: The Pivotal Roles of Jules Dalou and Edouard Lantéri in British Sculpture' in *Impressionists in London: French Artists in Exile (1879-1904)*, Corbeau-Parsons, C., ed, Tate Britain, exh cat, 2017.

Tavender, I.T., *Casualty Roll for the Indian Mutiny 1857-59*, 1983.

Tennyson, A, *In Memoriam*, 1851.

Tennyson, H., *Alfred, Lord Tennyson: A Memoir by his Son*, 2 vols., 1897.

Todd, T., *Distinguished Men of the county, or Biographical Annals of Kinross-shire*, Kinross, 1932.

Thompson, H.W., *A Scottish Man of Feeling: Some Account of Henry Mackenzie, Esq of Edinburgh and of the Golden Age of Burns and Scott*, 1931.

Trevor-Roper, H., 'Invention of tradition: The Highland tradition of Scotland', in Eric Hobsbawm and Terrence Ranger, eds, *The Invention of Tradition*, 1983.

Troubridge, L., *Memories and Reflections*, 1925.

Tytler, W., *An Historical and Critical Enquiry Into the Evidence Produced by the Earls of Murray and Morton, Against Mary Queen of Scots. With an Examination of the Rev. Dr. Robertson's Dissertation, and Mr. Hume's History, with Respect to that Evidence* 1759.

Urquhart, M., *Sir John St. Barbe*, 1983.

The Victorian Vision, exh. cat., Victoria and Albert Museum, London, 2001.

The Vision of G F Watts, Veronica Franklin Gould, ed, exh cat., Watts Gallery, 2004.

Wake, J., *Princess Louise: Queen Victoria's Unconventional Daughter*, 1988.

Warner, M., *Queen Victoria's Sketchbook*, 1979.

Wilson, A. N., *The Victorians*, 2002, 2003 edition.

Abbreviations

A	Watts, M. S. *George Frederic Watts: The Annals of an Artist's Life*, 1912.
AFT	Alexander Fraser Tytler, Lord Woodhouselee.
CEFT	Charles Edward Fraser Tytler.
CEFT.J	His journal.
D	M's diaries and diary notes.
DT	Dorothy Tennant Journals, later Lady Stanley, transcr. Dr Kedrun Laurie.
EJ	The Journals of Eglantyne Jebb (private collections).
Fiche	Microfiche film from Watts letters (WG, NPG, Courtauld Institute of Art).
GFW	George Frederic Watts OM RA.
HAC	Highland Archive Centre houses the Aldourie papers.
HFT	M's stepmother, Harriet Fraser Tytler, née Pretyman.
JMC	Julia Margaret Cameron.
M	Mary Seton Fraser Tytler. After marriage: Mary Seton Watts.
M.Alb	M's *cartes-de-visite* album (© Watts Gallery Trust).
M.Com	M's commonplace book (© Watts Gallery Trust).
MQS	Mary Queen of Scots.
RBKC	Kensington Local Studies Library.
RSA	Royal Scottish Academy.
SNPG	Scotish National Portrait Gallery, Edinburgh.
TRC	Tennyson Research Centre, The Collection, Lincoln.
V&A	Victoria and Albert Museum, London.
W.Cat/P	M's catalogue of Watts Portraits (© Watts Gallery Trust).
W.Cat/S	M's catalogue of Watts Subject Pictures (© Watts Gallery Trust).
WFT	Sheriff William Fraser Tytler.
WG	Watts Gallery.

Notes

PREFACE

[1] *The Times*, 10 November 1902.

[2] D 13 November 1902.

1 VALIANT SETON

[3] Fraser Tytler, 1904, 22.

[4] Sir William Cecil to Sir Nicholas Throckmorton, 26 August 1561 (BL Add MS 35830, f.189r.).

[5] Maitland, 1827.

[6] Tytler, 1728, 1-3; Fraser Tytler, 1904, 1, 29-31, 42; Fraser, 1969, 13, 199-201; Burgon, 1859, 2.

[7] Duffy, 2003, 197-98 and 200; Home, 1802, 109.

[8] Mackenzie, 1996, 148 and 168; Fraser Tytler, 1904, 184-85.

[9] *Ibid.*; Tytler, 1760, I, ii, 260; Burgon, 1859, 4. and 154-55; Fraser, 1969, 286-87 and 390.

[10] Hume, 1753.

[11] Fraser Tytler, 1904, 49-50; Burgon, 1859, 5; Herman, 2002, 163-64; Tytler, 1772, iii-viii; Mackenzie,1996, 150-54 and 157. Greig, 1932, I, 318-21.

[12] Private collections; Tytler, 1759; Mackenzie, 1996, 156.

[13] *Gentleman's Magazine*, xxx, October 1760, 453-56.

[14] Wallace, 1958, 240-41; Burns to Tytler, [4 May 1787] quoted in Burns, 1800, IV, 353 and Mackay, 1987, 291.

[15] SNPG, 1864.

[16] Mackenzie, 1996, 170-71; Burgon, 1859, 7.

[17] Fraser Tytler, 1904, 1, 18-19, 51.

[18] *Transactions of the Royal Society of Edinburgh*, ii, 1790; Fraser Tytler, 1904, 52-53.

[19] AFT to Burns, 12 March 1791, quoted in Burns, 1800, II, 330-33 and III, 21; Mackay, 1987, 578.

[20] Burns, November 1793, reprinted in *The Times*, 13 June 2018.

[21] April 1791, quoted in Mackay, 1987, 578.

[22] SNPG, 1999, 27, fig. 21 and 59-60, cat. 46; Skirving portrait of 1798, 48, pl. 15 and 66, cat. 91. (Private collection).

[23] SNPG, 1997, 27, fig. 20 and 73-74, cat. 142.

[24] Lord Byron to William Bankes (undated, 1807) in Thompson,1931, 323.

[25] 'Cadyow Castle', Robertson, 1967, 667-70 and 689-90; Anderson, 1972, 182, 6 August 1826; Burgon, 1859, 30-31.

[26] *Ibid.* 29-30.

[27] 'Marmion: A Tale of Flodden Field, Canto II, XXXIII, Robertson, 1967.

[28] Burgon, 1859, 32.

[29] 'The Lord of the Isles' (1815), Canto II, xxvi, quoted in Robertson, 1967, 426.

[30] Lockhart, 1837; Burgon, 1859, 162-63 and 173-81; Fraser Tytler, 1843; Fraser Tytler 1904, 55-57; Anderson, 1972, 275.

[31] Burgon, 1859, 173-81, 319, 324-35.

[32] Signed and dated 1785.

[33] Private collections; SNPG, 1997, 67, cat. 96. Carpenter also painted PFT's portrait (NPG 226). D, 29 July 1898; Fraser Tytler 1905, 58-59.

[34] Dalrymple, 2002, 46.

[35] From Dr Duncan Robertson, Headmaster of Anderson's Academical Institution, Forres, 1834 (India Office: J/1/94 f. 90); from Charles Grant, 17 July 1834 (India Office: J/1/52, f. 255). CEFT.J 6 February 1842.

[36] WFT's sister Jane married James Baillie Fraser of Moniack Castle, Kirkhill.

[37] CEFT.J 6 February 1842. Alexander died on 4 August 1832 and George on 12 March 1836.

[38] *Bombay Calendar and Almanac*, 1838, 104 and 184; CEFT.J: 3 May 1842.

[39] *Ibid* and 1839, 209; Fraser Tytler, 1853, (BL: I.S.BO.75).

[40] CEFT.J April 1841; analysis in Fraser Tytler, 1853, 34.

[41] CEFT.J 20 April 1842.

[42] *Ibid.* 18 Jan, 2 February and 15 April 1842.

[43] *Ibid.* 25 December 1841.

[44] *Ibid.* 17 July 1842.

[45] *The Parish Register of Allhallows London Wall* (MS 5088). Ethel was born on 30 November 1809.

[46] De Courcy, 2011, 1-11. *Bombay Calendar and Almanac*, 1843.

[47] Fraser Tytler 1905, 19.

[48] WFT to John St Barbe, 17 June1843. Margaret FT to Mrs St Barbe, 1 July and 19 September 1843.

[49] CEFT.J 3 January 1843.

[50] Urquhart, 1983, 35-36; Romsey, 1989, 2.

[51] The Fraser dress tartan – stripes of green and blue diagonals crossing each other over red ground, with single white and single red diagonal stripes. Adam, 1924, pl. 24 and 25.

[52] Lord Lovat to WFT (HAC); Fraser Tytler, 1925.

[53] Duff, 1980, 57 and 164; Warner, 1979, 176; Brown, 1966, 61-63; Wake, 1988, 26.

2 HIGHLAND MARY

[54] Herman, 2002, 128, 258-59; Fraser Tytler, nd, 1; *Inverness Courier*, 18 April 1850. D, 24 July 1898.

[55] *Ibid.* 2002, 111-12.

[56] *Inverness Courier*, 18 April 1850; *Bombay Calendar and Almanac*, 1851, xxvi.

[57] Margaret FT to Miss St Barbe, 25 July 1850 (HAC); D, 13 July 1898.

[58] From Margaret FT, 25 January 1851 (HAC); Fraser Tytler 1905, 73; *Inverness Courier*, 4 February 1851, 7.

[59] Fraser Tytler, 1852, I, 9-10, 22, 56, 88 and II, 2; 1867, 291.

[60] CEFT to Margaret FT, 31 August 1853 (HAC).

[61] Marriage certificate G002238; *John O'Groat Journal*, 7 April 1854. *Bombay Calendar and Almanac* 1854, 674; 1855, 318.

[62] D 6 July 1898.

[63] Fraser Tytler, nd, 2 and 11-12.

[64] Fraser Tytler, 1925, 4-5.

[65] Anderson, 1991.

[66] Fraser Tytler, 1904, 16-17; note from M for Lily Chapman, née Mackintosh, nd (Chapman papers).

[67] MacDonald, 1982, 43; Miller, 1981, 1-2.

[68] *John O'Groat Journal*, 7 April 1854.

[69] M to WFT, 3 February 1930 (HAC).

[70] *The Monarch of the Glen:* 2005, 13 and 115.

[71] MQS's pendant, a wedding gift from the King-Dauphin Francis, and her watch were given to James Fraser Tytler, Lord Woodhouselee, in 1877 and sold to America in 1923.

[72] Macrae, 1954, 49.

[73] D 14 February 1891; M to Hester Cameron, 31 August 1920 (HAC); M to Mrs Sophie Drummond, 13 November 1933 (private collection).

[74] CEFT to Margaret FT, 31 August 1853 (HAC).

[75] Stephenson Locomotive Society, 1955, 3-5, 88; *Inverness Courier*, 21 and 28 September 1854, 8 November 1855, 5.

[76] *Inverness Courier*, 2 and 16 July 1857; Hibbert, 1980, 55, 75-76.

[77] Fraser Tytler, 1904, 62.

[78] Tavender, 1983, 132.

[79] Nana Govind Dhondu Pant, adopted son of the last Peshwa of the Maratha Confederacy.

[80] Maude, 1894., I, 43 and II, 296-300; Hibbert, 1978, 205.

[81] Bunty Gasden to WFT, 23 January 1858; Lieut-Col Francis Maude to JBFT, 20 October 1859 (HAC); Fraser Tytler, 1904, 62; Maude, 1894, II, 550 and 557.

[82] Adam, 1924, 248.

[83] CEFT to Margaret FT, 20 February 1859 (HAC).

[84] *Bombay Calendar and Almanac,* 1860, 254 and 278 and 1862, 204.

[85] Fraser Tytler, 1904, 72.

[86] Arnold, 1867, 346.

[87] Gaskill, 1996, v-vi, xi-xv, 77-78.

[88] A I, 22; Herman, 2002, 249-50 and 254; Macpherson, 1765.

3 SANQUHAR

[89] D 14 February 1891; *Annals of the Royal Burgh of Forres,* 1934, 141-42.

[90] *Ibid.* Leslie,68; *Forres Gazette,* 3 February 1863, 2.

[91] CEFT.J 18 January 1842; CEFT to MFT, 31 August 1853 (HAC); Leslie, 1823, 68.

[92] Sueno's Stone is now believed to have been carved in the ninth or tenth century to commemorate a Scottish victory. Leslie, 1823, 56-57; James Ritchie, 1932, 148.

[93] John Ruskin, *Sesame and Lilies,* 1865.

[94] Parliamentary Archives, 1966, HC/CL/JO/6/416.

[95] D 7 February 1891.

[96] Anne Thackeray to Walter Senior, nd (Senior Papers).

[97] Cox and Ford, 2003, cat.228.

[98] *Ibid.* Terry, 1908, 15; 52-58, 77 and 85.

[99] *The Times,* 24 January 1871, 10 and 15 May 1871, 13.

[100] On 17 December 1865.

[101] Tennyson, cxxxi, 141-44; Young, 1977, 66.

[102] Tennyson, *In Memoriam,* 1851, cv.

[103] D G Rossetti, 1865, 8, 25, 27-28 and 30.

[104] CEFT, 1867, xv, 136, 235, 290.

[105] *The Times,* 25 May 1866.

[106] 'Harold's Wife' in Fraser Tytler, 1869, 281-82.

[107] Later General Sir Henry Fane Grant (1848-1919), son of Sir Patrick Grant. Gordon-Cumming, 1904, 191; *Forres, Elgin and Nairn Gazette,* 16 January 1867, 3; Fraser-Tytler, 1869, 38-40.

[108] *Reports of the Science and Art Department,* 1866-68.

[109] V&A, 2001, 228.

[110] Trever-Roper, 1983.

[111] Beveridge, 1909, 18-27, 42.

[112] Tennyson, 1883, 217, iv 15. The line should read 'And grow for ever and for ever'.

[113] CEFT to Margaret FT, 31 August 1853 (HAC).

[114] Parliamentary Archives.

[115] Hoge, 1974, 118-19; A, I, 205 and 287-88.

[116] A: I, 122. Terry, 1908, 53.

[117] Proposed to parliament in 1846 by Philip Stanhope, later 5th Earl Stanhope, formally established in 1856.

[118] A: I, 288.

[119] Inverness School of Art established in 1865; *Reports of the Science and Art Department* 1866, 130-31 and 1868, 135; *Inverness Exhibition of Art and Industry*, 1867, 3, 5, 7, 9-16, 18, 28-32, 42-43.

[120] Baker and Richardson, 1997, 33-35.

[121] CEFT's sister Emilia 'Mela', wife of Richard Torin, mother of Ernest, Annie and Lionel.

[122] Eliza Maria's father Sir Alexander Gordon-Cumming, son of Sir William Gordon-Cumming by his first wife Eliza Maria. Emilie is Sir William's daughter by his second wife, Jane Mackintosh.

4 ROSEBUD GARDEN OF GIRLS

[123] Tennyson, 1851, 156, ci last verse.

[124] D 5-28 March and 10 August 1868.

[125] Mansbridge, 1991, 11-12 and 190-91; D: 1, 3, 24-26 April 1868.

[126] D 1 April – 7 May 1868.

[127] Wake, 1988, 67.

[128] Major-General Sir George Tindal Pretyman (1845-1917).

[129] D 8 May 1868; EST, II, 110; Hoge, 1981, 275.

[130] D 18 January 1898; Hoge, 1981, 215.

[131] D 26 May 1868; Ritchie, 1892, 42-43, 1893, 9; Martin, 1980, 446-47; Lord David Cecil in Ovenden, 1975, 3; Tennyson, 1897, II, 86.

[132] D 26-31 May 1868; Emily Tennyson's Journal, II, 2; VI, f.81; Hoge, 1981, 275.

[133] Tennyson, 1855, I, iii, line 12.

[134] Ritchie, 1892 47; Ford, 1975, 11; *Nineteenth Century* XXXIII, 1893 170, quoted in Ricks, 1969, 784-85.

[135] D 5 May and 15 August 1868; Fraser-Tytler, 1869, 16, 45, 106, 120, 198, 217 and 287.

[136] D 10, 13 and 15 June 1868.

[137] D 18 June 1868.

[138] A: I, 205-6.

[139] D 19 June 1868.

[140] D 19-20 June 1868; Ford, 2003, 30; Thackeray Ritchie, 1893, 10.

[141] JMC to Sir John Herschel, 26 February 1864 (Royal Society: 159); Ford, 2003, 35, 41-42; International Museum of Photography, 1986, 98-99.

[142] Thackeray Ritchie, 1919, 24-25; Cox and Ford, 2003, 47; A: I, 206.

[143] Tennyson, 1883, 346-47, XXII, ix-x.

[144] Cox and Ford, 2003, 456-57, cats. 1124-26; PRO COPY 1/14/463-64, registered on 30 June 1868.

[145] 1865-66, Tate Britain.

[146] 1851, Fitzwilliam Museum, Cambridge.

[147] Allingham and Radford, 1990, 164-65; D: 20 June 1868.

[148] D. G. Rossetti to JMC, July 1869 (Wellesley College, Massachusetts).

[149] D 22 June 1868; *Art-Journal*, 1868, 2, 101, 111-12; Egyptian Hall, 1868.

[150] D 23 June 1868; M's copy of Royal Academy, 1868, cats. 30, 290, 323, 685, 1053; GFW to W. E. Gladstone, 3 May 1868 (Fiche 1, B4).

[151] Royal Academy, 1868, 36.

[152] D 23-24 and 27 June 1868.

[153] D 27 June 1868; Physick, 1982; Department of Science and Art, 1879.; Wake, 1988, 91-92.

[154] *Ibid*; *Royal Horticultural Gardens*, 1865, 9-18.

[155] D 28 June 1868; Sir Francis Seymour Haden P.R.E. (1818-1910).

[156] D 29-30 Jun, 3 July 1868.

[157] A: I, 204-5.

[158] A: II, 163; Tennyson, 1883, 218; Jump, 1992, 72; Ricks, 1969, 784-85.

[159] A: I, 206-7; Ford, 2003, 17-19.

[160] D 4 and 6 July 1868; Cox and Ford, 2003, 32-33.

[161] Tennyson, 1883, 342.

[162] Longfellow, 1886-87, II, 442-44. Longfellow to Tennyson, 6 July 1868, quoted in Lang and Shannon, 1987, II, 496n.

[163] D 17 July 1868; Tennyson, 1897, II, 56; Tiny Cotton to Agnes Jones, 18 July 1868, quoted in Lang and Shannon: 1987, II, 497-98.

[164] Tennyson, 1897, II, 56; Hoge, 1981, 277-78; Christina Fraser Tytler ms (private collection).

[165] D 18 July 1868; PRO: COPY 1/14/531-33 23 July 1868; Cox and Ford, 2003, 30, 334, cat. 712; Ford, 2003, 49; Hoge, 1981, 278; Allingham, 1990, 165.

[166] Heavens, 2023, ix-x, 18, 36-37, 97., 121.

[167] D 23 July 1868; Hoge, 1981, 278-79; Tennyson, 1898, II, 56; Cox and Ford, 2003, 26.

[168] PRO: COPY 1/14/541-52 27 and 29 July 1868; Cox and Ford, 2003, 454-57, cats. 1114-22; Allingham, 1990, 166-67.

[169] D 7 July 1868; Hallam Tennyson to Alfred, Emily and Lionel Tennyson, 16 and 23 August 1868 (TRC: 1074-75); Thwaite, 1996, 444. Cox and Ford, 2003, 456-57, cat. 1125.

[170] Cecil's introduction to Ovenden, 1975, 7.

5 GRAND TOUR

[171] Berkeley, 1867, II, 367.

[172] D 31 December 1868; Carr, 1991, 101-2 and 105.

[173] D 27-29 July 1868; Giebel, 1992, 130 and 139.

[174] Mallgrave, 1966, 194, 197.

[175] D 29 July – 31 December 1868.

[176] D 16-17 November 1868.

[177] D 21 August and 13 November 1868; A: I, 289.

[178] Tennyson, 1851 civ.

[179] D 8 and 28 Sep, 18 & 28 November and 12 December 1868; Gruner, 1862., cat. 25.

[180] *The Times*, 22 September 1869, 10.

[181] Chapman's mother, Lily Mackintosh, was M's ward.

[182] Blunt, 1970, 99.

[183] King Ludwig of Bavaria to Richard Wagner, 31 May 1868, quoted in Blunt, 138.

[184] *Good Words for the Young*, 1868-69, 240, 283, 336-42, 406-12, 517-22.

[185] Tennyson, 1851, 32, xix; Liddell, 1870, 2, 16-18 and 33.

[186] A: I, 289.

[187] *The Times*, 4 January 1870, 10; Thorvaldsen Museum, 1977, 15, 18-20.

[188] M.Com 30.

[189] *Ibid.* 10 July and 6 August 1870.

[190] *The Times*, 24 January 1871, 10 and 15 May 1871, 13.

[191] M.Com 17 February 1870 and 19 June 1871.

6 PAINTER OF PAINTERS

[192] A: I, 289.

[193] *Art-Journal*, 1870, 290; W.Cat/S: 33a and 54c; W.Cat/P: 23c; *Athenaeum*, 30 April 1870, 584; Royal Academy, 1870, 8 and 29.

[194] Carlyle, 1907, 5.

[195] Robinson and Suleman, 2005, 20-21; Dakers, 1999, 49-50 and 60-61.

[196] A: I, 289; W.Cat/P:167b.

[197] Carlyle, 1907, 14-15.

[198] *Vision of GFW*, 2004, 49 and 63.

[199] MacCarthy, 1994, 199-200 and 270.

[200] A: I, 289-90.

[201] Science and Art Department, 1870, vii; *Athenaeum*, 28 May 1870, 716; Avril Hart and Emma Taylor, *Fans*, 1998, 95.

[202] M.Com 2.

[203] *Ibid.* 26.

[204] *Ibid.*.31.

[205] *Ibid.* 26, 29 and 57.

[206] Liddell, 1916, 22 and 24.

[207] M.Com 32-33.

[208] *Ibid.* 38-41.

[209] *Ibid.* 31-32.

[210] M.Com 42-49; Egremont, 1980, 13.

[211] RSA Exhibitors 1826-1990, 1991, cat.83 *Comin' through the rye*, cat. 210 The *chief mourner*, cat. 385 *A secret between two*, cat. 400 *Irises and moor-hen*.

[212] *The Times*, 24 February 1871.

[213] M.Com 1a and 74.

[214] Physick, 1982, 9, 126-27, 140; *Report of the Science and Art Department*, 1871, 379-80 and 1872, 388; *Graphic*, 26 February 1870, 298.

[215] *Royal Albert Hall*, 1871, 9, 14, 18, 24 and 31.

[216] *London International Exhibition*, 1871, cats. 2404-5, 2465-66.

[217] Carr, 1991, 115.

[218] Emily Tennyson to Edward Lear, 22 February 1871 (TRC: 5526); Hoge, 1981, 320.

[219] M.Com 60.

[220] *Ibid.* 66-67.

[221] Thwaite, 1996, 437, 492; Hoge, 1981, 322 and 324.

[222] *Forres, Elgin, and Nairn Gazette*, 27 September 1871.

[223] Liddell, 1916, 25-26.

[224] M.Com 64.

[225] *Good Words for the Young*, 1872, 441, 457 and 481.

[226] Leander, 1873, cover and frontispiece 'Heino in the Marsh', 27 'The Knight who Grew Rusty', 49 'The Wishing Ring', 79 'Sepp's Courtship', 103 'The Unlucky dog and Fortune's Favourite', 121 'The Dreaming Beech'; *Art-Journal*, 1872, 129; Poynter 1879, 102-3.

7 I FELT A HAND

[227] Poynter, 1879, 101-2, 111-12 and 133-34; Engen, 1981, 43.

[228] DT 5 November 1873.

[229] *University College London: Calendar*, 1873, 155-60; D 1868, end note; Engen, 1981, 43.

[230] *Ibid*, 1873, 43; Shaw Sparrow, 1925, 93-96.

[231] M.Com 112; *Collected Works of the late George Mason* ARA., 1873.

[232] M.Com 70-71; M To GFW, Saturday [6 November 1886], quoted in Chapman, 1945, 126).

[233] Annie Prinsep, to Harry Prinsep, 3 July 1873 (private collection).

[234] *Globe*, 10 February 1873.

[235] D 3 October 1887; A: I, 278.

[236] A: I, 298; Franklin Gould, 2004, 115-19; M.Com 83, 86 and 102-3.

[237] M.Com 131.

[238] *Ibid*: 102, Norway, Fosford, 1 August 1874.

[239] 'The first cap worn by G.F. Watts Esq RA (Signor) made by Miss A Prinsep 1874' inscribed on red velvet cap, 23.75cm diam.

[240] M.Com 103; Troubridge, 1925, 24; WG, 1998, 24.

[241] *Ibid*. 103-4; A: I, 298; Fuller, 1992, 25.

[242] *Ibid*. 104-5.

[243] A, I, 300-01; Tennyson, 1897, II, 84; Ritchie, 1919, 31; Cox and Ford, 2003, 467.

[244] Mc.Com: 108.

[245] W.Cat/P 126c.

[246] Blanche, daughter of Major Herbert and Mary Clogstoun, was born on 17 October 1862.

[247] D 31 May 1893.

[248] A: I, 298-99, 303-4; Blanche Clogstoun's diary, 20 November and 1 December 1875.

8 YOU DO *SO!*

[249] Pinnington, 1896, 2, 166, 174-78.

[250] M.Com 112-13.

[251] *Mary Seton Watts*, 1998, 25, cat.8.

[252] M.Com 113-14; Greig, 1911, 61-62; Pinnington, 1896, 191, 233-34.

[253] Pinnington, 1896, 2; *Art Journal*, 1897, 83-88. *Hansard* vol 238. 5 March 1878.

[254] GFW, 24 May 1876, quoted in Chapman, 1945, 111.

[255] Dreyfous, 1903, 69-70; Beattie, 1983, 14-16; Frayling, 1987, 55; Chapman, 1945, 115. Simier, 2017, cat. 1018, 145-69.

[256] Christina Liddell, *Jonathan*, 1876. Liddell, 1916, 34, 36-43 and 46.

[257] *Forres, Elgin, and Nairn Gazette*, 12 July 1876; MacCarthy, 1994, plate xviii; M.Com 111; John Henry Newman, 'The Pillar of Cloud', line 5, a locket June 10.

[258] I Samuel I, 10; M.Com 120-21.

[259] A: I, 323-24; Hallé, 1896, II, 110; *Grosvenor Gallery*, 1877; *Illustrated London News*, 12 May 1877, 450. Surtees, 1993 146-47.

[260] W.Cat/P 23c, 95c and 173a; Dakers, 1993, 52.

[261] Grosvenor Gallery, 1877 cats. 1-3, 11-13, 30 and 233; Cat.S.6-7; Elliott, 2006, 86; Wake 1988, 104-5, 202.

[262] *Queen*, 8 July 1876, 34 and 15 December 1877, 420.

[263] Bruce, 1973, 236; *Eton Register*, 1907, IV, 120.

[264] Owen, 1977, 280-82; Emboden, 1974, 28-32, 38, 168; *Queen*, 28 April 1877, 286 and 8 September, 163 and 15 September, 178.

[265] M.Com 131-34 and 140; D 29 April 1887.

[266] M.Com 147.

[267] Holmes, 1979, 21 and 23.

[268] Aldourie Game Book; WG 1998, 27; letter to Mrs Drummond, 20 December 1922.

[269] M.Com 150, 29 April 1882.

[270] Fraser Tytler, nd, 2; *The Richmond and Twickenham Times*, 17 December 1881; *Inverness Courier*, 18 Dec, 3.

9 MARY DECLARES

[271] A: II, 9.

[272] M to GFW, 14 March 1882, quoted in Chapman, 112; A: II, 53; *The Grosvenor Gallery Winter Exhibition*, 1881-82, 94 and 96.

[273] GFW to M, 17 March 1882, *ibid.* 112-13.

[274] Gilbert and Sullivan parodied Wolseley as the Major-General in *The Pirates of Penzance*. M.Com 152-53, 19 August and 14 September 1882; Fraser Tytler, 1904, 74; Todd, 1932; *The Times*, 10 November 1902.

[275] M to Hallam Tennyson, 5 December 1883 (TRC: 4919).

[276] A: II, 25.

[277] M.Com 154-61.

[278] *Ibid.* 161.

[279] Franklin Gould, 2004, 175-77.

[280] M.Com 161-63; Tennyson, 1883, 428.

[281] A: II, 56-57.

[282] *The Times*, 26 June 1884, 5; Thwaite, 1996, 553-55.

[283] Diperna and Keller, 2002.

[284] M.Com 164, July 1884; W.Cat/S 92a.; A: II, 49.

10 E M E R G I N G C R A F T S W O M A N

[285] Barnett, 1918, I, 218.

[286] A: II, 57-58.

[287] Ashley-Cooper, 1885, X, 9-10 and 123-33.

[288] *The Ragged School Union Annual Record*, 1883, 20-22; 1884, 13-14; 1885, 14-15.

[289] *Hobby Horse*, 1884, April 1884, no. 1; Barnett, 1918, I, 221 and II, 151; A: II, 57-58.

[290] Jebb, 1885, 3-4.

[291] EJ; Jebb, 'The Rights of Women', leaflet reprint from *Temperance Vision*, 25 August 1882; Wilson, 1967, 29-30.

[292] Burne-Jones, II, 81.

[293] *Home Arts and Industries Association Minute Book 1884-90*, 1-3 and 16 (RIBA: HAIA/1); EJ: 27 November 1884.

[294] Barnett, 1918, II, 170; Franklin Gould, 2004, 182-84.

[295] A: II, 55.

[296] M to WFT, 3 February 1930.

[297] Barrington, 1905, 146.

[298] M to GFW, 26 January 1885, GFW to M, 27 January (WG, quoted in Chapman, 1945, 113-15).

[299] *The Ragged School Union Quarterly Record*, 1885, 112-15.

[300] EJ: 6-9 July 1885; Jebb, 1885, 3-13; *Cheltenham Ladies' College Magazine*, 1886, 89; *Magazine of Art*, August 1885, xlii.

[301] Booth, 1884, 131-32, 142-43; Booth, 1885, 137; Sandall, 1956, 22, 42, 96.

[302] *Pall Mall* Gazette, 6-10 July 1885; W.Cat/S 100c; Franklin Gould, 2004, 189.

[303] GFW to M, 13 March 1886 (WG, quoted in Chapman, 1945, 115).

[304] EJ 21 April 1886; Jebb, 1885, 11; Wake, 1988, 290-91.

[305] *Ibid.* 17, 23, 31 March and 3 April 1886 (WG); GFW to the 10th Earl of Wemyss, 10 Jan; GFW to Walter Crane, 18 March (RBKC); A: II, 58; Franklin Gould, 2004, 193-95.

[306] MFT to Hallam Tennyson, 5 May 1886 (TRC: 7525).

[307] GFW to MFT April 1886 quoted in Chapman, 1945, 115, and 6, 10 and 20 May 1886 (WG); A, II: 49.

[308] D 11 July 1891.

[309] *Scottish News*, 7 June 1886; EJ 20 Jun.

[310] EJ 22-23 June 1886.

[311] *Ibid.* 24-25 June 1886 and *Home Arts and Industries Association Minute Book*, 1884-90, 33 and 35 (RIBA: HAIA/1).

11 THE RIVALS

[312] Barrington, 1905, 98 and 142-43.

[313] M.Com 172; GFW to Mrs E. Wardell, 6 July 1886 (Smallhythe, ZI, 579); GFW to MFT, 12 July 1886 (WG); Blunt, 1975, 174.

[314] GFW to M, 13 and 23 July 1886 (WG); Barrington, 1905, 166.

[315] M.Com 173-74.

[316] GFW to M, 8 August and 1 September 1886 (quoted in Chapman, 117-18); A: II, 63; Barrington, 1905, 167.

[317] Barrington, 1905, 163.

[318] GFW and M, 12-21 September 1886 (WG); Barrington, 1905, 93 and 96.

[319] W.Cat/S 1b; Franklin Gould, 2004, 201.

[320] M to GFW, 23 September 1886 (quoted in Chapman, 120).

[321] News report kindly sourced by Hilary Calvert.

[322] GFW and M, 28 Sep, 3, 5, 7, 8 October 1886 (WG).

[323] Ibid. 10, 13 and 17 October 1886 (WG) Memorial now on loan to WG.

[324] M to GFW, 17 October 1886 (WG); Devine, 2000, 299 and 430; Egremont, 1980, 78.

[325] GFW to M, 12, 13 and 18 October 1886 (WG).

[326] St Matthew, V-VIII.

[327] I Corinthians XIII.

[328] M to GFW, 21 October 1886; GFW to M, 23 October 1886, quoted in Chapman, 124).

[329] Quoted in Chapman, 124-25).

[330] A: II, 60.

[331] GFW to M, 24 October 1886 (quoted in Chapman, 125); GFW to Blanche Somers-Cocks, 24 October (Eastnor Castle Collection) and 4 Nov; Andrew Hichens to GFW, 27 October (quoted in A: II, 61). A: II, 60.

[332] A: II, 62.

[333] Hallam Tennyson to GFW, 11 November 1886 (NPG: 94).

[334] Anne Thackeray Ritchie to GFW 1886 (NPG: 260-63); GFW to ATR, 10 November 1886 (Eton College Library); GFW to M, 10 November 1886 (WG).

[335] M and GFW, 6, 7 and 11 November 1886 (WG).

[336] Barrington, 1905, 167.

[337] GFW to M, 7, 12-13 November 1886 (WG).

[338] GFW to Lady Holland, 19 November 1886 (copy dated September 1912, BL, Add. MS 52163.ff.132); GFW to Blanche Countess of Airlie, 16 November 1886 (Airlie papers).

[339] Bernard Bosanquet to M, 17 November 1886.

[340] William Holman Hunt to Henry Wallis, 30 January 1887 (Bodleian Libraries, MS.Eng.c.7039.ff.55-56.)

[341] W.Cat/S 111c; Barrington, 1905, 167, Chapman, 1945, 127; A, II: 62-63; Blunt 177; National Gallery, London, 2003, 434-36, cat. 195; Tennyson, 1883, *The Princess* 251.

[342] D 22 January 1887; A: II, 62-63; Barrington, 1905, 167-68; GFW to the Earl of Wemyss, 23 November 1886 (Wemyss papers); Chapman, 1945, 127.

[343] Tennyson, 1883, *The Princess* 251.

EPILOGUE

[344] GFW to Briton Rivière, 23 January 1895 (ts, NPG album XIII, 201).

[345] Mason, Marsh et al, 2017, 156.

[346] D 30 August 1893; A II, 208-9.

[347] D 1 October 1893.

[348] D 27 March 1898.

[349] D 18-19 May 1898.

[350] *Country Life*, 15 March 1902, 328-30.

[351] *Exhibition of Modern Celtic Art*, 1903; *Founding a National Industry*, 1903; D 1 July 1904.

[352] *Surrey Advertiser and Times*, 20 January 1923. The rebuilding of more solid pottery workshops was covered by Insurance.

[353] Interviews with author; Sir Edwin Lutyens to M, 28 March 1933 (Fiche 43, D11).

Index

179

VERONICA FRANKLIN GOULD

After an early career in publishing, Veronica moved with her young family to Compton, where she published a guide to *The Watts Chapel: An Arts & Crafts Memorial* and curated Watts Gallery's centenary exhibitions *Mary Seton Watts (1849-1938) Unsung Heroine of the Art Nouveau* and *The Vision of G F Watts*. Her biography of *G F Watts: The Last Great Victorian* was published by Yale University Press. Veronica has since curated *Tennyson at Farringford*. Among her publications as founder of the charity Arts 4 Dementia are *Music Reawakening* and *A.R.T.S. for Brain Health: Social prescribing transforming the diagnostic narrative for dementia: From Despair to Desire*. Now living in London, Veronica is writing a double biography of Watts's wives, the actress Ellen Terry and Mary Fraser Tytler.